Best Wishes

Robert Knudsen

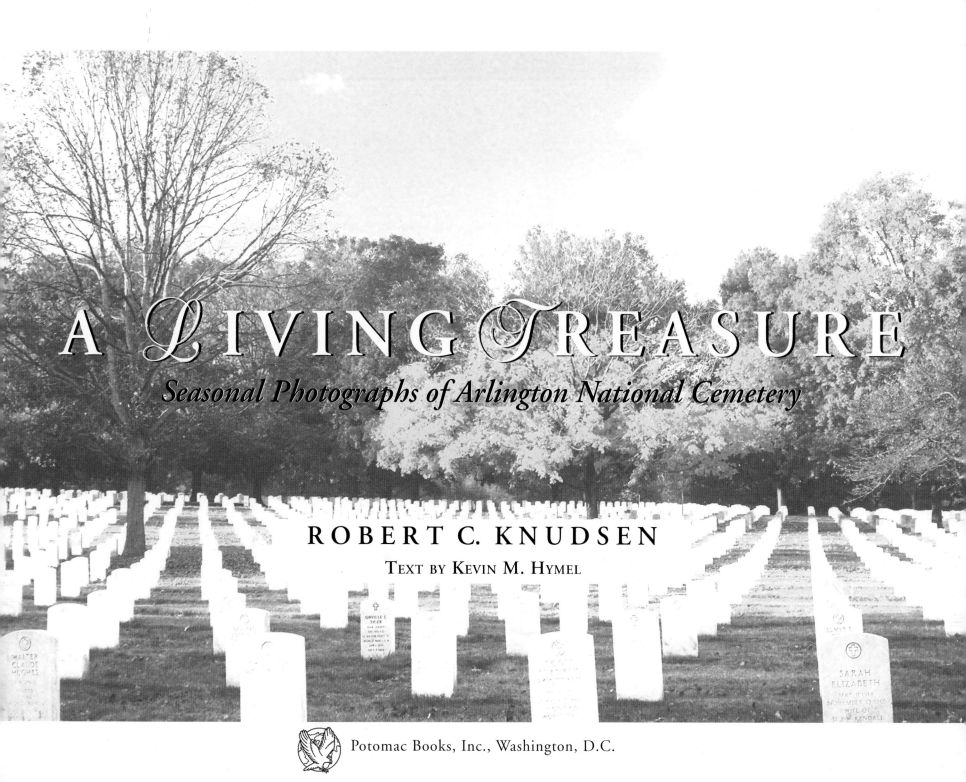

A LIVING TREASURE

Seasonal Photographs of Arlington National Cemetery

ROBERT C. KNUDSEN

TEXT BY KEVIN M. HYMEL

Potomac Books, Inc., Washington, D.C.

Library of Congress Cataloging-in-Publication Data
Knudsen, Robert L. (Robert LeRoy), 1929-1989.
A living treasure : seasonal photographs of Arlington National Cemetery / Robert
L. Knudson ; text by Kevin Hymel. — 1st ed.
 p. cm.
ISBN 978-1-59797-272-7 (hc : alk. paper)
1. Arlington National Cemetery (Arlington, Va.)—Pictorial works. 2. Seasons—
Virginia—Arlington—Pictorial works. I. Hymel, Kevin, 1966- II. Title.
F234.A7K68 2008
363.7'509755295—dc22

 2008019903

(alk. paper)

Printed in the United States of America on acid-free paper that meets the
American National Standards Institute Z39-48 Standard.

 Potomac Books, Inc.
22841 Quicksilver Drive
Dulles, Virginia 20166

 An AUSA Book

First Edition

10 9 8 7 6 5 4 3 2 1

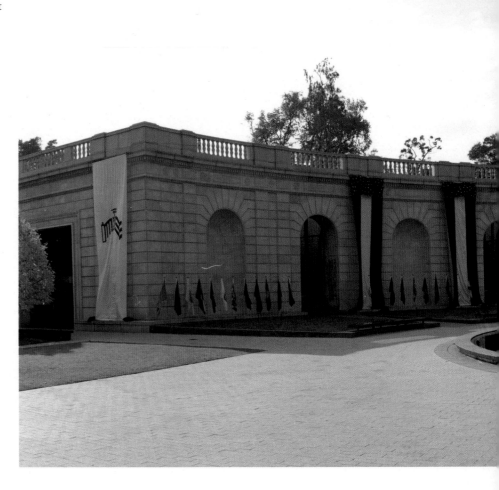

To my father, Robert L. Knudsen,
who taught me the art of photography.

To our gallant men and women in uniform,
who serve and protect our nation.

To all those who ensure the best quality of life and well
being for our military personnel and their families.

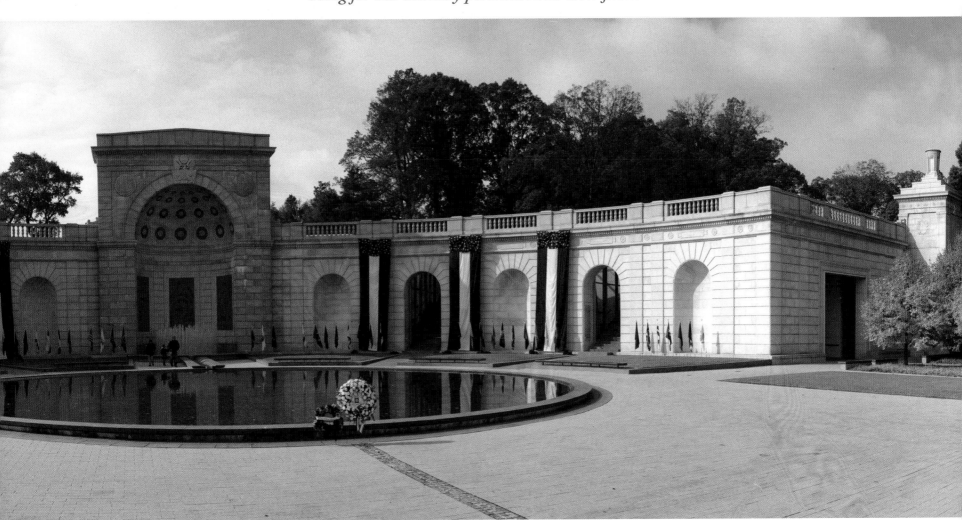

Acknowledgments

I would like to thank everyone who has contributed and been a part of this book, but it would be impossible to personally acknowledge everybody without writing a book just on them. So I would like to begin by thanking my Heavenly Father for gifting me with the creative talents I used. Andrea, my wife, who not only assisted with photo editing and suggested creative ideas, but would also come along with me on several early morning and cold-day shoots. She was always there to welcome me home from all the late nights, weekends, and holidays, then nourish me and encourage me to keep up the good work. Kevin Hymel, for his encouragement, friendship, wisdom, and writing. Pete Murphy, who did so much for me, I can't thank him enough. Pete was instrumental in bringing me together with John Metzler, Jr., who turned my idea of taking one photo into this photograph book. Pete then, along with Metzler, continued to help me with unselfish time and support through photo editing, technical and historical information, and unlimited access for the duration of this book project.

The creators of this book together would like to thank the following people: Tom Sherlock and Lori Cavillo at Arlington National Cemetery. COL Chuck Taylor and COL Bob Pricone of The Old Guard, who provided full support and access to their soldiers. CDR Scott Chapman (Ret.), CDR Chris Higginbotham, LCDR Jesse Virant, and LT Adam Krumbholz of the Navy. SSgt. Madelyn Waychoff of the Air Force. LTJG Damien Ludwig of the Coast Guard. SGT Jeremy Kern, SGT Brian Parker, and SPC Chance Wiley of the Army. Capt. Antony Andrious and GySgt. William J. Dixon of the Marine Corps. Robert Frost provided inspiration through his poetry about the seasons.

This book would not have been possible without the tireless work of the people at Potomac Books. Kevin Cuddihy kept the whole project on track. Michie Shaw did a great job laying out the pages and making the most out of the material we provided her. ❧

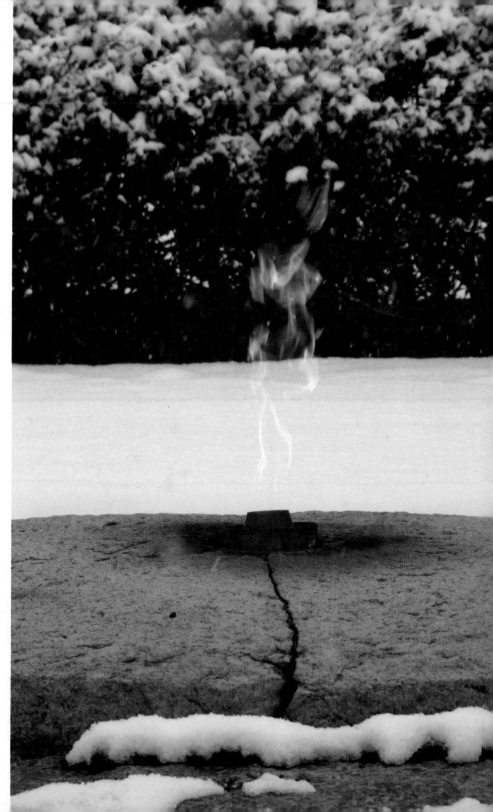

OREWORD

For six years, I lived less than a mile from the gates of Arlington National Cemetery. I drove along two sides of the cemetery—past the iconic scene of those perfect rows of white headstones, forming a line from every angle—each day on my way to and from work at the Pentagon. During most of those years we were a nation at war, and it was a constant and poignant reminder that freedom doesn't come without a cost—a human cost. Many of my fellow soldiers are buried there and I've attended a number of services, both personally and in my capacity as Chairman of the Joint Chiefs of Staff. I have mourned friends laid to rest at various periods throughout my forty years in the military, and I've paid tribute to brave men and women whom I never had the opportunity to meet.

There are 300,000 individual stories that make up the narrative of Arlington. Seeing the graves of these men and women, united in death by their sacrifice and honor, is a reflection of one of America's founding principles: that all men are created equal. There is democracy in death, evidenced by the identical markers at each grave, the same marker for privates and corporals as for generals, for Confederate soldiers as for Union soldiers, for black as for white, for rich as for poor, all lying side by side whatever the divisions may have been in life. Arlington gives us a lens through which to view our nation and evaluate how we are living up to the principles for which those who are buried there stood.

In this respect, Arlington is not a memorial to death but rather a celebration of life and the ways in which our country has become greater with each subsequent generation's fight for something larger than themselves. It is a tribute to a life well lived for these mostly unknown, regular citizens whose contributions were anything but ordinary.

Robert Knudsen truly understands Arlington. He has captured both the glory and the quiet solitude of the place in these photographs. His exquisite shots of the rows upon rows of white marble; the Tomb of the Unknowns; the Eternal Flame; and the many memorials are wonderful and respectful. The visual essays and accompanying sidebars on the five Honor Guards demonstrate the hard work and sacrifices they undertake to properly lay their fallen comrades to rest. And he captures the color and natural brilliance of the seasonal splendor surrounding the Cemetery in an absolutely breathtaking manner.

The United States is seen as a wealthy and prosperous nation; I believe the source of our fortune lies in the hills of Arlington National Cemetery. While on one level it's sad we have to have an Arlington National Cemetery, on another it's fortunate we have men and women willing to sacrifice for our country and preserve our way of life. As you turn the pages of this book, you will see those white marble headstones stretching into the distance in shot after shot. The fact that there will be more means that our country is in good hands. This experiment in democracy is fragile, and it takes people who are willing to serve to protect it, to fight for it. What a fortunate country.

—General Richard Myers, USAF (Ret.)
Former Chairman of the Joint Chiefs of Staff

INTRODUCTION

Every day at Arlington National Cemetery, a uniformed servicemember raises bugle to lips somewhere and plays "Taps." Somewhere else a firing squad fires a three volleys gun salute, and at the Tomb of the Unknowns a sentinel marches back and forth, protecting one of America's most sacred shrines. The final resting place for many of America's heroes, the Cemetery is the site of constant ceremonies and tributes: sometimes mournful, often reflective, and always respectful.

George Washington's stepson, John Parke Curtis, in 1778 purchased the wooded acreage that makes up today's Cemetery to create a plantation. After Curtis's death, his son decided to create a national memorial for Washington and began building a home on the west bank of the Potomac River in 1802 to serve as a museum. He wanted to call the area "Mount Washington," but friends encouraged him to name it after the original Curtis estate in Virginia, acquired by a grant from the Earl of Arlington. Thus the home became "Arlington House," and remains as one of the main buildings at Arlington National Cemetery today.

In 1831 Mary Anna Curtis married a young army lieutenant named Robert E. Lee. The wedding took place in Arlington House and was considered the estate's grandest event. The new husband and wife team took over responsibility for the house and the collection of Washington memorabilia, and in 1857 Lee took over the day-to-day plantation operations. However, the Lees departed the mansion as the Civil War commenced and Lee took command of the Confederate army, and Arlington House became a headquarters for Union troops. It became federal property after the Lees were unable to pay a property tax that had to be paid in person in Washington, D.C. The land thus came under the control of the Union Army's quartermaster general, Montgomery Meigs.

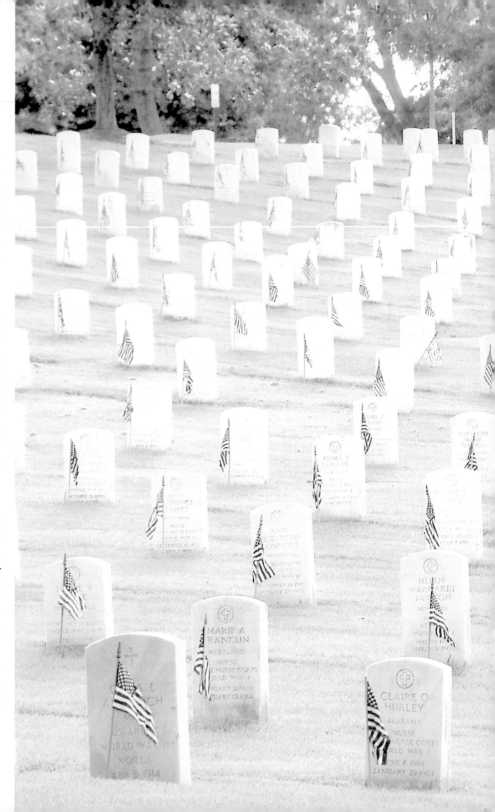

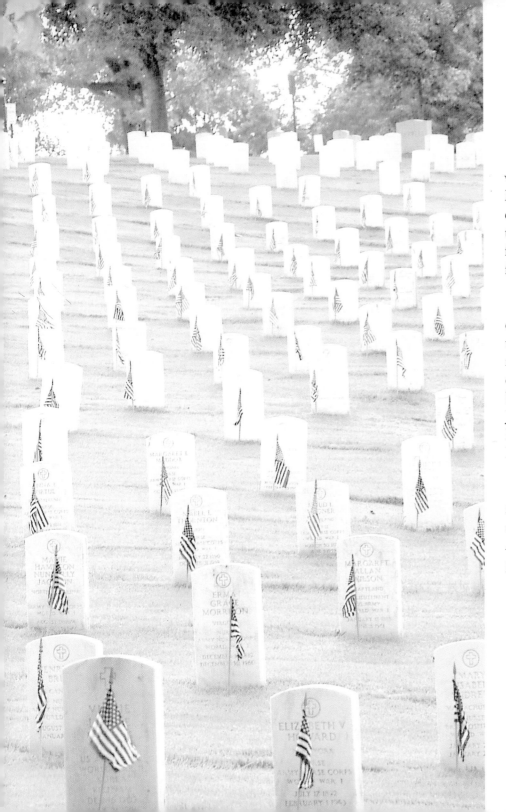

As the war continued and casualties mounted, Meigs was tasked with surveying new locations for a cemetery. On June 15, 1864, Meigs proposed Arlington House to Secretary of War Edwin Stanton, explaining, "the grounds about the Mansion are admirably adapted to such use." With those words, Meigs changed Arlington House from a memorial to the first president to a resting place for the nation's fallen.

Arlington National Cemetery became an official national cemetery of the United States in 1864. Originally two hundred acres at the end of the Civil War, its size doubled in 1897 and the Cemetery now occupies 624 acres. One of the nation's largest operating cemeteries, dead from every major war in American history are buried beneath its grounds. It became the final resting place for President John F. Kennedy on November 25, 1963, after his assassination, and Kennedy's "Eternal Flame" can be seen from across the Potomac River on clear nights.

Today, presidents and foreign leaders come to lay wreaths, funerals are conducted with honor and respect, and memorials to wars and battles are continuously erected. With its own unique history, Arlington National Cemetery has become a memorial to America's past and to its fallen. It is our living treasure. ❧

—— ❦ —— ❦ ——

Buds forming on trees and flowers in bloom means Spring has come. Snow has melted and the ground is ready for rebirth. And although the sun is warm, the wind still brings a chill. At Arlington National Cemetery the reds, whites, yellows, and purples of Spring are enhanced with another color: the light pink of cherry blossom trees.

General George S. Patton's daughter Ruth Ellen summed it up best when she wrote, "There is no place more beautiful than Arlington Cemetery in the Spring."

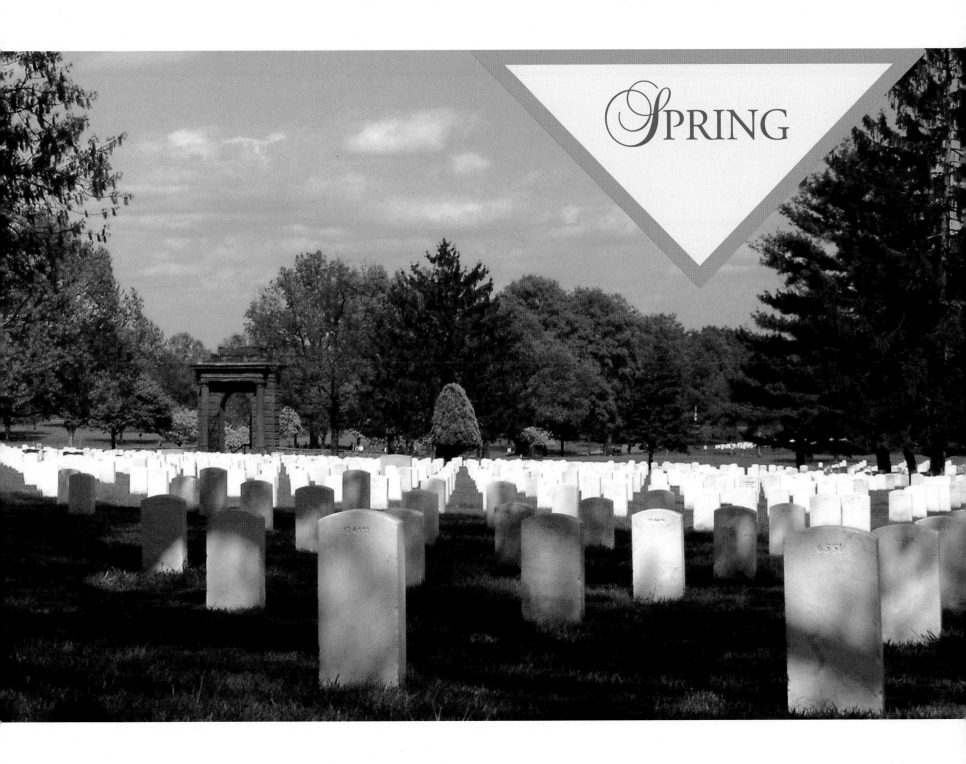

SPRING

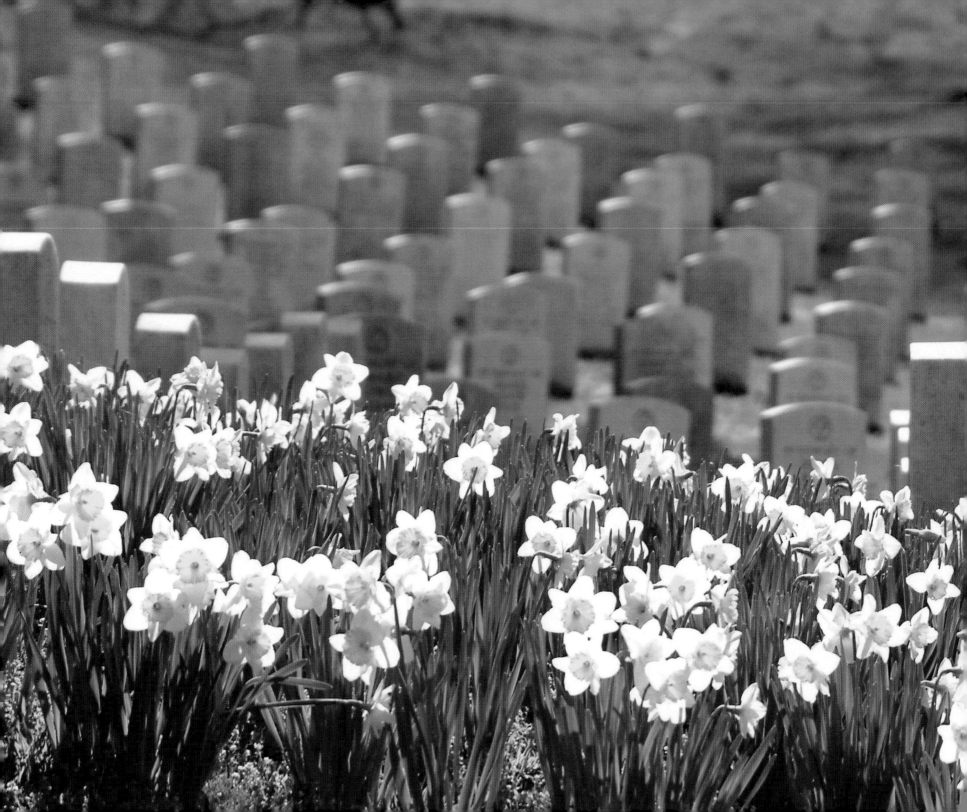

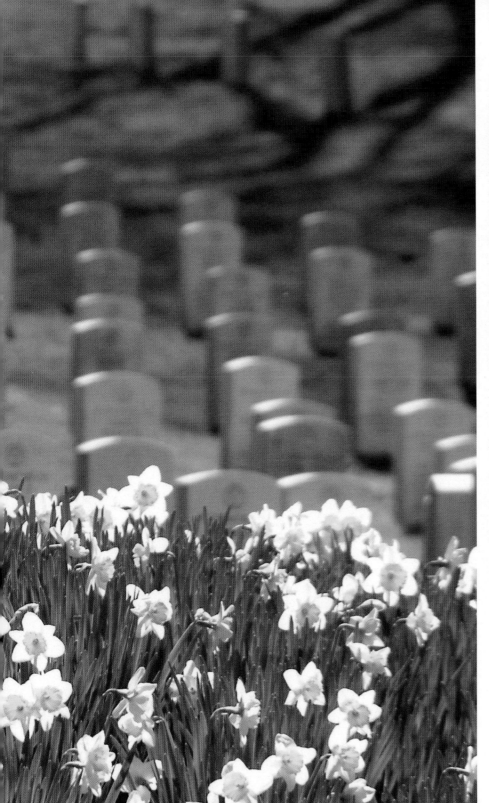
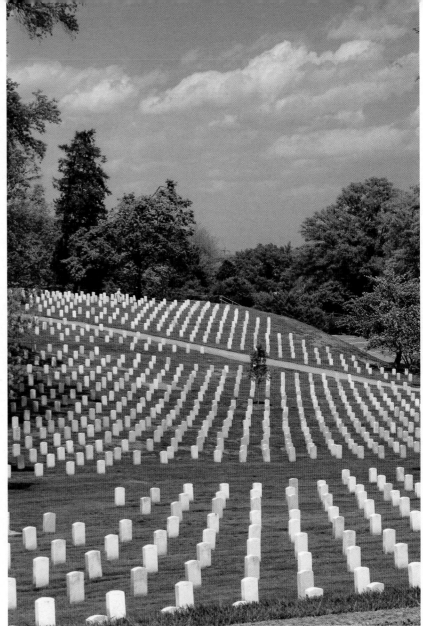

Spring's blossoming pink dogwoods and cherry trees in Section 35 (above). The daffodils in the Memorial Sections along Porter Drive are among the first blooms of the colorful Spring at Arlington (left).

The slopes of Section 3 have both the older private headstones and the traditional government provided headstones, here decorated in the colors of Spring (below).

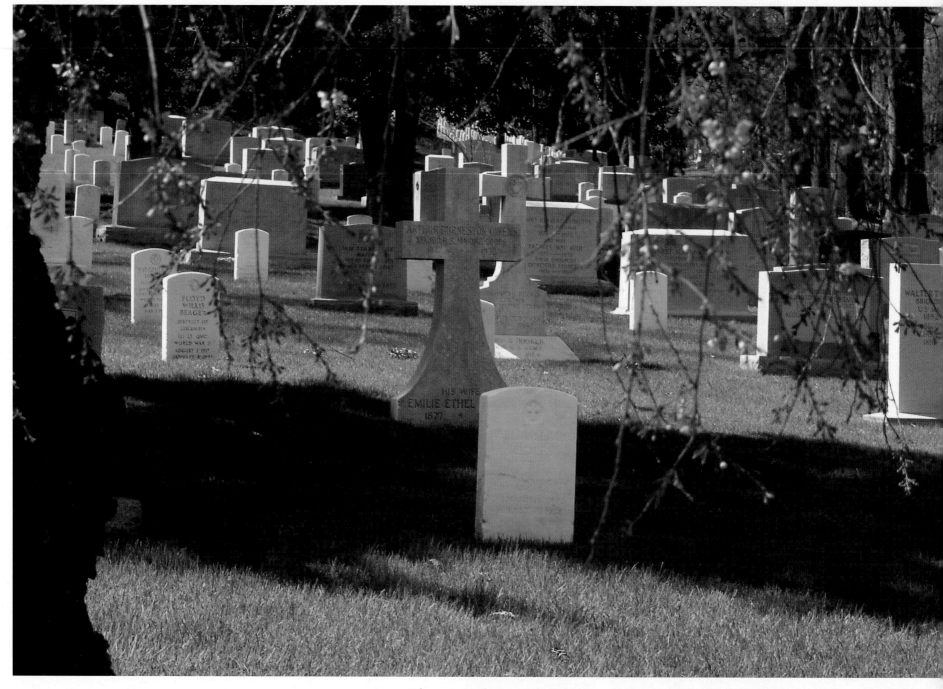

The original Custis family plot, located in Section 13, is the only privately owned and maintained area found in Arlington (right).

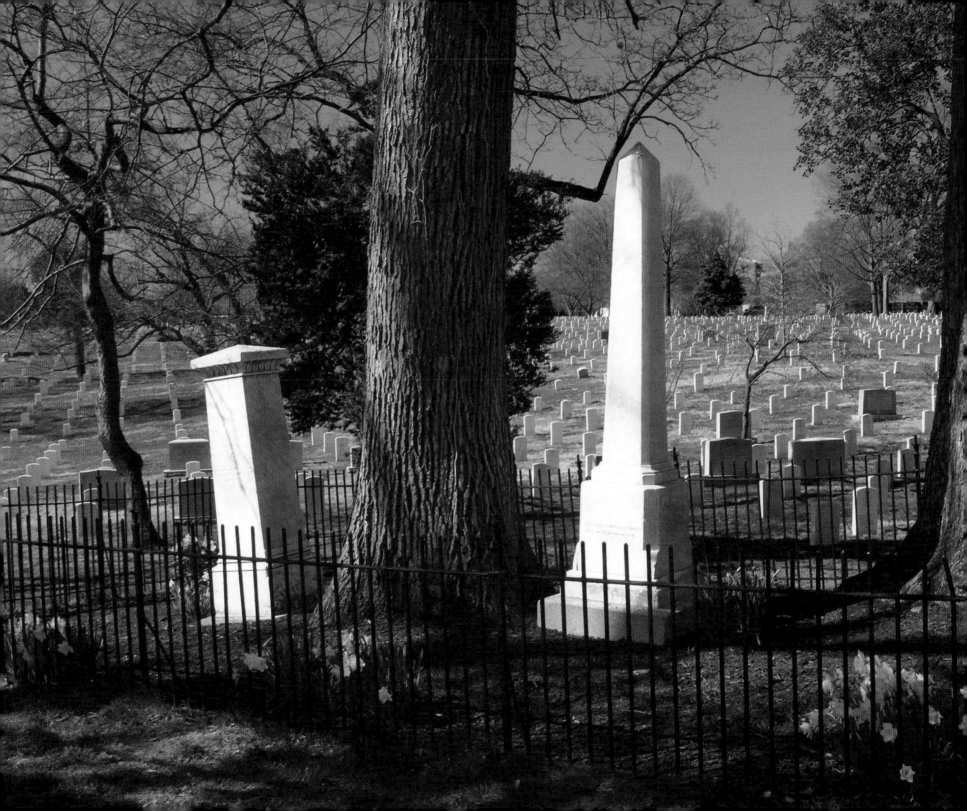

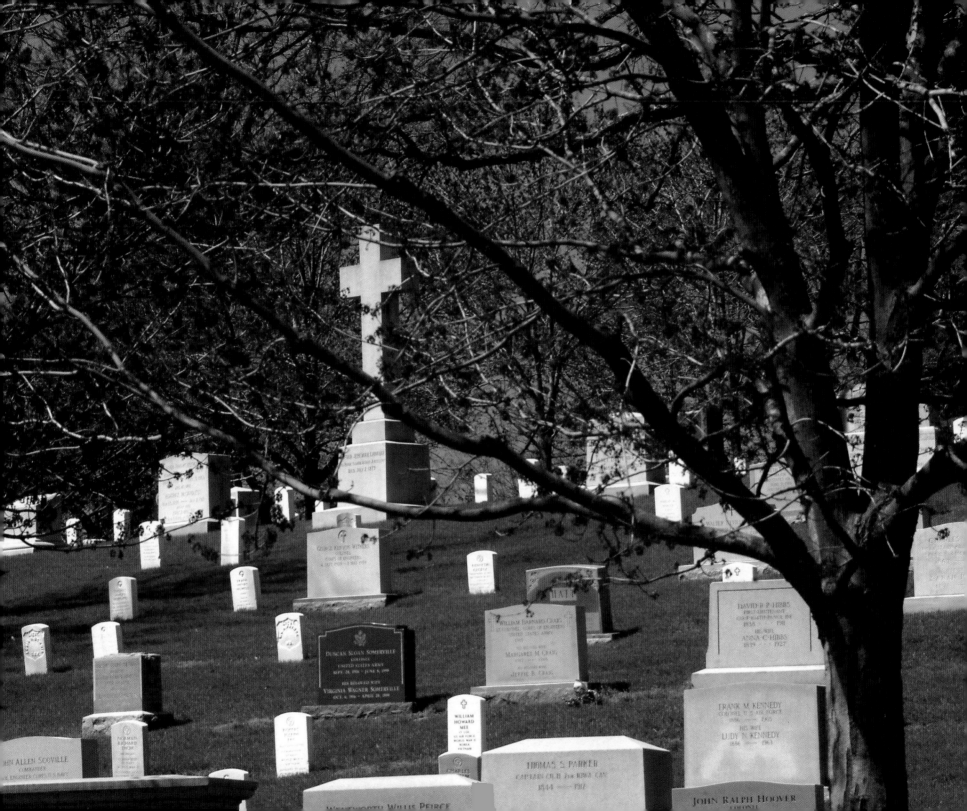

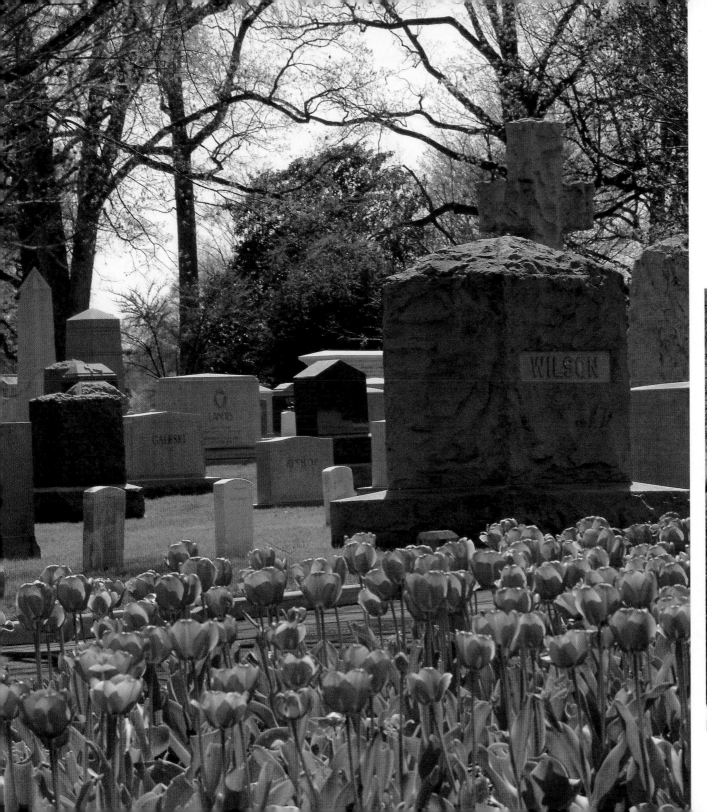

Section 3 is one of the few Sections in Arlington that still allows placement of private headstones (far left). Springs bursts of color add to the unique and older headstones of Section 1 (left).
A different view of Memorial Amphitheatre and the Tomb of the Unknowns from Miles Drive (below).

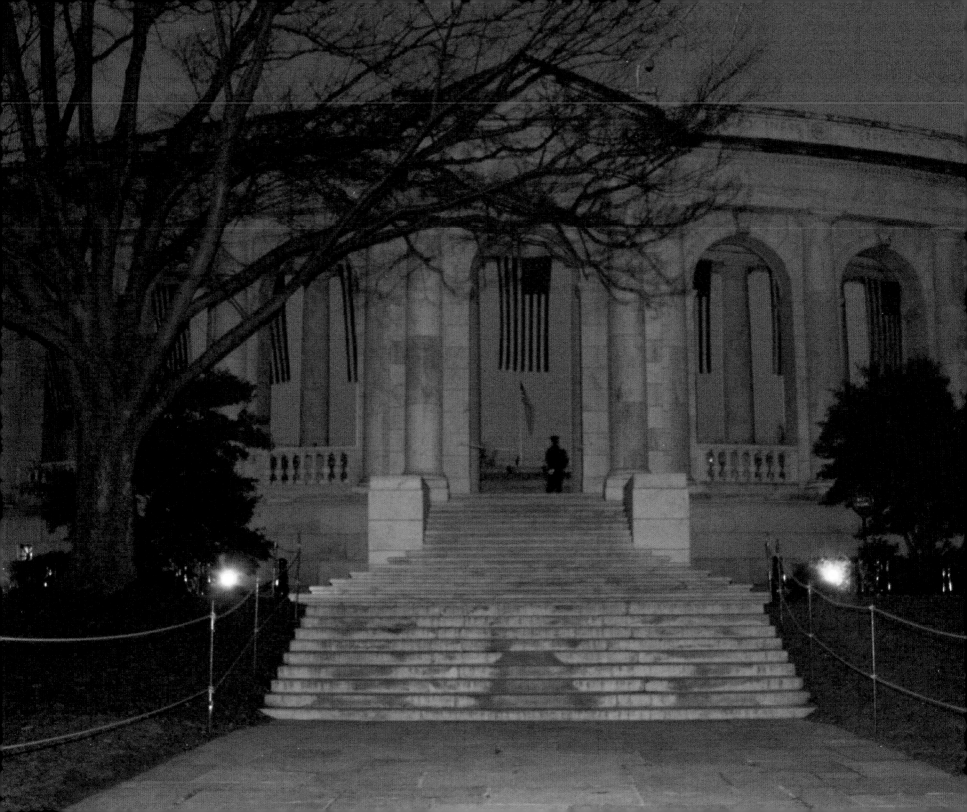

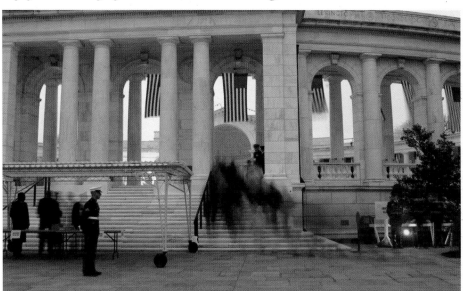

The pre-dawn quiet is enjoyed by a member of the Joint Military Ceremonial Guard, the first to arrive for Easter sunrise service (far left). Early Easter visitors pass through security and enter the Amphitheatre to enjoy the beauty of sunrise service at Arlington.

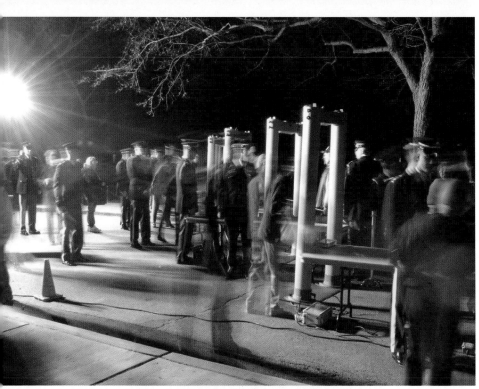

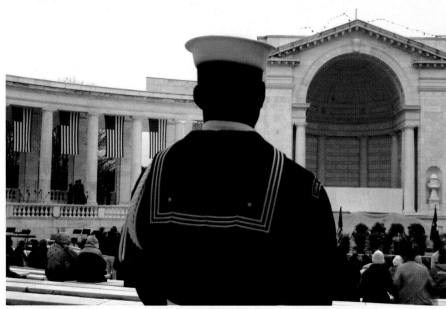

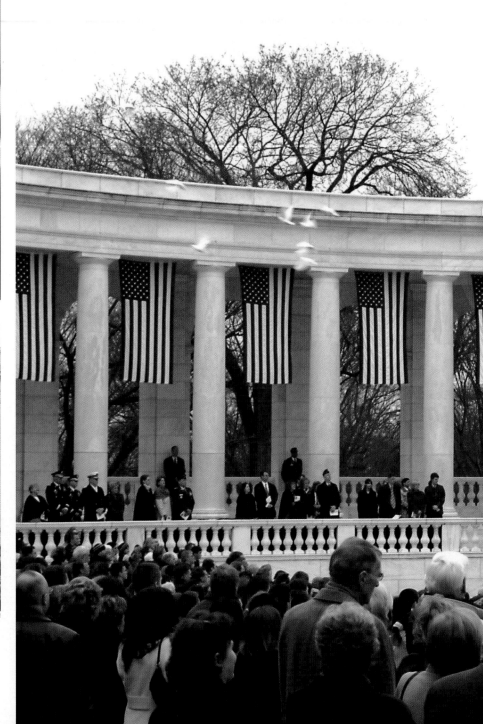

Military, government officials, and civilians from around the world sit side by side to take part in this annual ceremony (above). White doves capture everyone's attention at the end of one service (right).

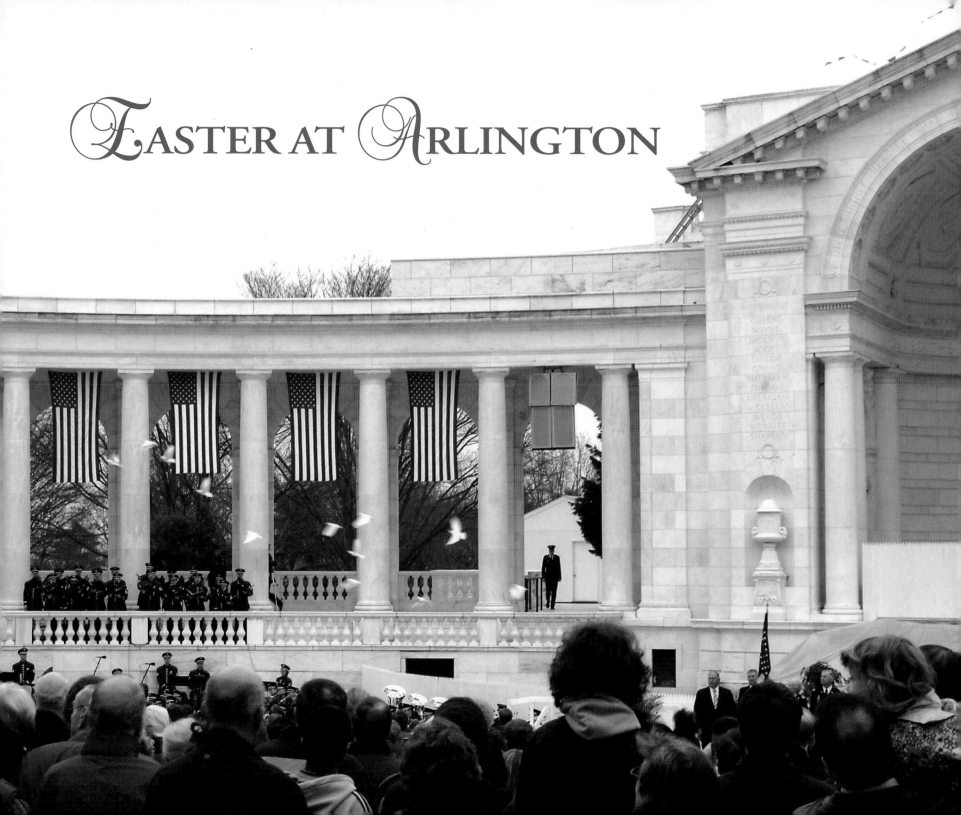

EASTER AT ARLINGTON

Trees in Section 34 show their Springtime beauty. Many trees are planted to mark specific events, people, or military units in our nation's history. More than 8,000 trees and shrubs have been carefully identified and marked by GPS to keep record of their location.

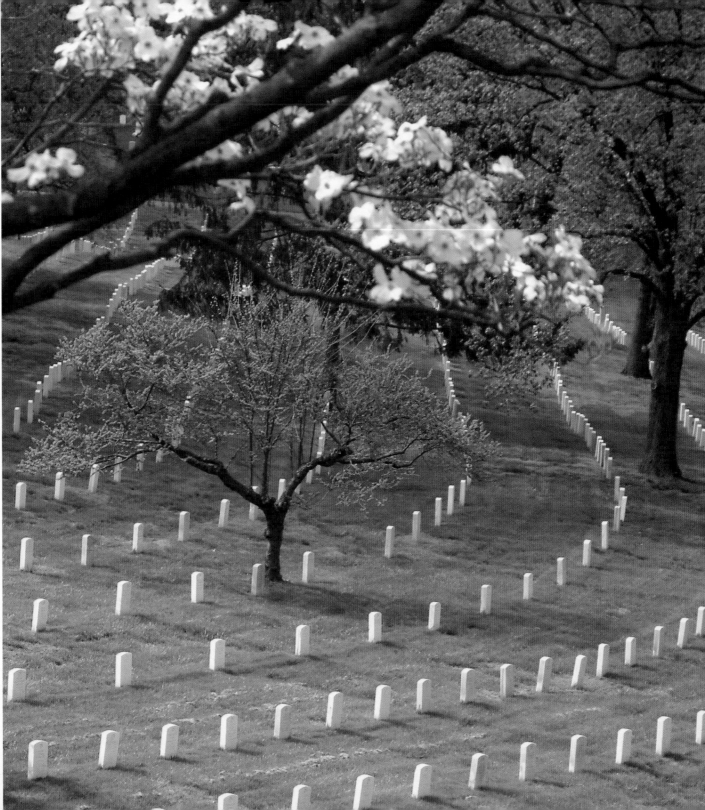

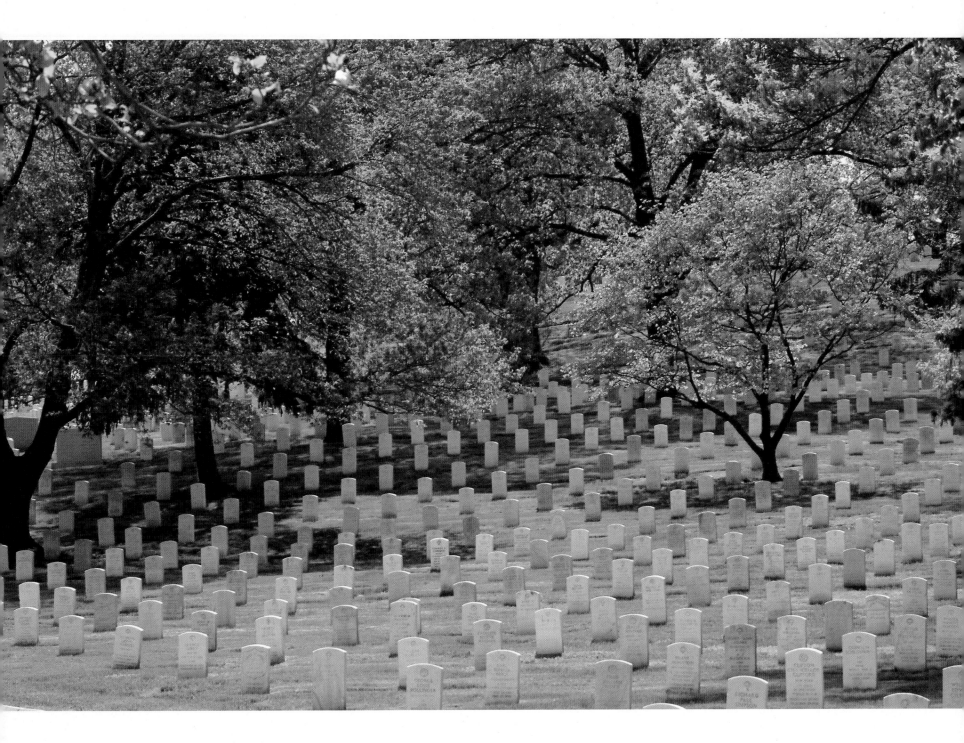

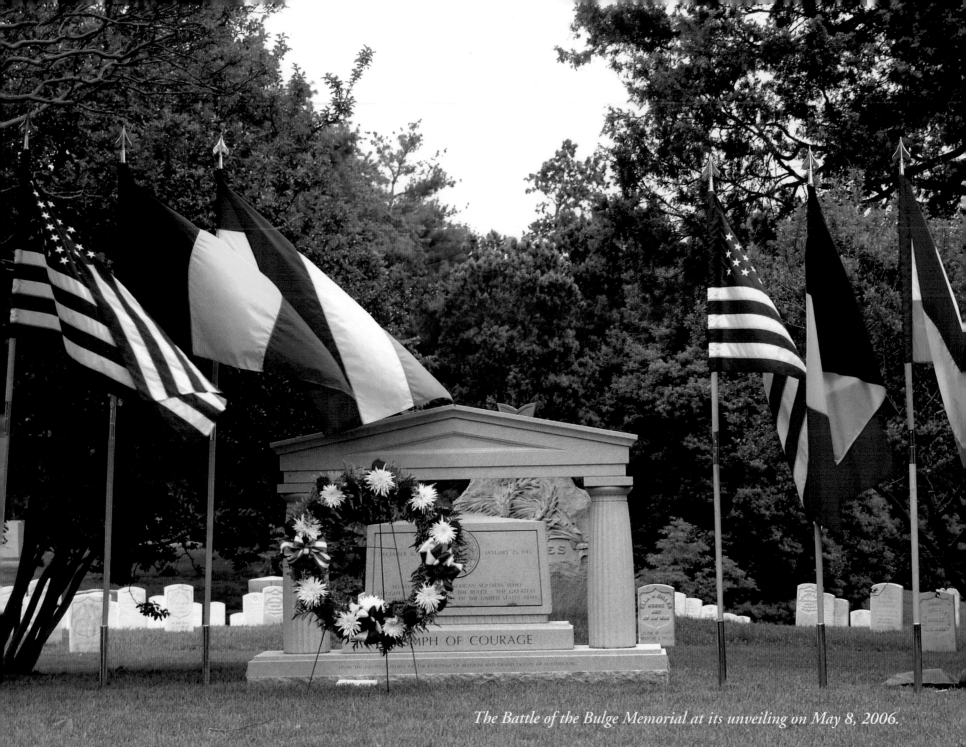

The Battle of the Bulge Memorial at its unveiling on May 8, 2006.

Veterans of the Battle of the Bulge and their families and friends celebrate at the dedication of the new memorial in Section 21 (right).

General George S. Patton called death in battle "a function of time. The longer troops remain under fire, the more men get killed." If it were not for these battles, Arlington National Cemetery would not exist, so monuments to battles can be found all over the Cemetery's rolling hills.

The Battle of Meuse-Argonne ended World War I, but it cost the lives of 26,277 Americans. The battle, which took place in the Argonne Forest, was the greatest battle fought by the American army in the war. To remember the battle, a grove of nineteen pine trees—representing the forest—surround a thirteen-foot marble cross with an eagle and wreath at the juncture of the cross's arm and stem.

A number of living memorials—trees planted with a plaque—pay tribute to other decisive battles. The Pearl Harbor memorial pays respect to those Americans who survived the attack on the American fleet by Japanese fighters, bombers, and torpedo planes on December 7, 1941, bringing the United States into World War II. The Second Schweinfurt Raid Memorial salutes American airmen who faced flak and German fighters during a raid on the German town. The raid cost 650 men and seventy B-17 Flying Fortress bombers. The Battle of the Bulge Memorial recalls the gallant stand Americans made against the attacking German army on December 16, 1944, in Belgium and Luxembourg. In 1968 in Vietnam, the Marine base at Khe Sanh withstood a siege that lasted over four months and cost 730 Americans killed. The Khe Sanh Memorial pays tribute to the veterans of the battle.

Battles have also been fought in the Global War on Terror, but are too fresh for memorials. The battles during the two wars with Iraq, as well as the war in Afghanistan, will eventually need memorials, and Arlington National Cemetery will welcome them. ∞

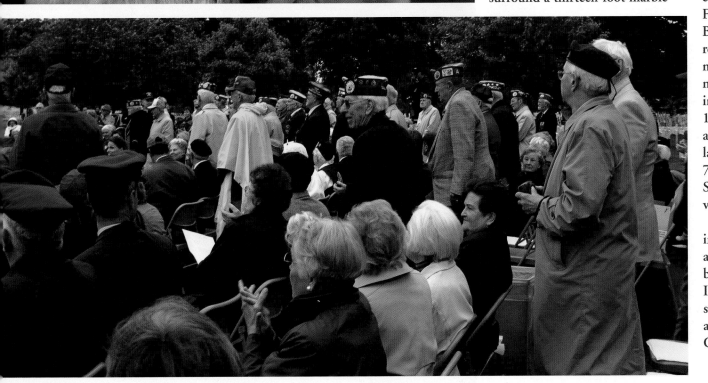

The original mast and a historical anchor
are only a small part of the larger
USS Maine Memorial, located between
Sections 46 and 24 (right).
The War Correspondence Memorial, the
Canadian Cross of Sacrifice, and the USS
Maine Memorial of Section 46 (far right).
Third Infantry Division and the Space Shuttle
Memorials are all found in Section 46 (below).

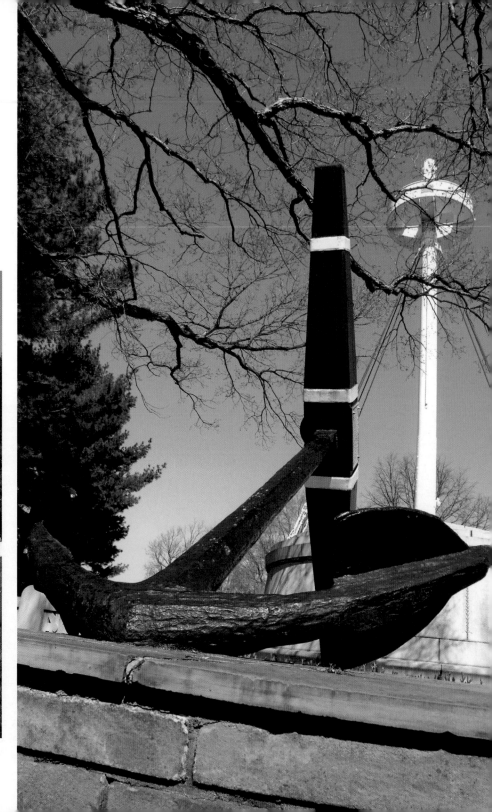

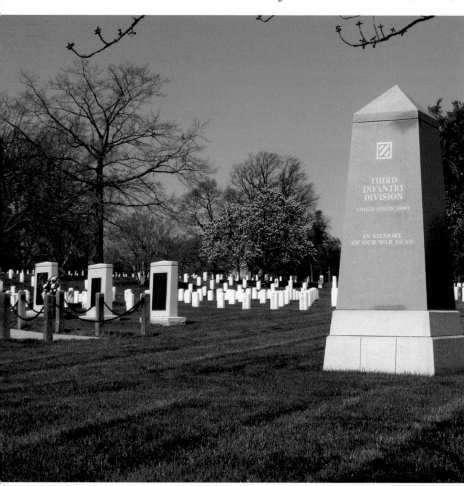

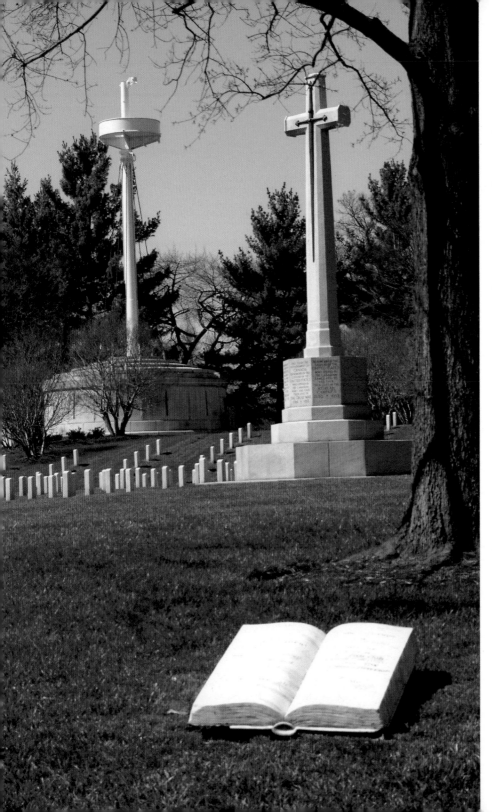

Tragedies

Both soldiers and civilians have been on America's front lines, even if some of those front lines are not officially considered wars. Arlington National Cemetery is filled with memorials to tragic events that either led to wars or occurred during them.

Memorials to tragedies include the mast of the USS *Maine,* which is the actual mast that flew the American flag into Havana Harbor in January 25, 1898, to protect American interests. On February 15, the *Maine* exploded, killing 260 men. The tragedy eventually led America into the Spanish-American War. Today, the mast's base resembles a battleship turret with the names of the dead on it. An octagon-shaped memorial salutes the crew of the USS *Serpens,* a World War II ammunition ship which blew up off the coast of Guadalcanal on January 29, 1945, killing 250 servicemen on board.

Not all memorials are to servicemen. The Lockerbie Memorial Cairn remembers the deaths of 259 passengers onboard American Airways Flight 103 who were killed when a terrorist bomb exploded, raining debris over Lockerbie, Scotland. The memorial is a twelve-foot conical tower made of red Scottish sandstone, representing a typical Scottish Cairn (memorial).

Tensions in the Middle East also claimed the lives of servicemen trying to either bring peace or rescue their fellow Americans. A cedar tree with a plaque salutes the servicemen killed in 1983 in Beirut when a suicidal bomber crashed through the gates of a Marine compound and exploded. The Marines and sailors had been sent to Lebanon as part of a peace-keeping force. A white stone marker with a bronze plaque lists the names of eight servicemen killed during the failed rescue attempt of the American hostages in Iran in 1980. The men were killed in an accident in the Iranian desert where helicopters and fuel plans rendezvoused before attempting the rescue of the fifty-three hostages taken in 1979.

When the Space Shuttle *Challenger* exploded just seconds after takeoff on January 28, 1986, all seven of her crew members were killed. Space travel has always been a mission of peace for the United States, and this mission exemplified it—a school teacher was onboard to teach from space. *Challenger's* pilot, Captain Michael

(continued)

(continued)

Smith, is buried at Arlington National Cemetery, as are the unidentified remains of the rest of her crew. Their faces and names are carved into a group headstone that pays tribute to their brave sacrifice.

To remember those killed when a plane slammed into the Pentagon on September 11, 2001, a granite marker bears five plaques engraved with the names of 184 civilians and servicemembers. The remains of fifty of the sixty-four victims buried at Arlington are grouped under rows of nearby tombstones. Eight others are in the Columbarium and four are in graves throughout the Cemetery.

Tragic events are a consequence of security and exploration. As long as Americans go into harm's way to protect others and explore the reaches of the unknown, there will be tragedies. Arlington National Cemetery will make sure those sacrifices are remembered. ෴

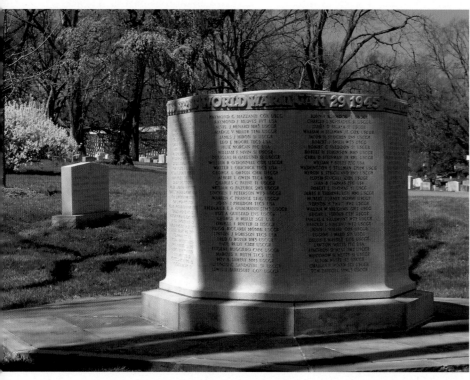

USS Serpens *Memorial, Section 34, sits at the five-corner intersection of Grant, Jessup, and Porter Drives.*

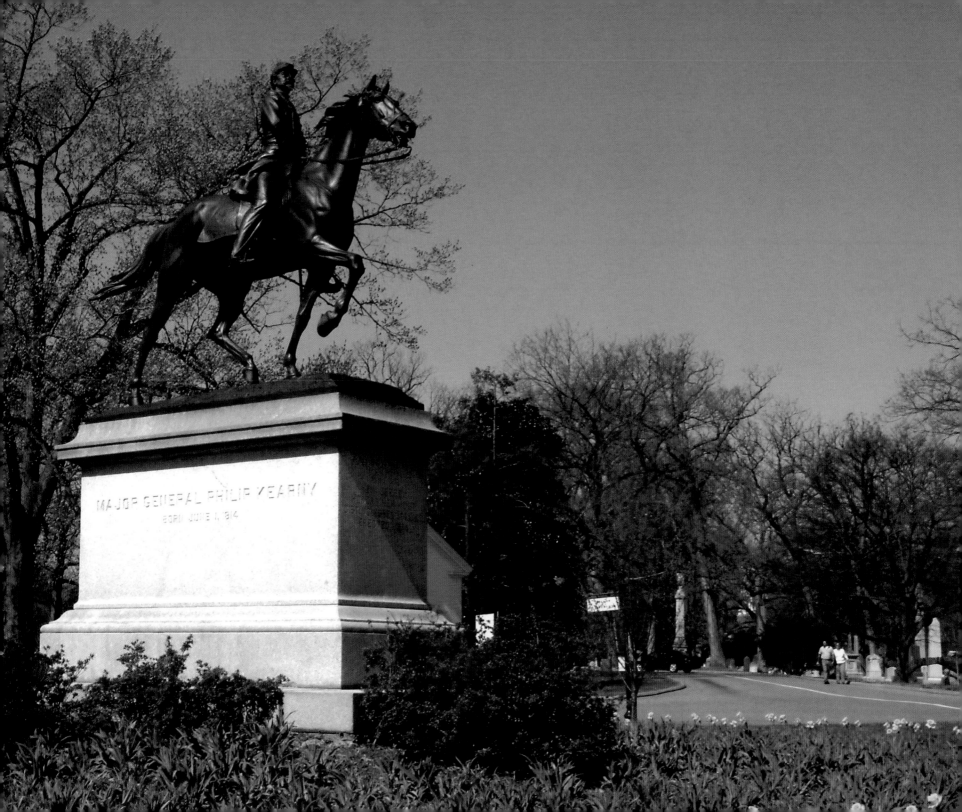

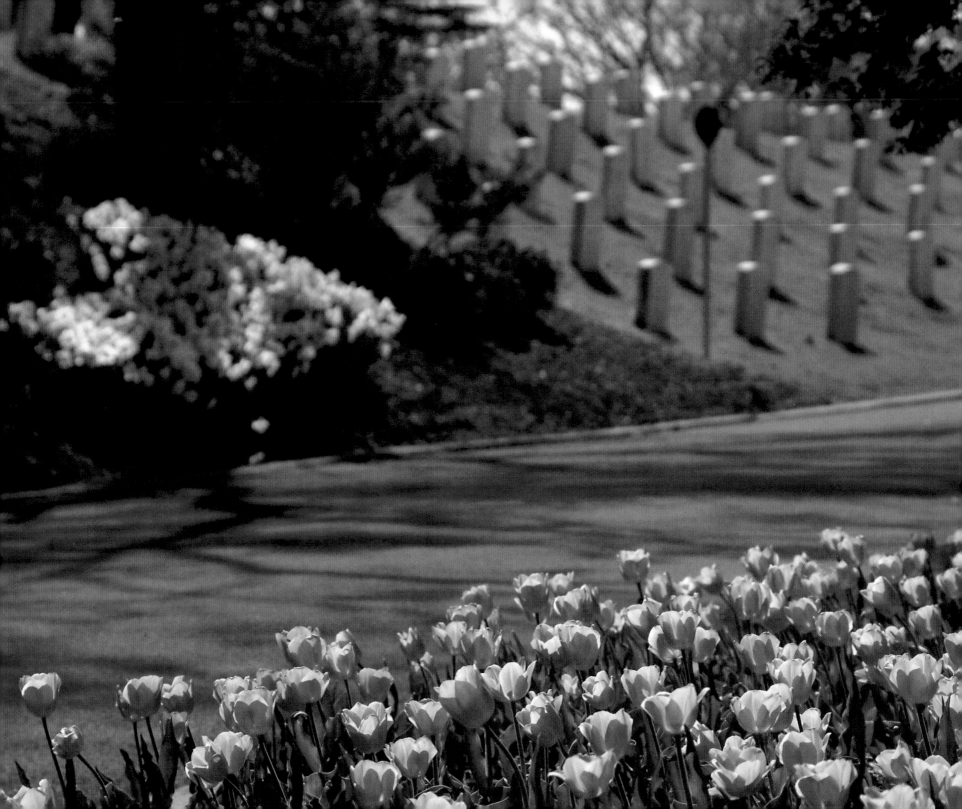

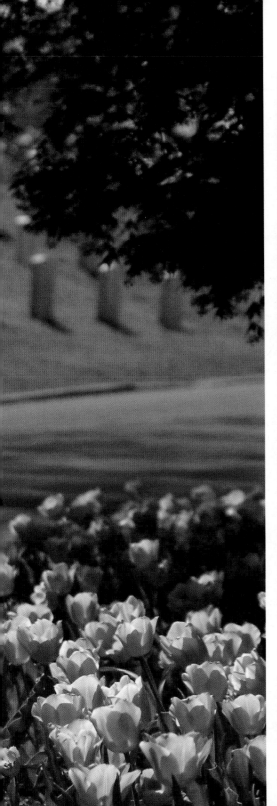

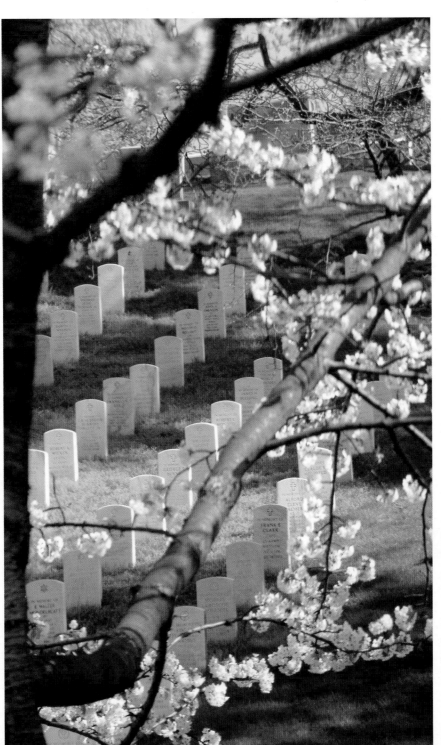

*Beauty abounds
in the Spring along the hilly
memorial sections of windy
Porter Drive.*

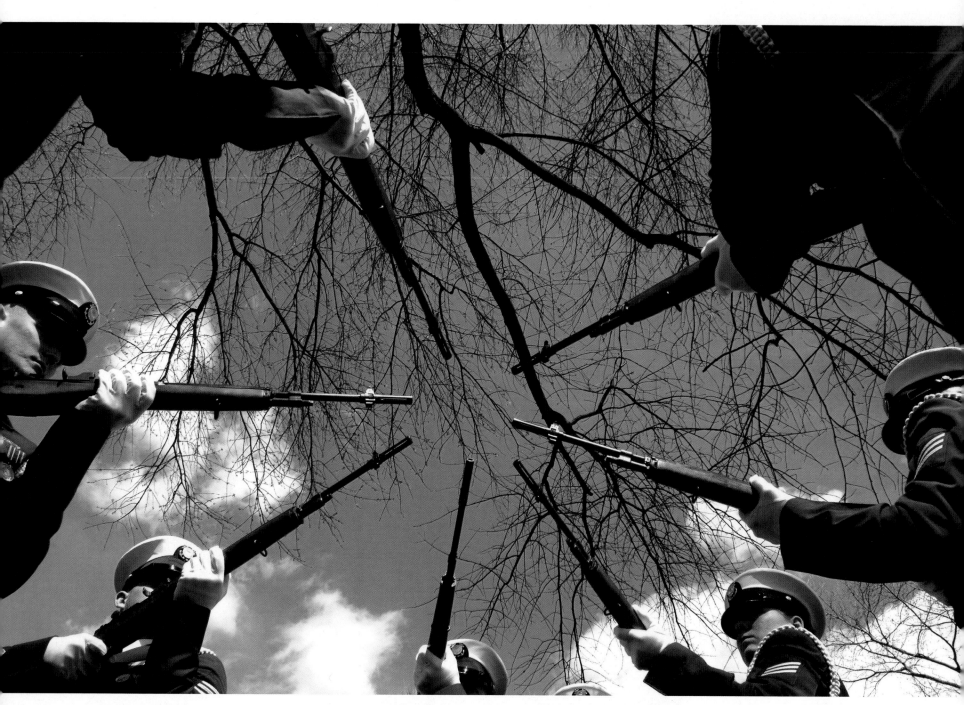

The Coast Guard Ceremonial Firing unit demonstrates their unique way of practicing firing the three-round volley before and in between services.

U.S. Coast Guard Ceremonial Honor Guard

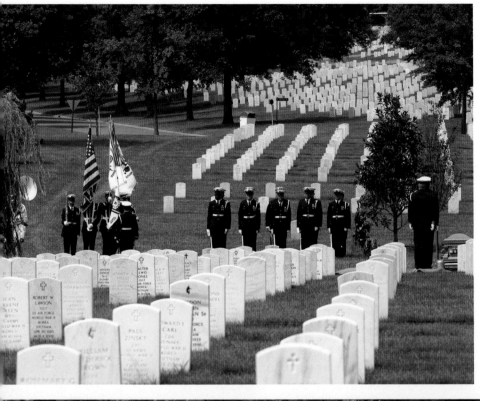

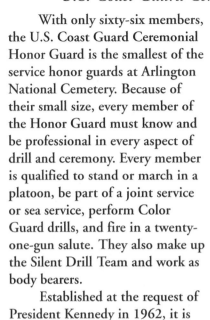

With only sixty-six members, the U.S. Coast Guard Ceremonial Honor Guard is the smallest of the service honor guards at Arlington National Cemetery. Because of their small size, every member of the Honor Guard must know and be professional in every aspect of drill and ceremony. Every member is qualified to stand or march in a platoon, be part of a joint service or sea service, perform Color Guard drills, and fire in a twenty-one-gun salute. They also make up the Silent Drill Team and work as body bearers.

Established at the request of President Kennedy in 1962, it is the youngest Honor Guard unit at the Cemetery and is headquartered at the Coast Guard's Telecommunication and Information Systems Command in Alexandria, Virginia. The Honor Guard does not belong to the Coast Guard. Instead, it answers to the Military District of Washington, then Arlington, and finally to the Commandant of the Coast Guard.

The Coast Guard Honor Guard provides two officers for Full and Special Full Honors at the Cemetery—one to run the platoon, the other to coordinate the funeral. For large funerals, such as for a former commandant, the Honor Guard is supplemented by Coast Guard non-rates to provide the proper two platoons with Gideon and Color Guard.

The unit is commanded by one lieutenant, two junior officers, one Chief Petty Officer and four Petty Officers. The members of the Honor Guard are handpicked for their tour of duty from volunteers during boot camp at Camp May in New Jersey. Because the Coast Guard is smaller than the other services, the Coast Guard Honor Guard performs at funerals across the country for any active duty death, the only Honor Guard at Arlington to do so.

Each member of the Coast Guard Honor Guard wears a white lanyard around their left shoulder and they take seriously their creed that, "By wearing this rope I have accepted a commitment to excellence as a way of life." ✠

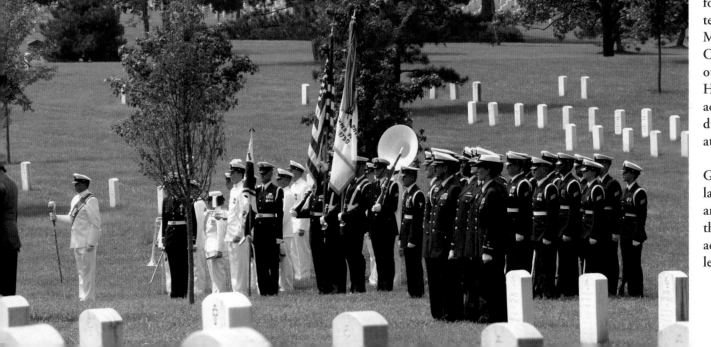

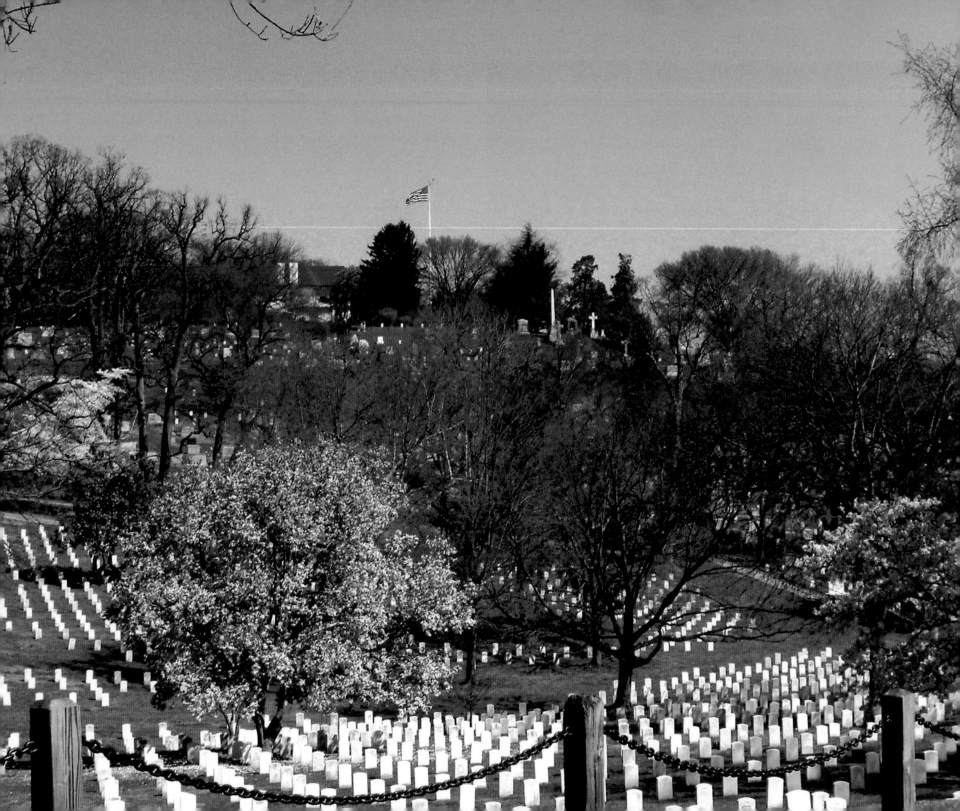

A view from Farragut Drive across Sections 37, 9, and 2 to the Arlington House is even more beautiful on this cloudless Spring day (left).

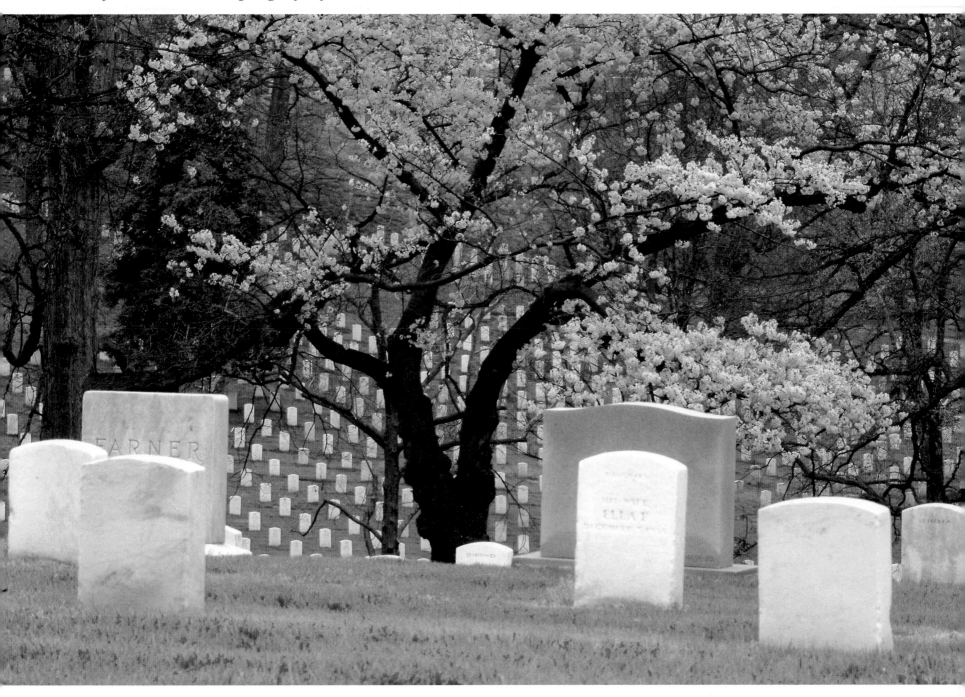

Many cherry trees still survive from the earlier plantation days throughout the grounds of Arlington.

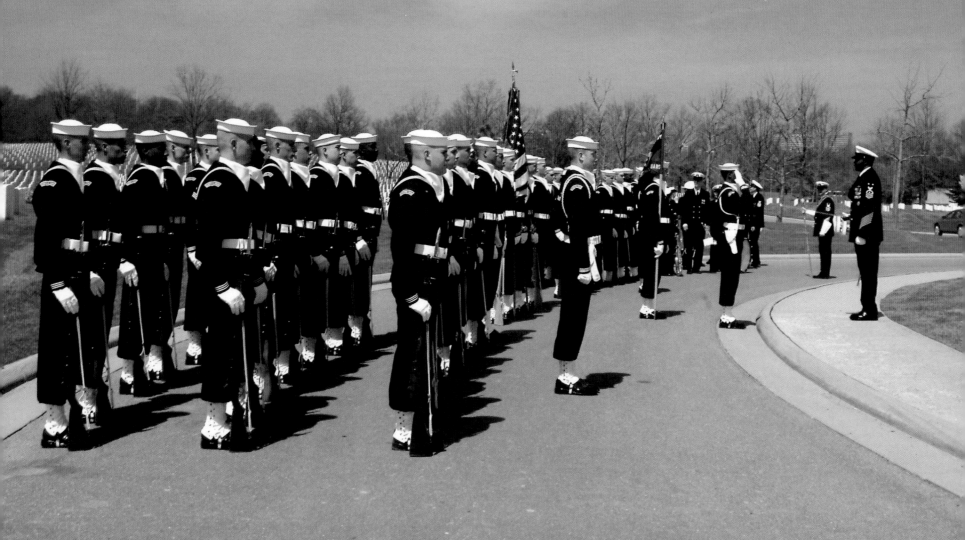

"It is an immense privilege to command the sailors of the Navy Ceremonial Guard. I am humbled by the great care and pride which these very young men and women exhibit, spending up to twelve hours a day performing funeral honors for our nation's heroes in Arlington National Cemetery. The work is hard physically and emotionally, but they never complain. The Guardsmen appreciate the sacrifices of those whom they lay to rest, and they wholeheartedly accept their responsibility to go forth and assume the watch from those who have bravely trodden the decks of our Navy before them. So long as young people such as these choose to serve in the Navy, America should have no fear for its future."

CDR Chris A. Higginbotham
Commanding Officer
U.S. Navy Ceremonial Guard

Navy Ceremonial Guard

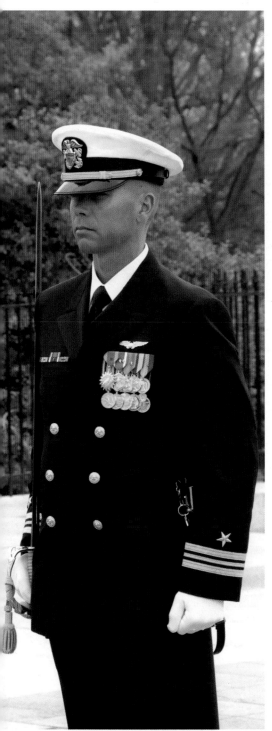

Every sailor who served the U.S. Navy from the high seas to the lakes and rivers of the world, as well as land-based assignments, is entitled to a Naval Honor Guard at their funeral at Arlington National Cemetery.

The Naval Honor Guard, better known as the "Ceremonial Guard," escort caskets to their final resting place, fire volleys, perform drills, and fly the service flag as well as the Stars and Stripes at Navy funerals. They are the only service that wears two different colors—white or Navy blue—within the cemetery.

Their movements are razor sharp and their uniforms are immaculate—especially important when wearing white. They rehearse constantly and perform more than twenty funerals a week for their fallen shipmates.

The Ceremonial Guard comprises four operational platoons: The Ceremonial Drill Team, Casket Bearers, Color Guard, and Firing Party. Originally established in 1931 as a ragtag assembly of men awaiting transfers and referred to as the "Seaman Guard" until 1951, the Ceremonial Guard now numbers over 200 enlisted men and women, and is based at the Naval Support Facility in the Anacostia section of Washington, D.C.

Beyond its duties at the Cemetery, the Ceremonial Guard participates in presidential inaugurations, joint Armed Forces events, and public ceremonies. They also perform at arrival ceremonies for foreign officials. The drill team travels the country, putting on performance displays for huge crowds. ❦

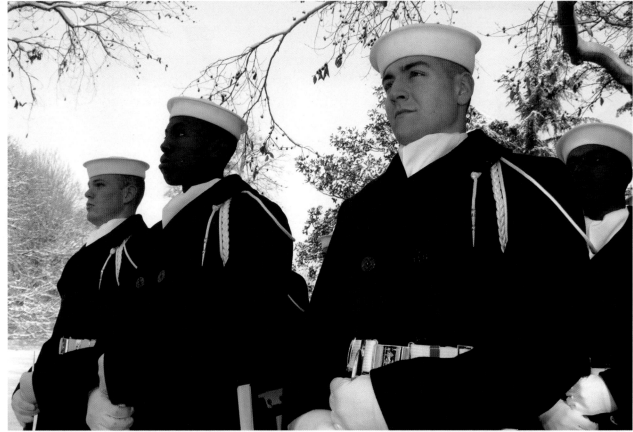

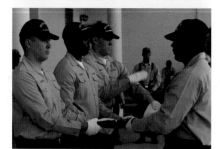

Daily practice, inspection, and marching ensure that all ceremonial performances properly reflect the honor and tradition the Navy Ceremonial Guard represents.

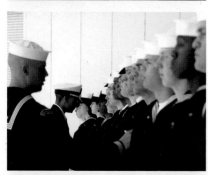

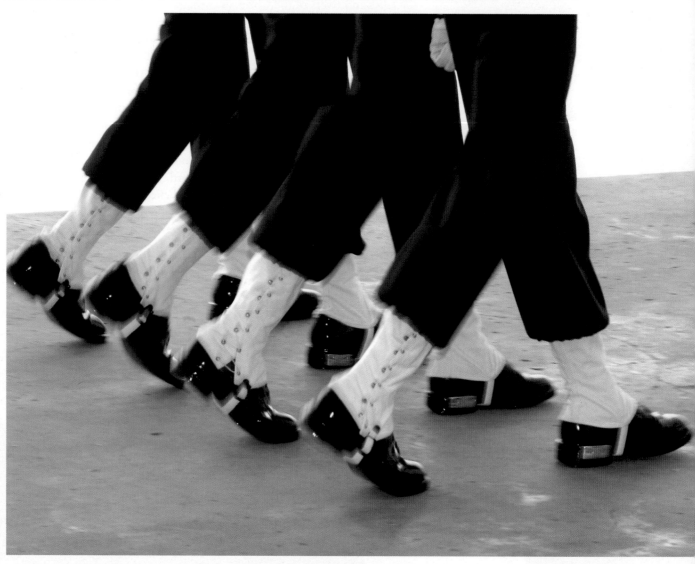

The Navy casket bearers bring their fallen shipmate to a final resting place as the Navy Arlington Lady and her escort pay their respects (right).

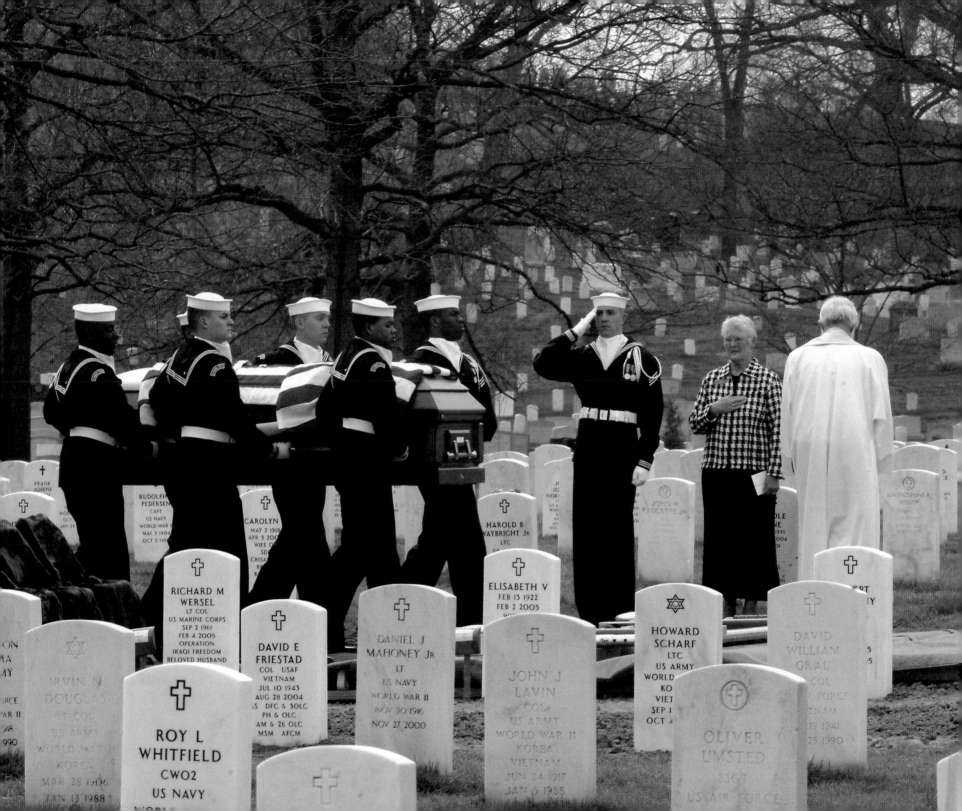

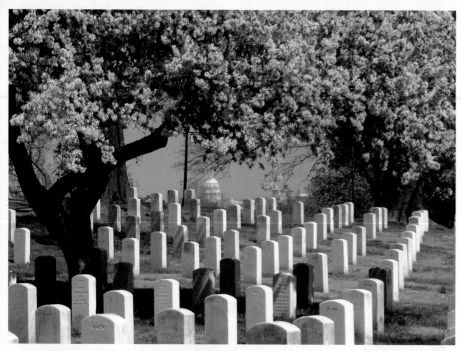

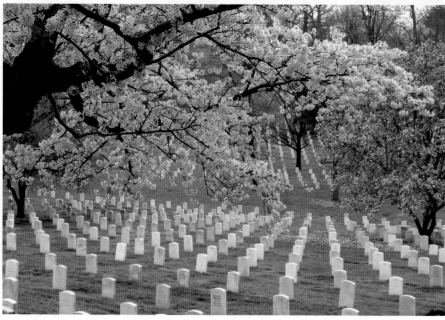

*The U.S. Capitol, as seen through the
beauty of the Spring blossoms of Section 30 (top).
Throughout the entire grounds of Arlington, the colors of
Spring add to the beauty of the almost perfect rows of white
marble and green covering these hallowed grounds.*

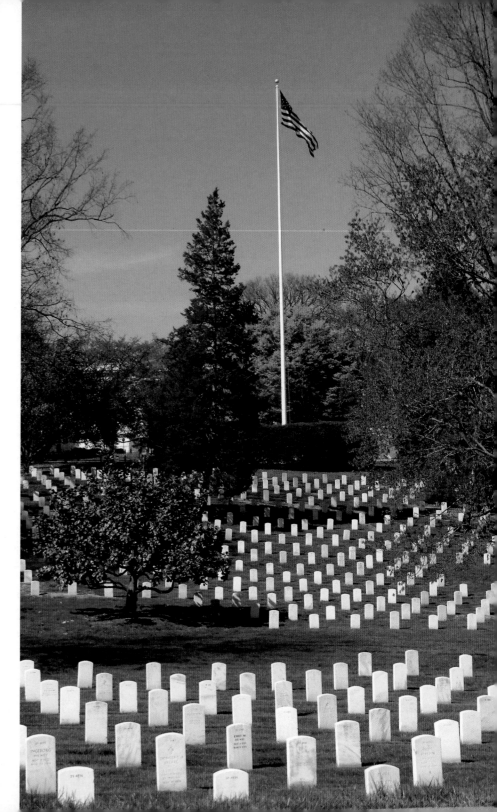

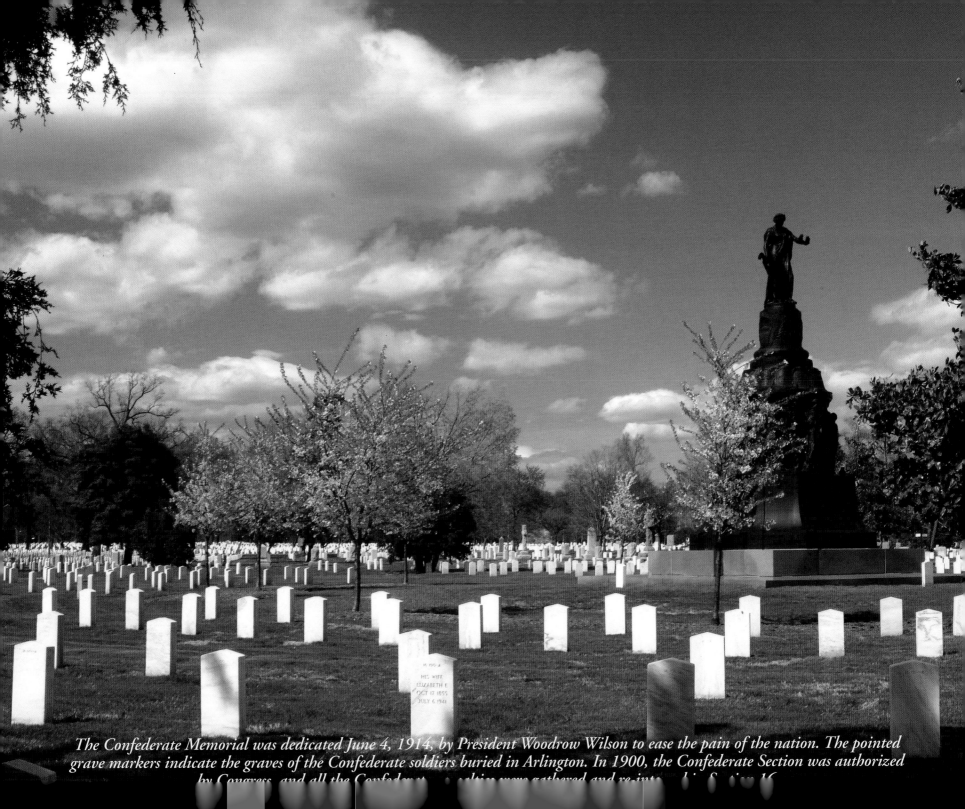

The Confederate Memorial was dedicated June 4, 1914, by President Woodrow Wilson to ease the pain of the nation. The pointed grave markers indicate the graves of the Confederate soldiers buried in Arlington. In 1900, the Confederate Section was authorized by Congress, and all the Confederate were gathered and re-inte..... in Section 16.

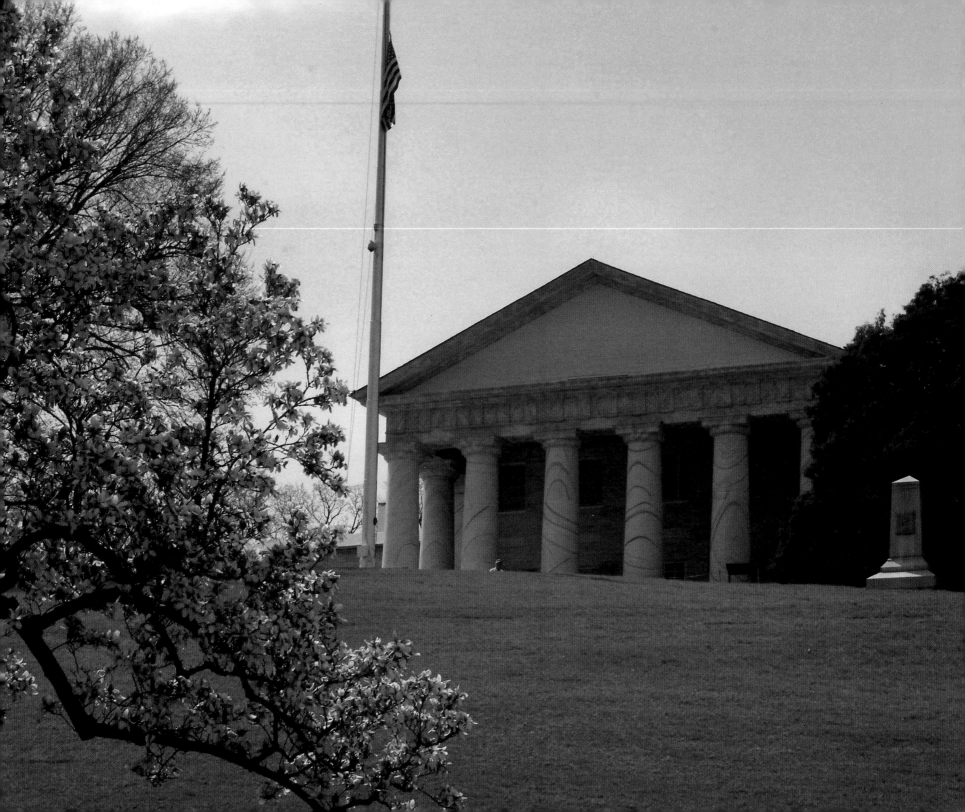

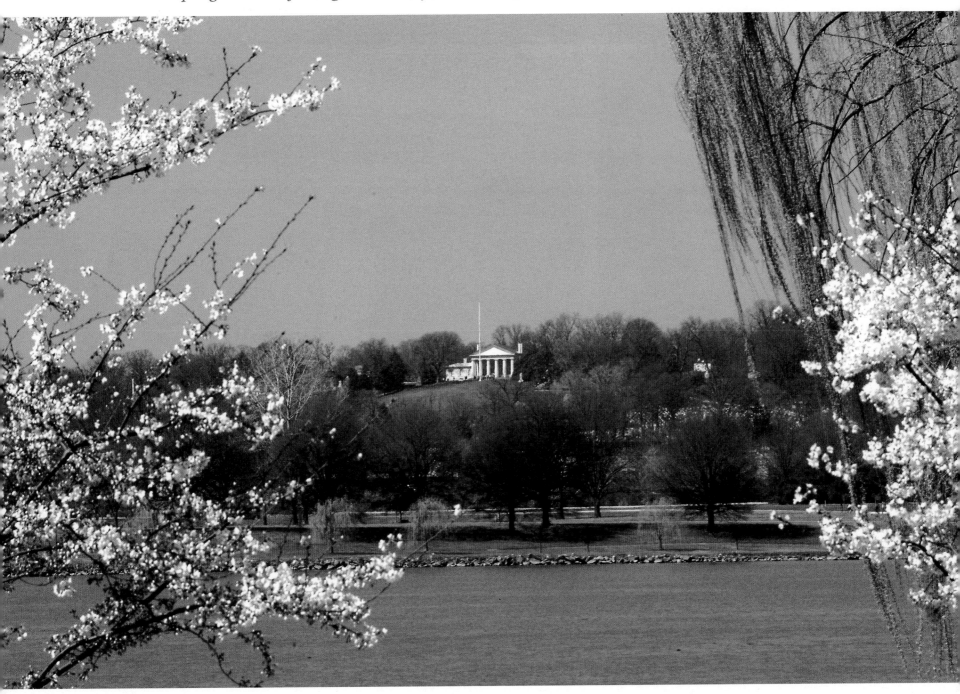

A Springtime view of Arlington House (left) and as seen from across the Potomac River in Washington, D.C. (below).

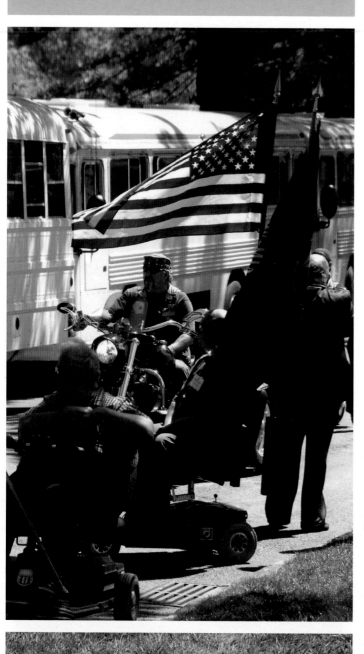

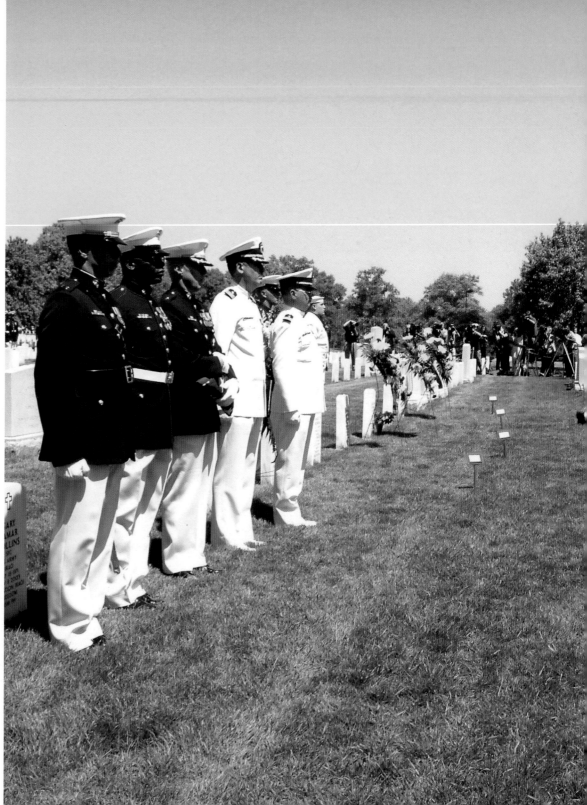

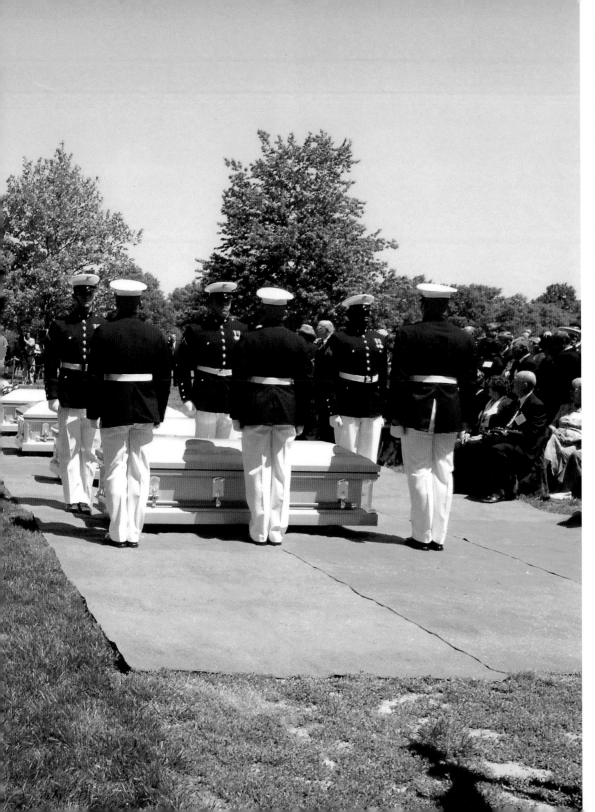

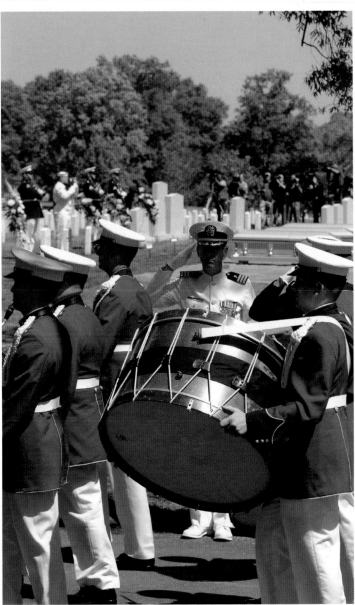

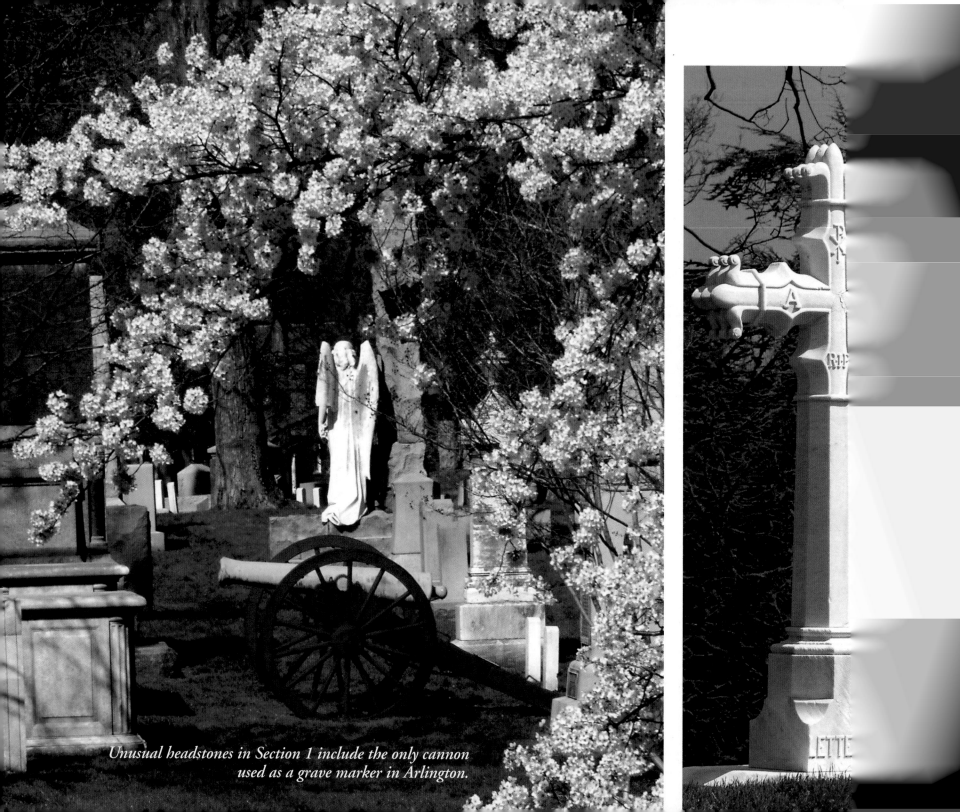

Unusual headstones in Section 1 include the only cannon used as a grave marker in Arlington.

*A Section Sergeant and his
Section Horse return from a ceremony (right).
Old Guard sentries are posted for dignitary arrivals (below).*

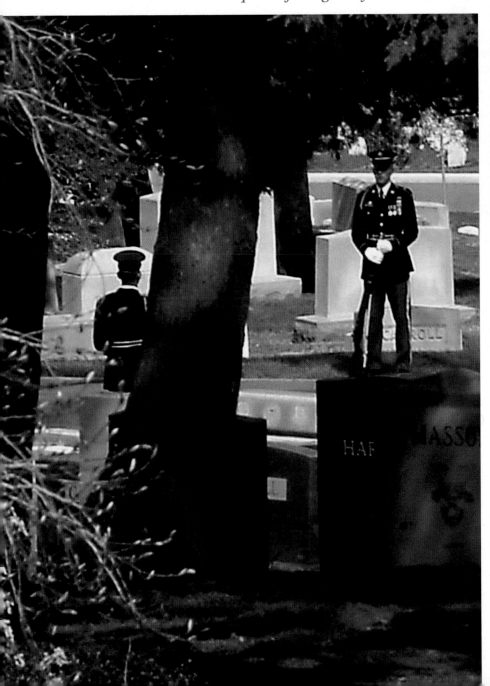

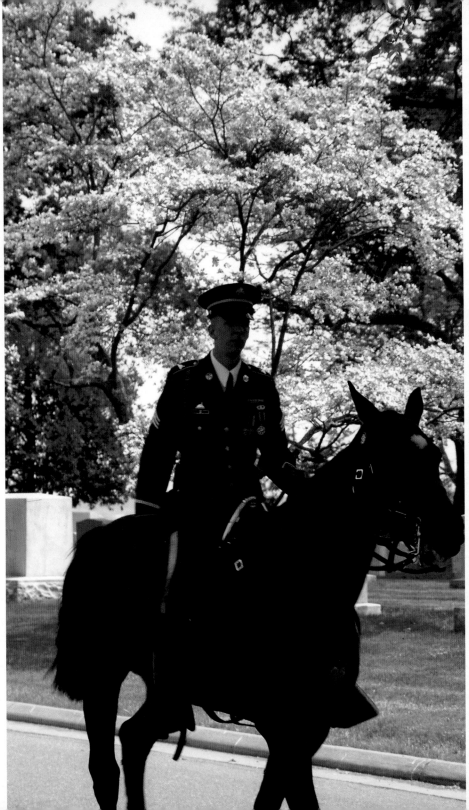

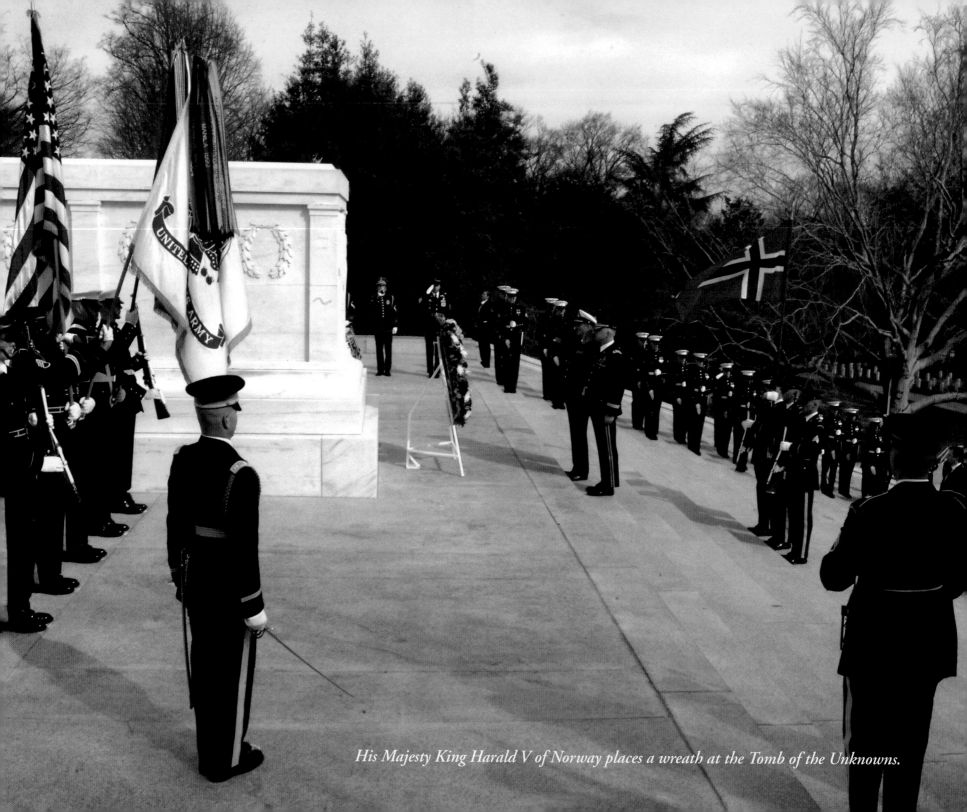

His Majesty King Harald V of Norway places a wreath at the Tomb of the Unknowns.

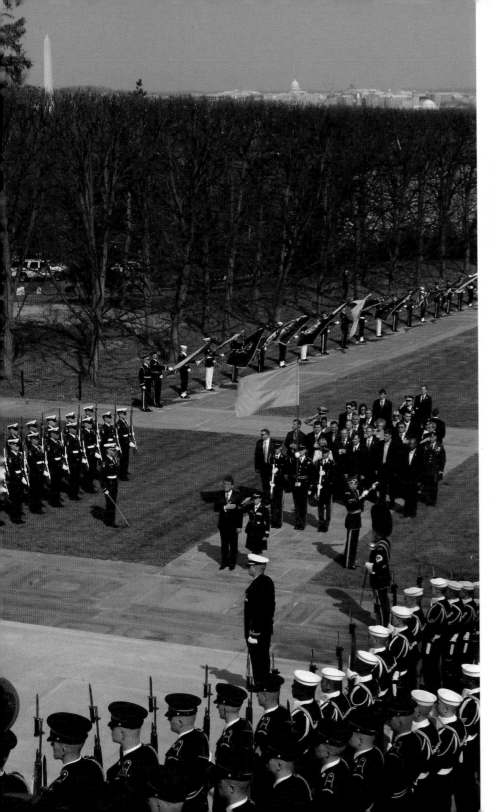

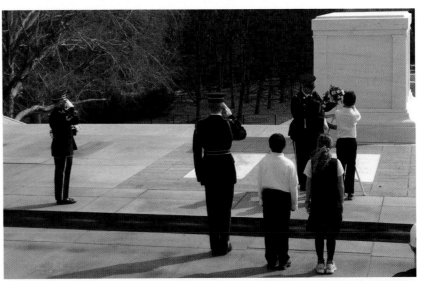

The diversity of wreath ceremonies at the Tomb of the Unknowns can be seen here as The Old Guard prepares for an Army wreath ceremony (bottom); students from St. Mark's School pay their respects by placing a wreath (below); and President Victor Yushchenko of the Ukraine during a wreath ceremony (left).

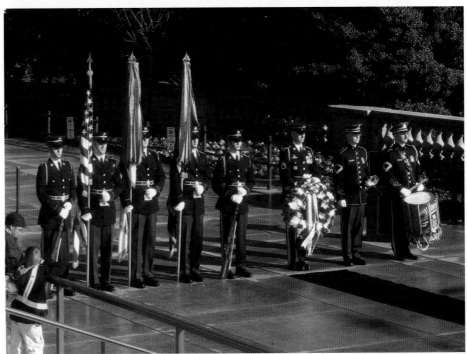

——— ❧ ❧ ———

The days are long and the air is warm. Rain showers leave rainbows in their wake. It is Summer at Arlington National Cemetery, when crowds swell as vacationers visit the Lee Mansion, President John F. Kennedy's grave, and take tours of the grounds.

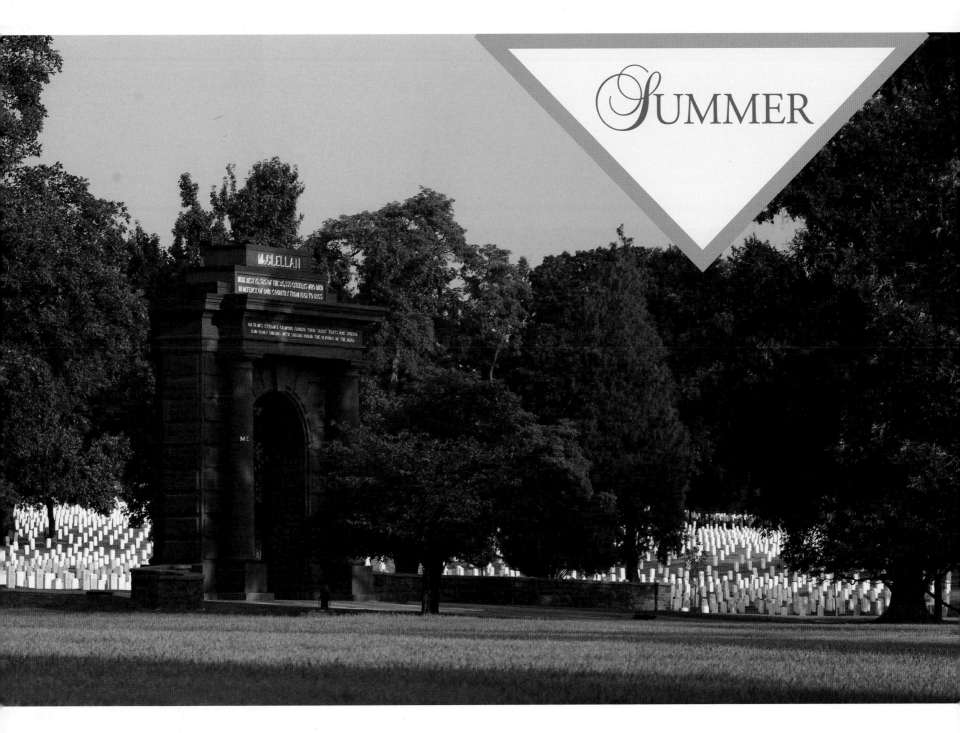

SUMMER

*Early morning haze gives a
ghostly look to the distant trees and headstones.*

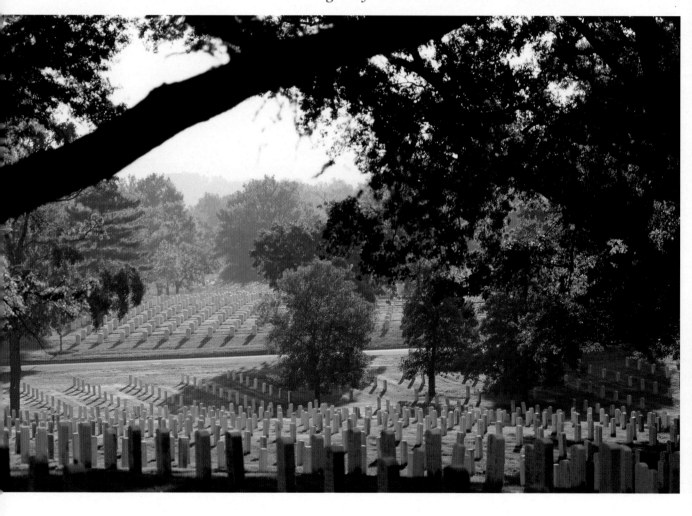

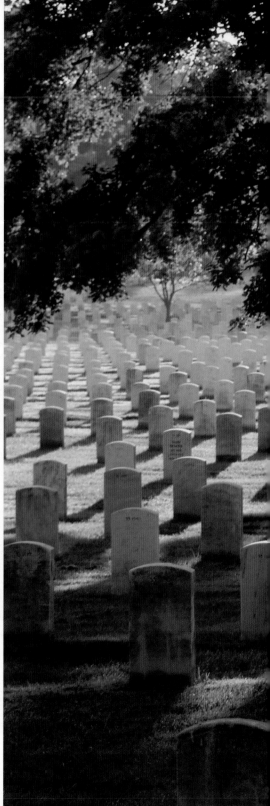

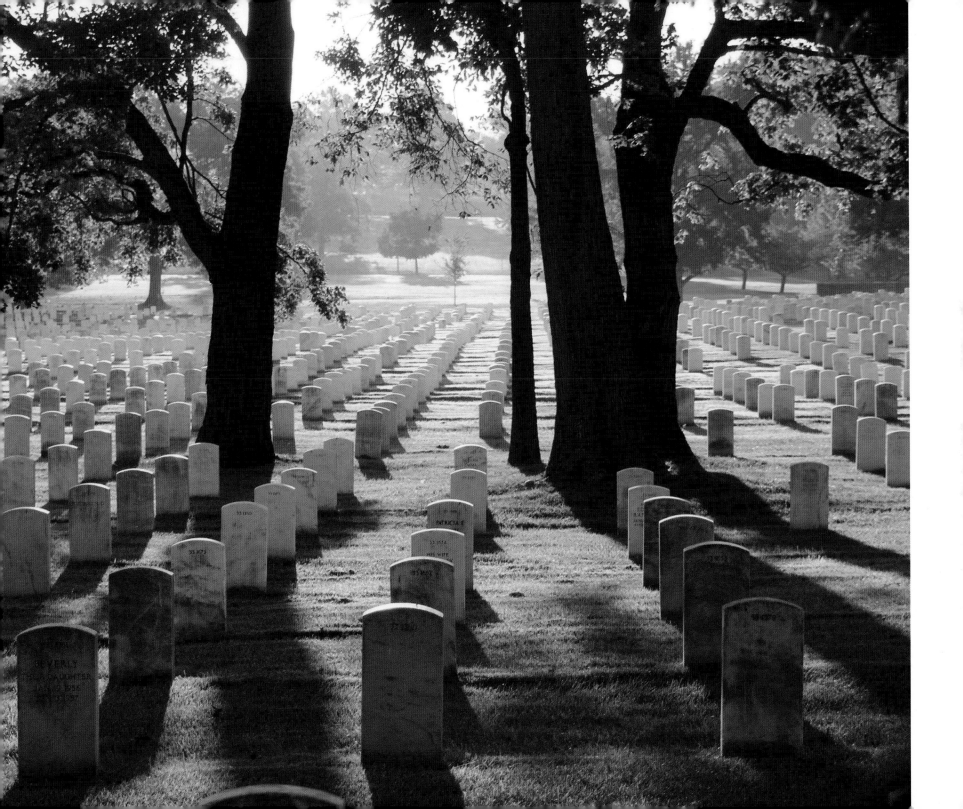

Air Force Honor Guard

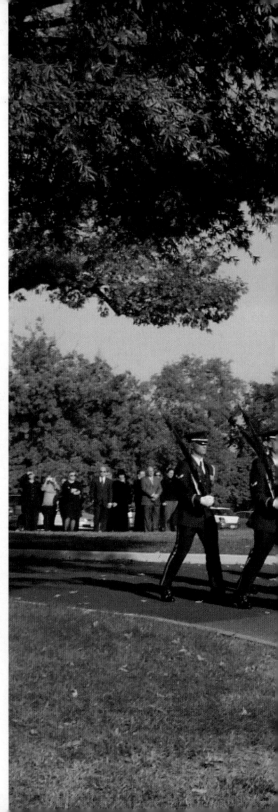

Airmen of the United States Air Force serve their country both in the air and on the ground. Those who strap themselves into a plane and soar into the sky know the importance of everyone on the ground working to make their mission a success. That is why all Airmen are saluted during their funerals at Arlington National Cemetery with the Air Force Honor Guard.

Headquartered in Washington, D.C., the Air Force Honor Guard traces its beginnings back to the Air Force's infancy when Headquarters Command, U.S. Air Force, activated the 1100th Air Police Squadron as a ceremonial detachment in September 1948. Because of transfers and attrition the detachment was disbanded by the end of the year; it was not until March 1949 that sufficient personnel were assigned to enable the unit to function. On January 1, 1972, the Air Force Honor Guard became the separate unit known today.

The Honor Guard renders military honors in Arlington National Cemetery and represents the Air Force in ceremonies and official events involving the president, senior Department of Defense and Air Force leaders, and in Joint Service ceremonies. The Honor Guard performs an average of ten ceremonies a day.

The Honor Guard is a selectively manned unit with more than two hundred ceremonial guardsmen and support personnel. It consists of three ceremonial flights—Colors, Bearers, and Firing Party. The Guard also operates the Drill Team, which tours worldwide, retaining and inspiring Airmen through precision performances.

Air Force funerals are collectively remembered for the Missing Man Formation—a wing of planes flying over the funeral site with one plane pulling out of formation as it passes over. While not part of the Honor Guard and not exclusive to the Air Force anymore, the Air Force began the tradition in the United States. The first official formation was flown at Arlington National Cemetery in 1954 when a flyover of jet aircraft saluted the burial of Air Force General Hoyt Vandenberg. ❧

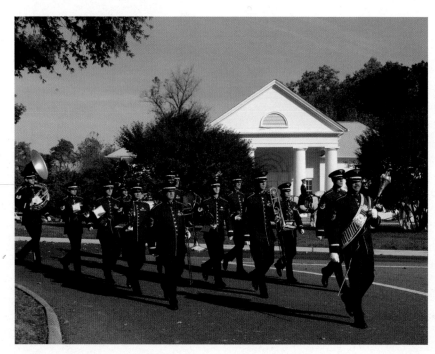

An Air Force Full Honors Funeral Ceremony leaves the Old Administration Building, bringing an Air Force fallen hero to a final resting place. Included in the ceremony are the Air Force Colors Unit, Firing Party, Body Bearer Band (right), and Band (above).

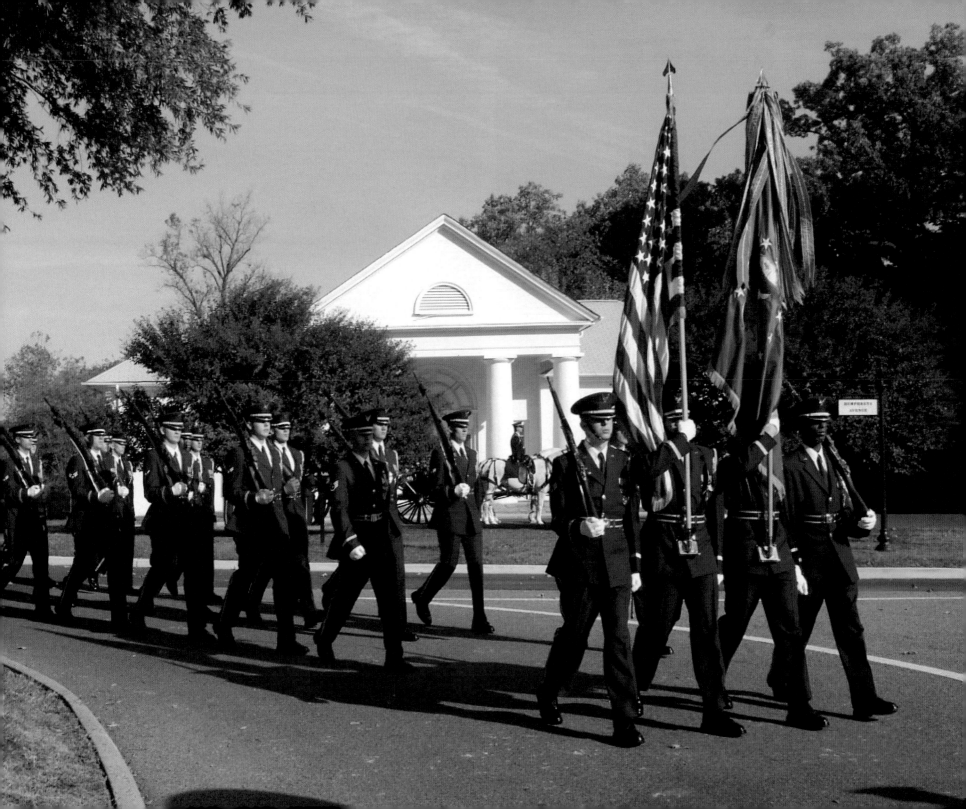

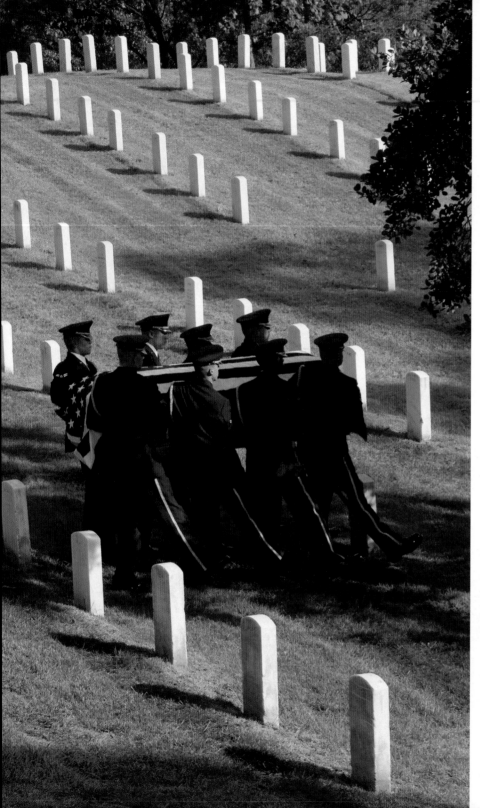
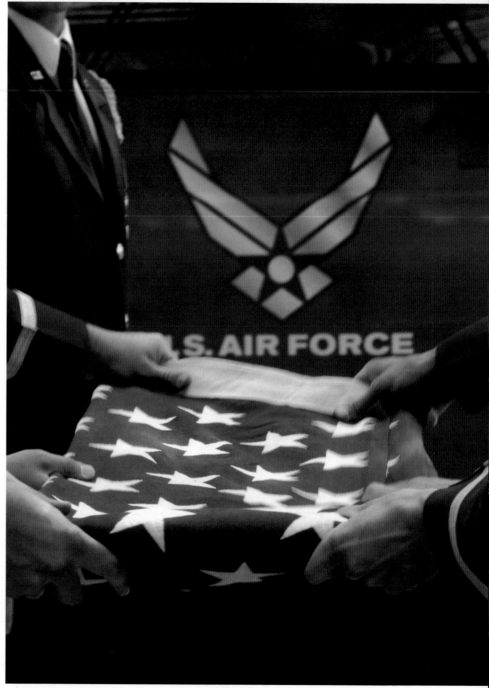

Body bearers traverse the hilly slopes of Arlington (left) and practice flag folding (above), making every ceremony a flawless honor to the fallen hero, the family, and those in attendance at the Cemetery.

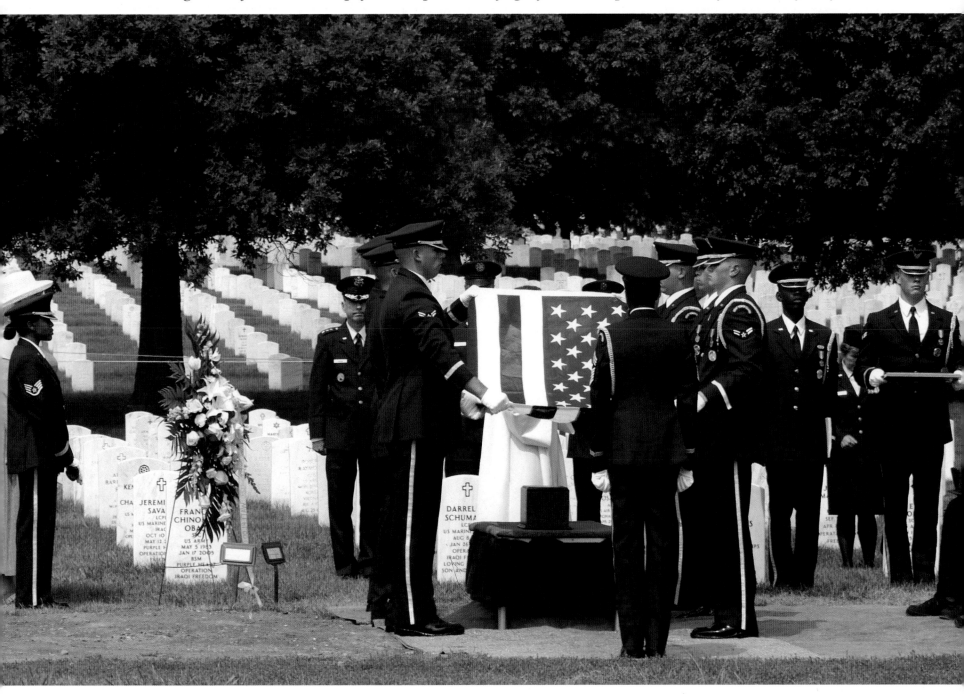

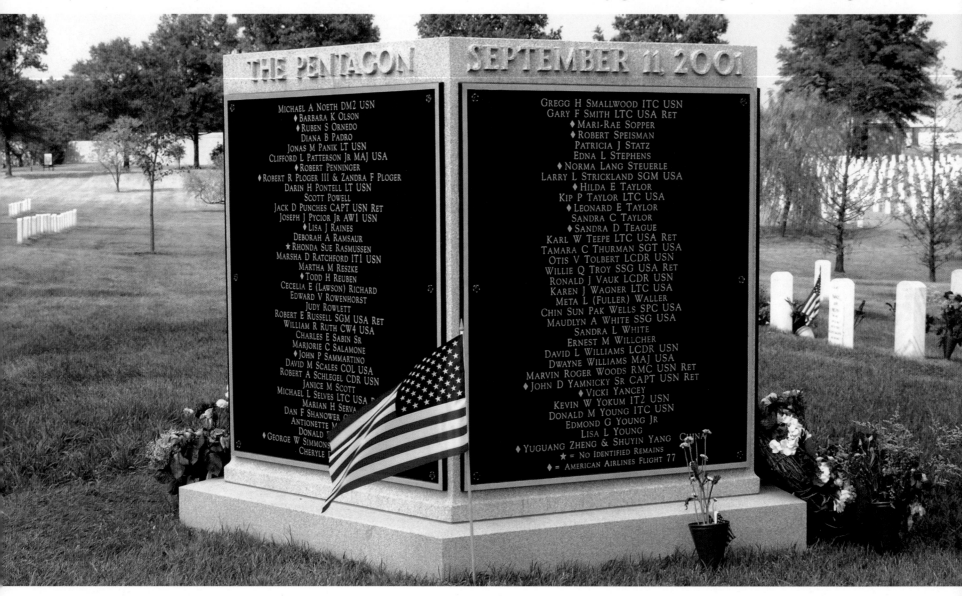

Memorial to the victims of 9/11, for those who died in the flight and on the ground at the Pentagon.

THE PENTAGON

SEPTEMBER 11 2001

Michael A Noeth DM2 USN
♦ Barbara K Olson
♦ Ruben S Ornedo
Diana B Padro
Jonas M Panik LT USN
Clifford L Patterson Jr MAJ USA
♦ Robert Penninger
♦ Robert R Ploger III & Zandra F Ploger
Darin H Pontell LT USN
Scott Powell
Jack D Punches CAPT USN Ret
Joseph J Pycior Jr AW1 USN
♦ Lisa J Raines
Deborah A Ramsaur
★ Rhonda Sue Rasmussen
Marsha D Ratchford IT1 USN
Martha M Reszke
♦ Todd H Reuben
Cecelia E (Lawson) Richard
Edward V Rowenhorst
Judy Rowlett
Robert E Russell SGM USA Ret
William R Ruth CW4 USA
Charles E Sabin Sr
Marjorie C Salamone
♦ John P Sammartino
David M Scales COL USA
Robert A Schlegel CDR USN
Janice M Scott
Michael L Selves LTC USA Ret
Marian H Serva
Dan F Shanower CDR USN
Antionette M Sherman
Donald D Simmons
♦ George W Simmons
Cheryle D Sincock

Gregg H Smallwood ITC USN
Gary F Smith LTC USA Ret
♦ Mari-Rae Sopper
♦ Robert Speisman
Patricia J Statz
Edna L Stephens
♦ Norma Lang Steuerle
Larry L Strickland SGM USA
♦ Hilda E Taylor
Kip P Taylor LTC USA
♦ Leonard E Taylor
Sandra C Taylor
♦ Sandra D Teague
Karl W Teepe LTC USA Ret
Tamara C Thurman SGT USA
Otis V Tolbert LCDR USN
Willie Q Troy SSG USA Ret
Ronald J Vauk LCDR USN
Karen J Wagner LTC USA
Meta L (Fuller) Waller
Chin Sun Pak Wells SPC USA
Maudlyn A White SSG USA
Sandra L White
Ernest M Willcher
David L Williams LCDR USN
Dwayne Williams MAJ USA
Marvin Roger Woods RMC USN Ret
♦ John D Yamnicky Sr CAPT USN Ret
♦ Vicki Yancey
Kevin W Yokum IT2 USN
Donald M Young ITC USN
Edmond G Young Jr
Lisa L Young
♦ Yuguang Zheng & Shuyin Yang China
★ = No Identified Remains
♦ = American Airlines Flight 77

Lancaster Monument (left and below): "This monument was erected on Flamenco Island, Panama Bay, by the officers and crew of the USS Lancaster to perpetuate the memory of nine shipmates who died during the years 1860 and 1861.

"In 1911 the monument was transferred to Ancon Cemetery, Isthmian Canal Zone, and in 1915 it was further transferred to Arlington National Cemetery, both of these transfers having been made necessary by the military development of the Flamenco and Ancon sites.

"When removed from Flamenco Island fifty years after its erection, no vestige of bodies was found."

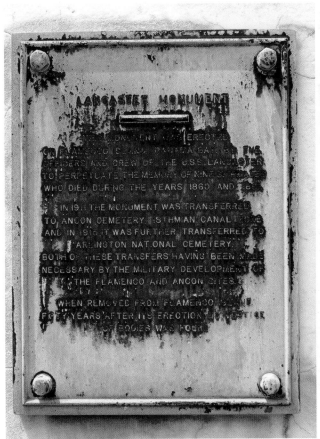

JOHN McCARTY — IRELAND
DIED JANUARY 30, 1860, AGED 25 YEARS

LIEUT. JOSEPH WHIPPLE HARRIS
BORN IN NEW HAMPSHIRE
DIED AUGUST 24, 1861
AGED 24 YEARS

ANDREW JACKSON — NEW YORK
DIED AUGUST 14, 1860 — AGED 27 YEARS

PATRICK BARRY — IRELAND
DIED AUGUST 10, 1861 — AGED 32 YEARS

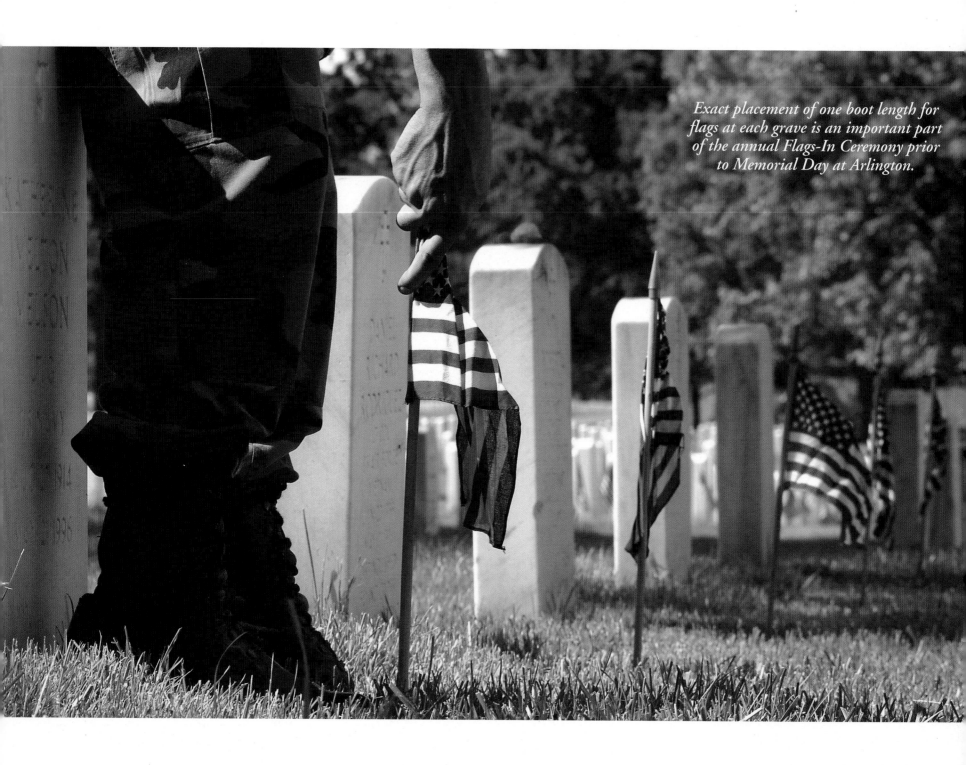

Exact placement of one boot length for flags at each grave is an important part of the annual Flags-In Ceremony prior to Memorial Day at Arlington.

Memorial Day at Arlington

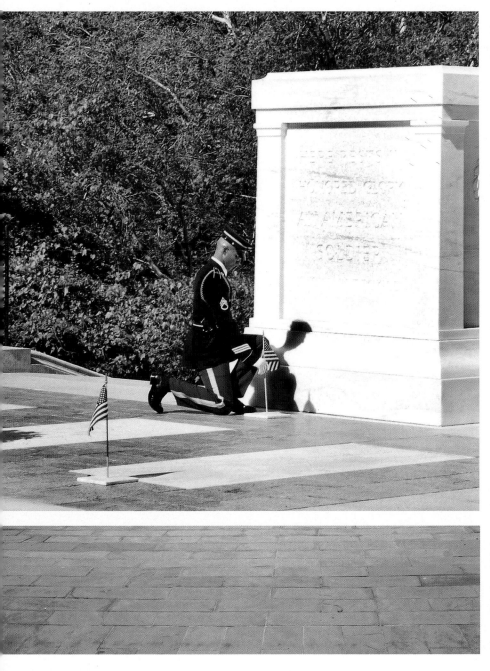

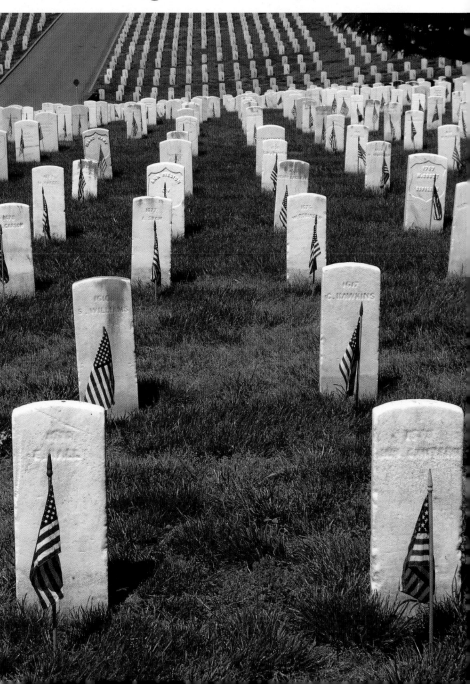

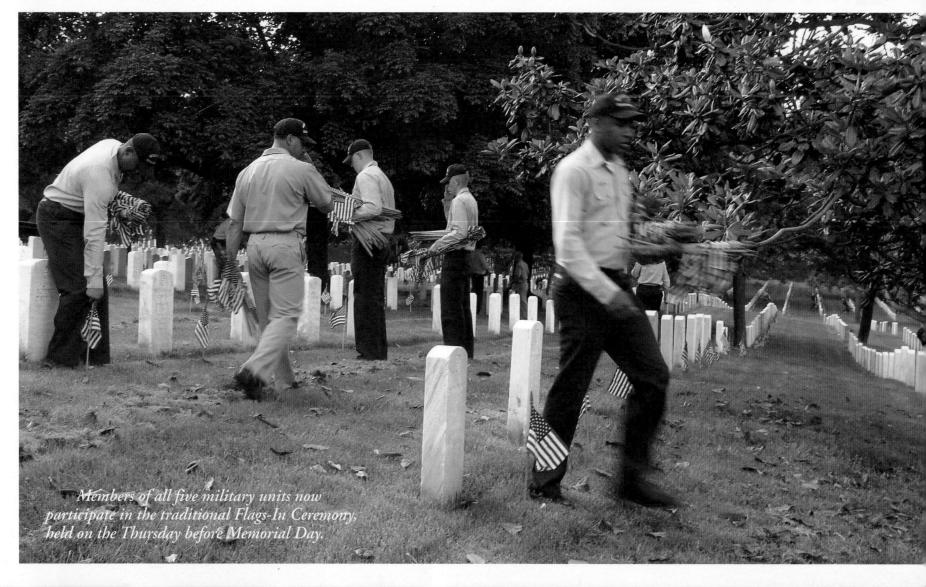

Members of all five military units now participate in the traditional Flags-In Ceremony, held on the Thursday before Memorial Day.

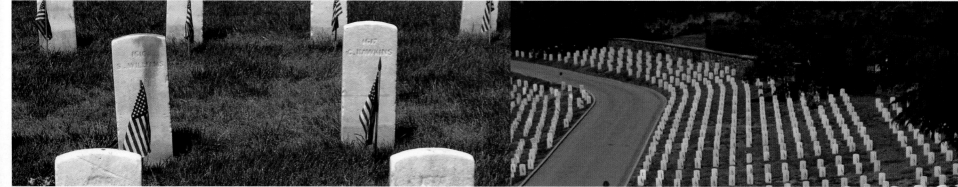

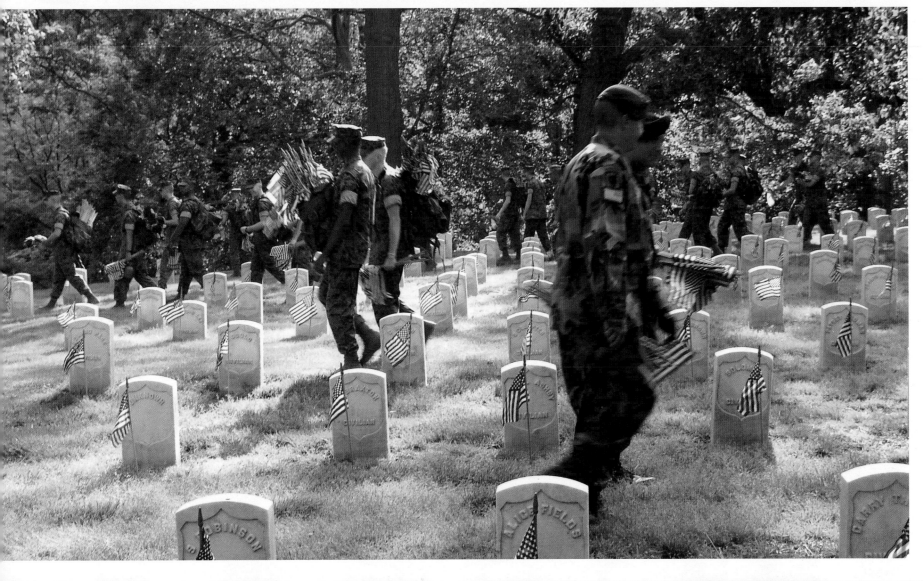
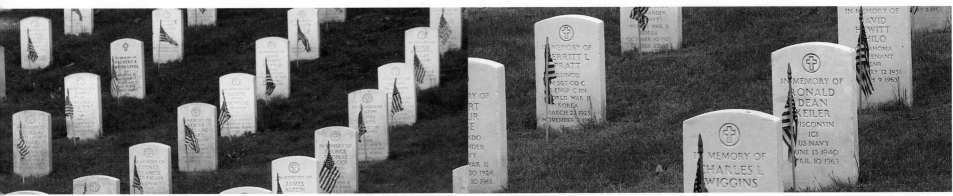

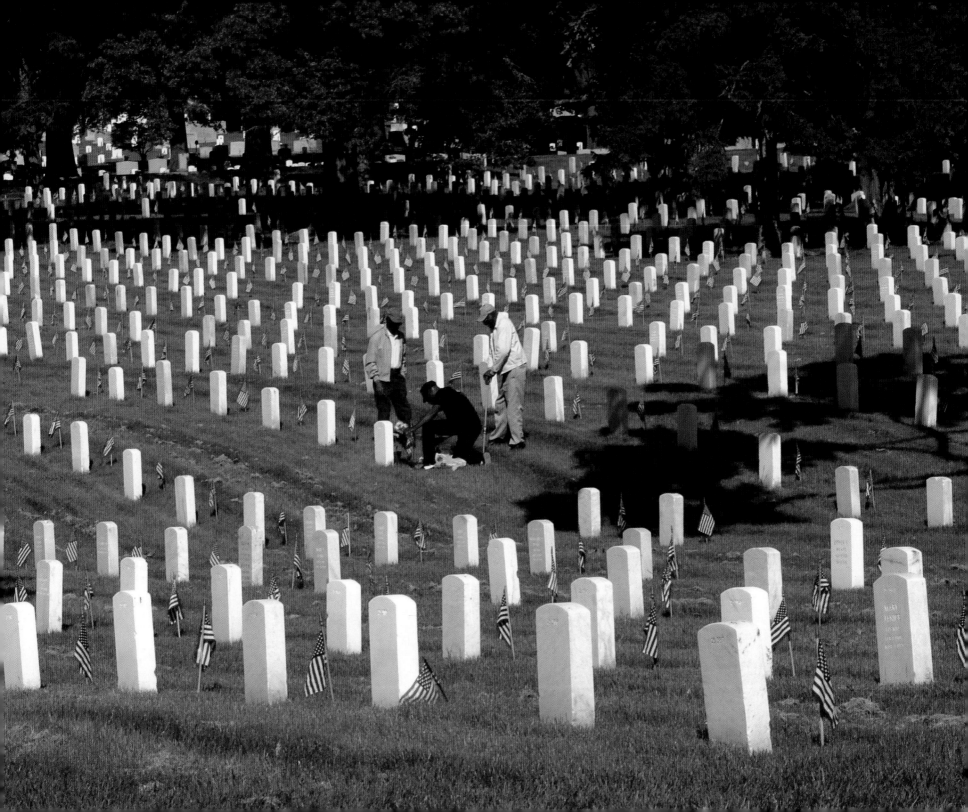

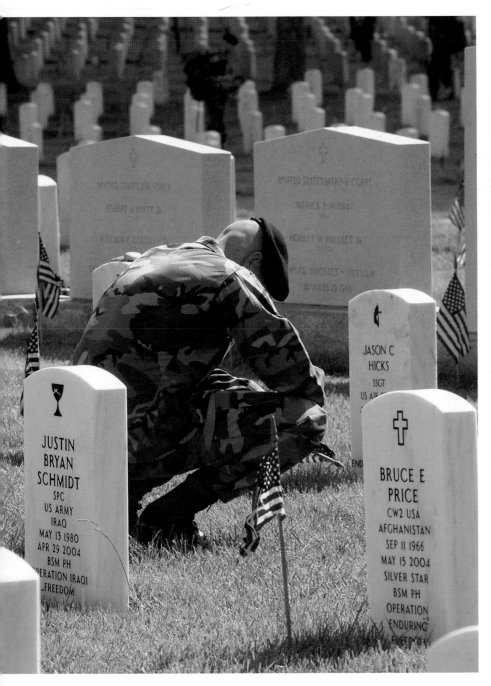

Time is taken during Flags-In Ceremony to pay respect to a friend and fallen hero.

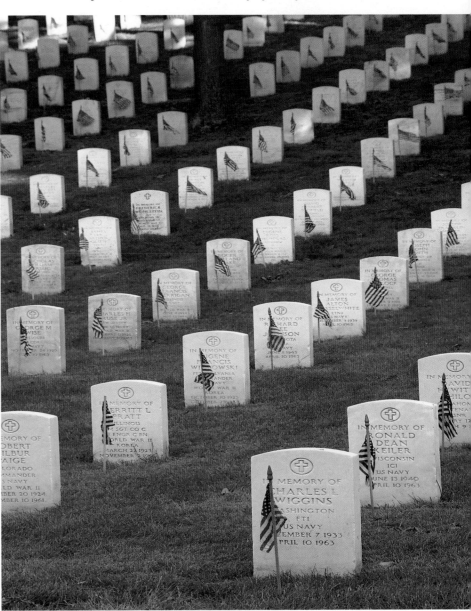

Many individuals pay tribute to their comrades, family, and friends on Memorial Day (far left).

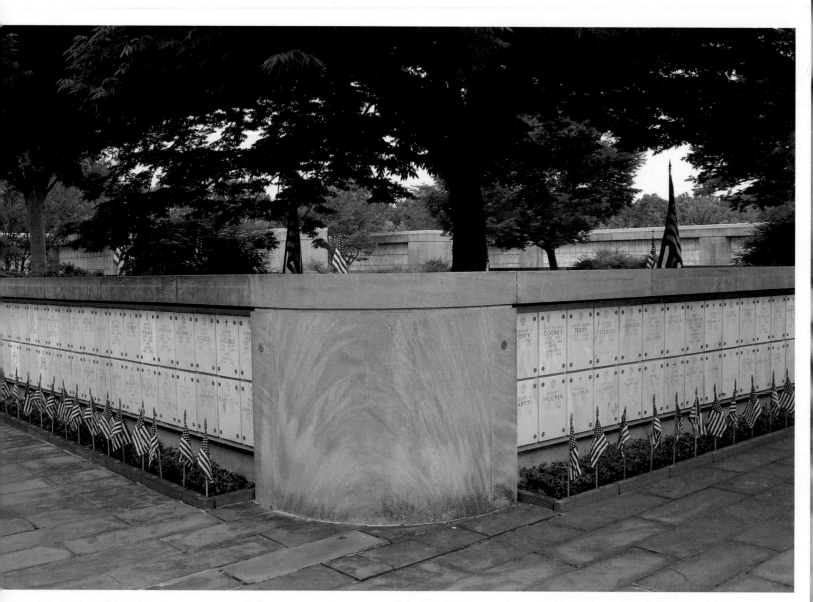

In the Columbarium of Arlington, flags are also traditionally placed to honor fallen heroes.

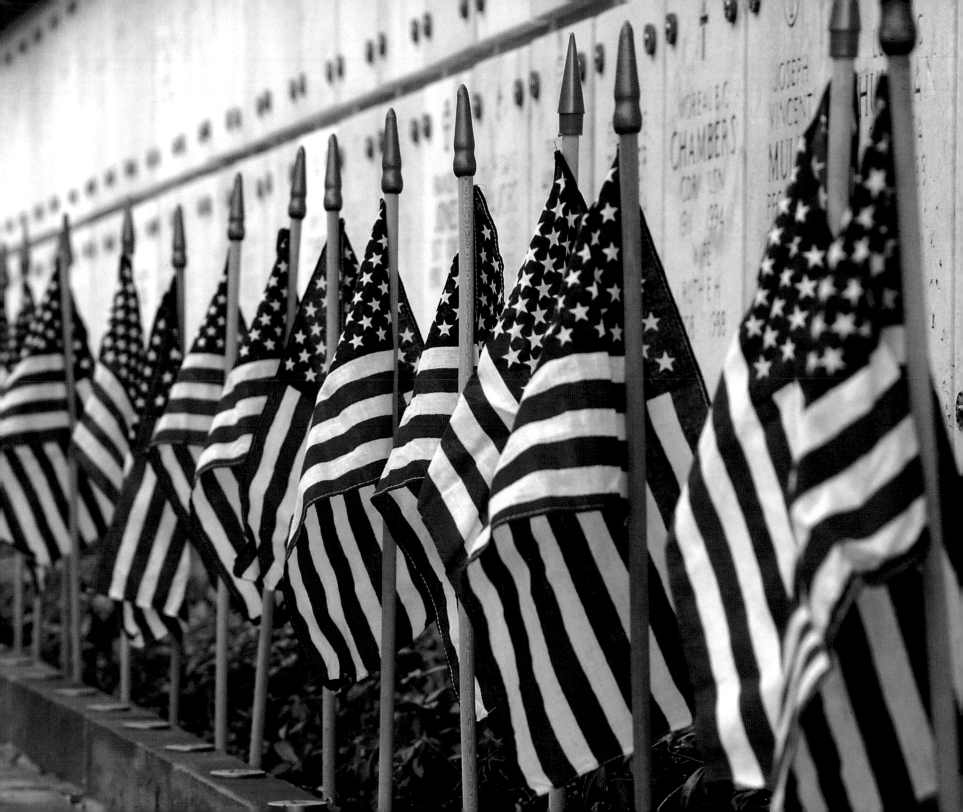

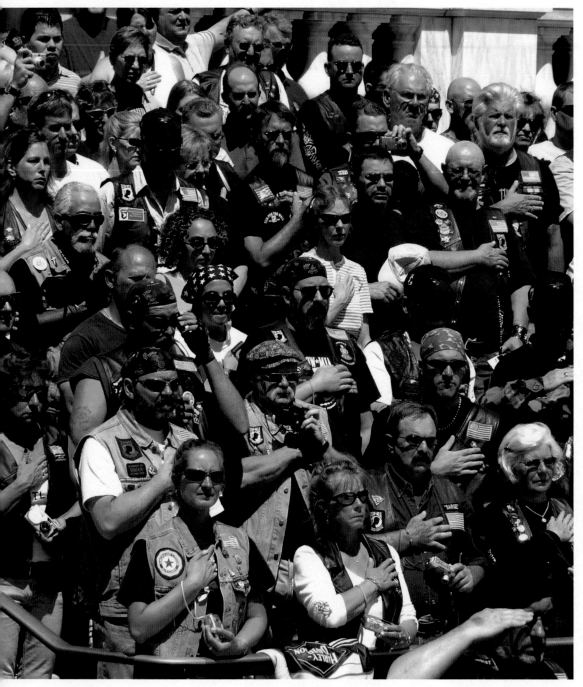

The quiet surroundings of Arlington are overwhelmed every Memorial Day weekend when thousands of motorcycles roar into the Cemetery for a wreath-laying ceremony. Since 1988, Operation Rolling Thunder has been responsible for this unique form of remembrance. Motorcyclists from across the nation converge on the Cemetery complete with American and MIA/POW flags flying to pay tribute to the dead and to those who never made it home.

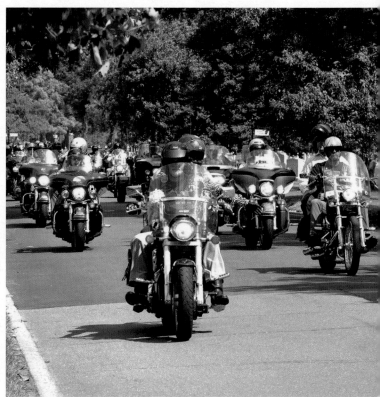

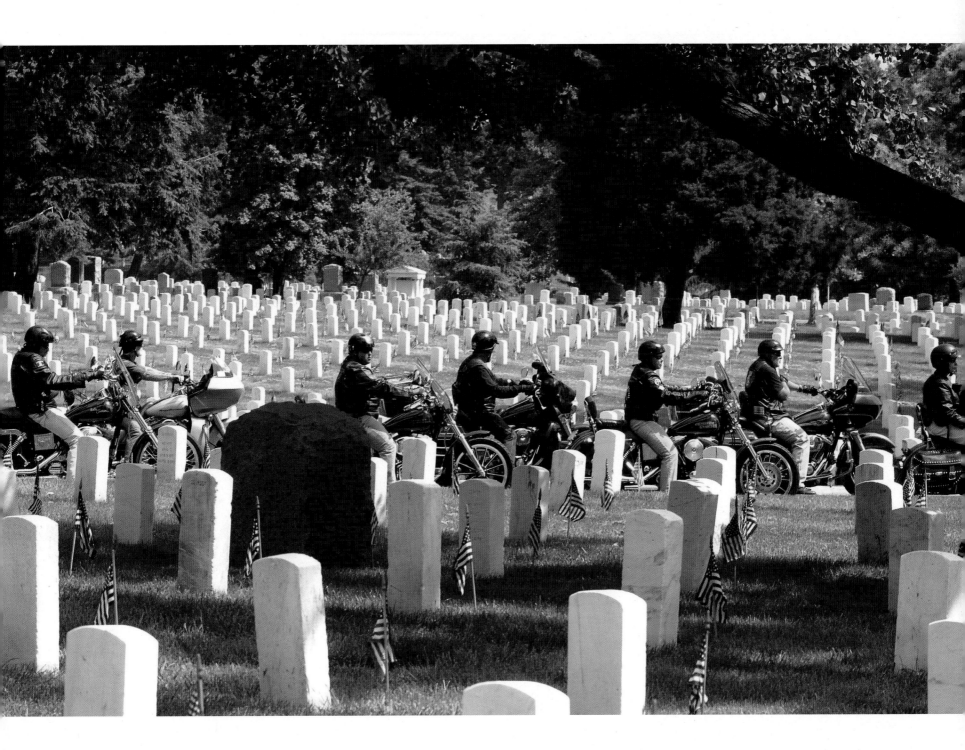

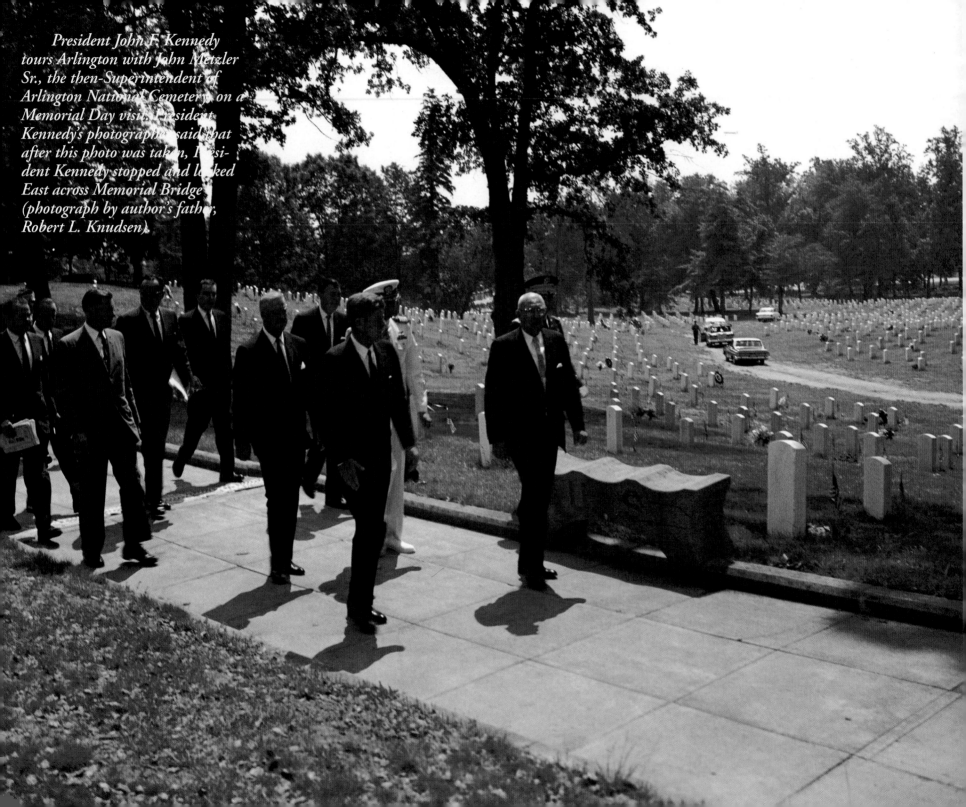

President John F. Kennedy tours Arlington with John Metzler Sr., the then-Superintendent of Arlington National Cemetery, on a Memorial Day visit. President Kennedy's photographer said that after this photo was taken, President Kennedy stopped and looked East across Memorial Bridge (photograph by author's father, Robert L. Knudsen).

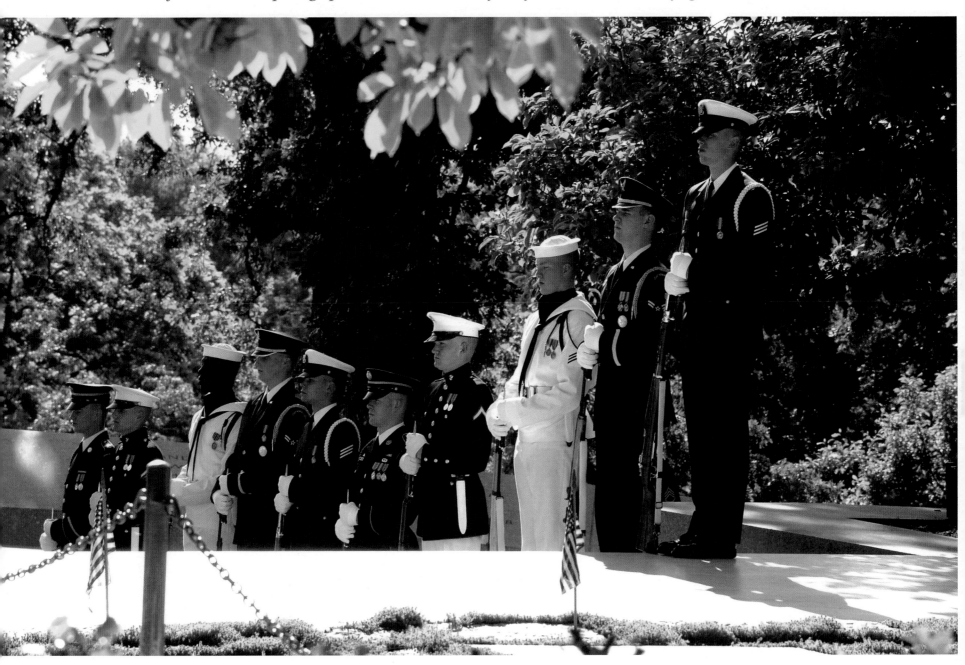

President Kennedy then said, "This is so beautiful. When I die I'd like to be buried here or in a place as beautiful as this." The photograph was taken about 100 yards from President Kennedy's grave (below).

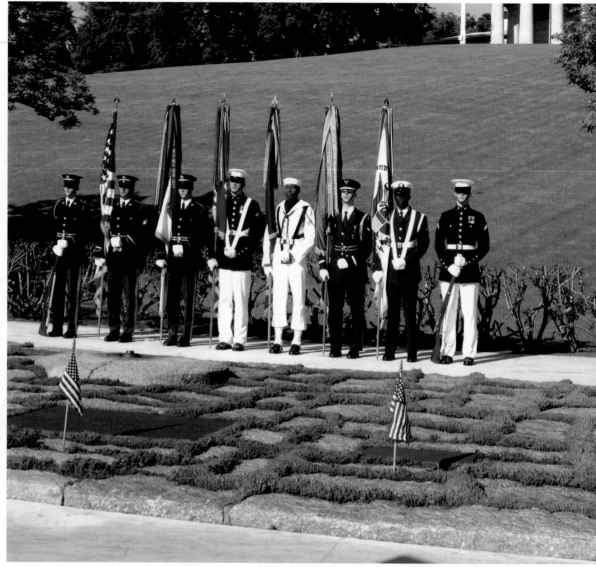

Members of the Joint Military Ceremonial Guard stand at rest before the annual ceremony commemorating President Kennedy's birthday. During this ceremony a wreath is laid and tributes are given, oftentimes by members of the Kennedy family.

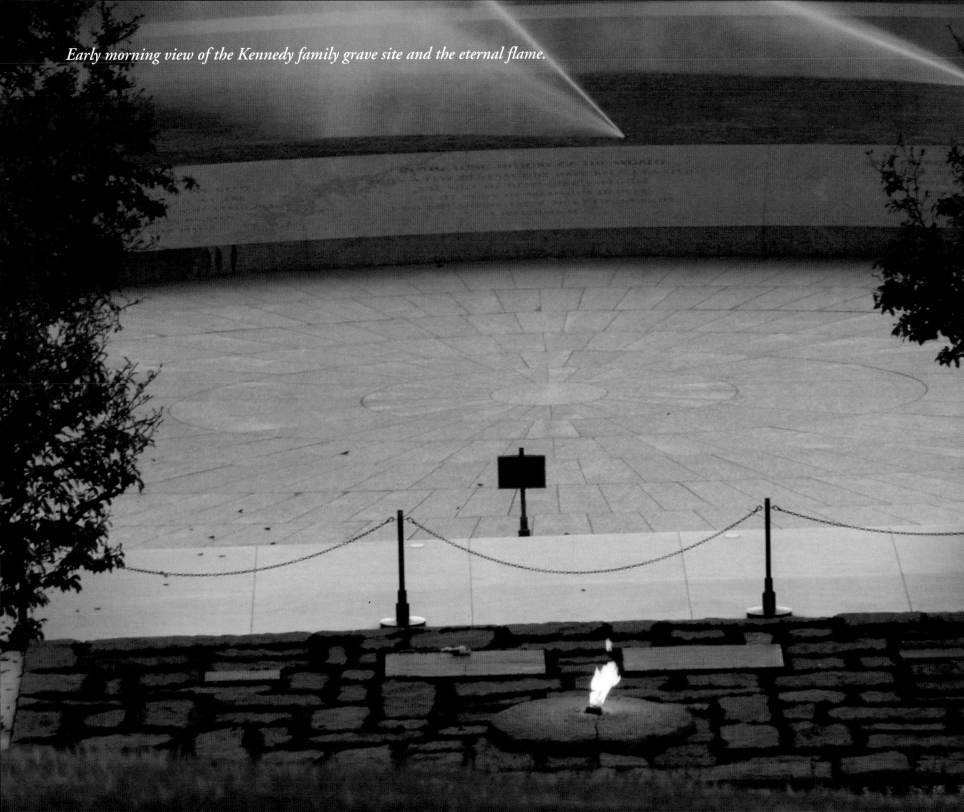

Early morning view of the Kennedy family grave site and the eternal flame.

Every four years, over 5,000 Boy Scouts visit Arlington to attend a non-denominational service in the Amphitheatre during their Jamboree.

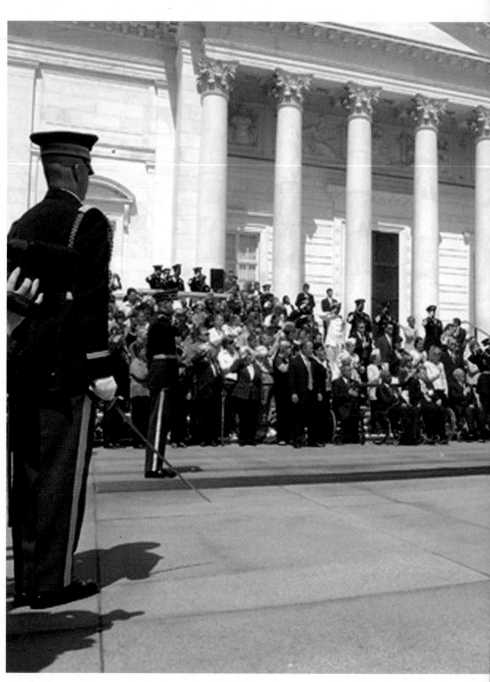

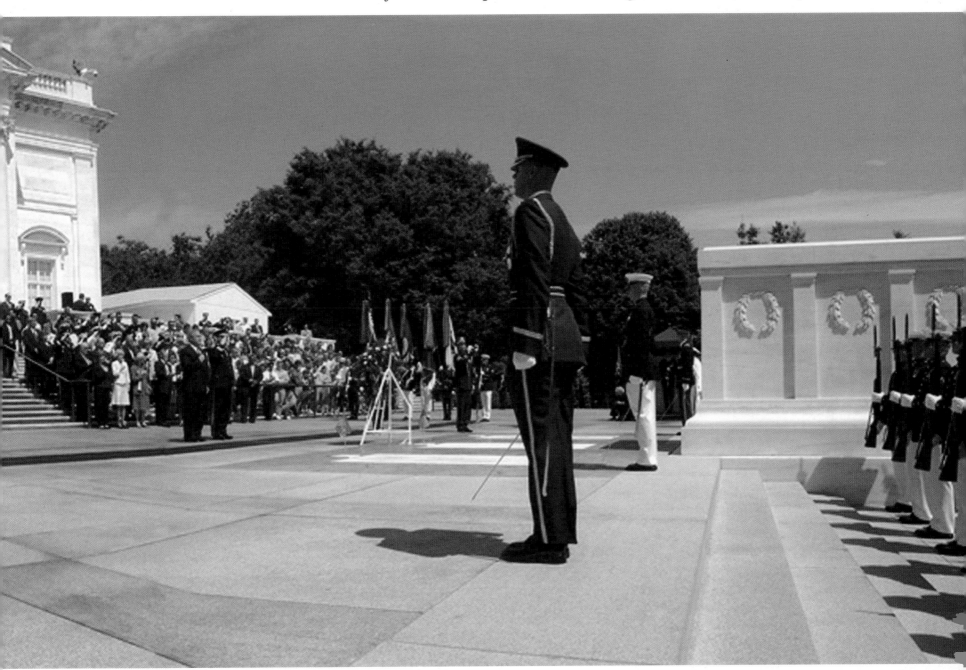

The Presidential Wreath Laying at the Tomb of the Unknowns is the highest wreath ceremony held at Arlington. It is also one of the two centerpiece ceremonies during the annual Memorial Day remembrances.

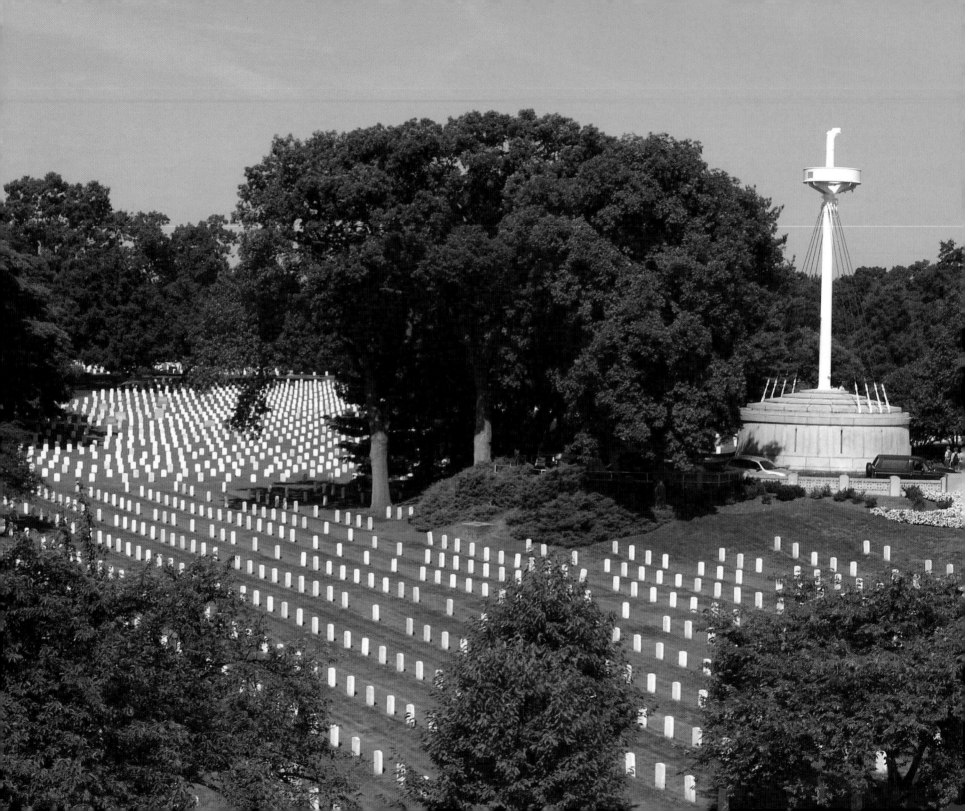

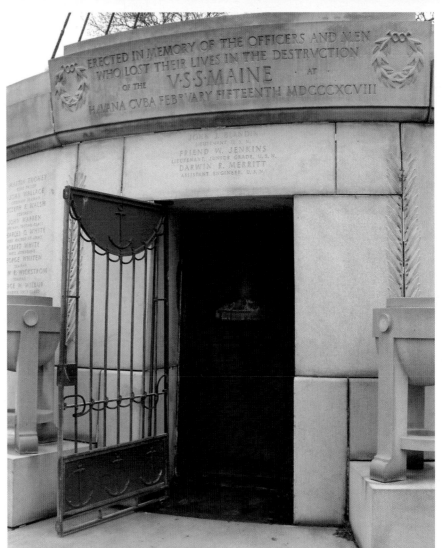

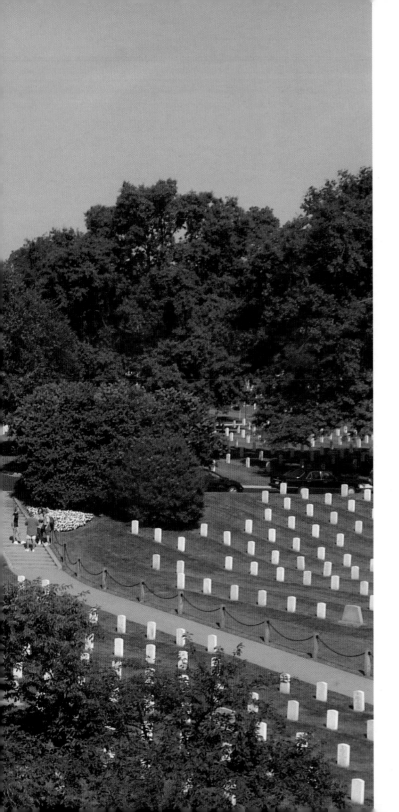

A rooftop view from the Amphitheatre across Section 46 and the USS *Maine* Memorial (left). The memorial has a unique history. The room behind the door (above) kept the remains of Ignace Paderewski, a Polish nationalist from 1941 through 1992. President Franklin D. Roosevelt called the State Department and asked the department to inform Paderewski's family and officials of the Polish embassy that Paderewski's body would be given a temporary resting place in the vault of the Mast of the USS *Maine* Monument. President Roosevelt said, "He may lie there until Poland is free." On June 26, 1992, Paderewski's remains were transferred from the USS *Maine* Memorial to his homeland, where his remains were placed in the Church of Holy Cross in Warsaw on July 4, 1992.

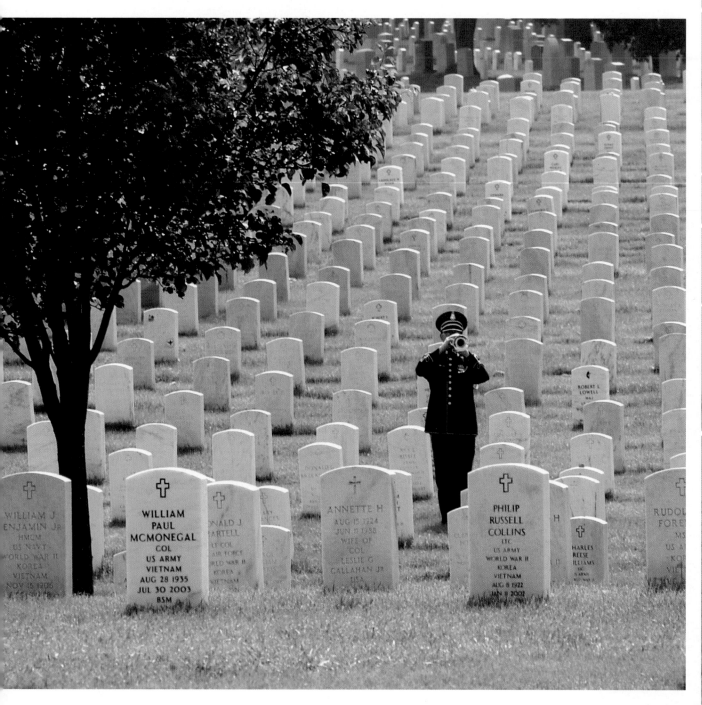
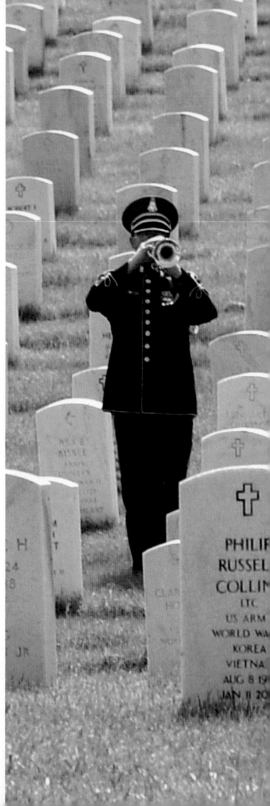

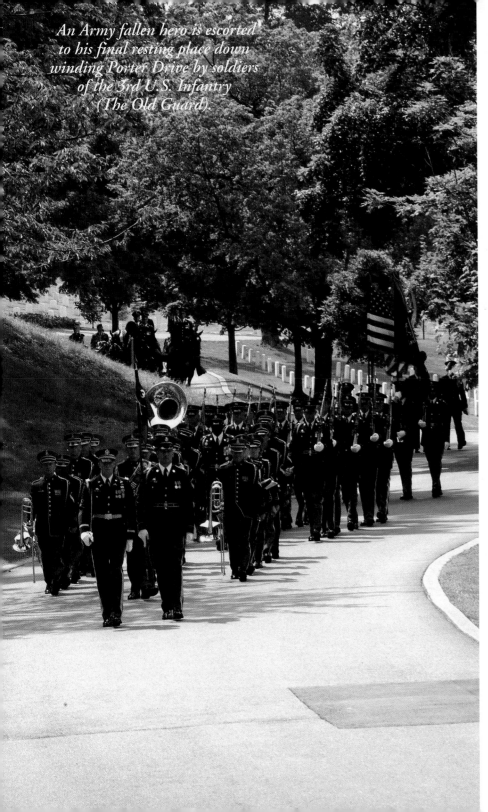

An Army fallen hero is escorted to his final resting place down winding Porter Drive by soldiers of the 3rd U.S. Infantry (The Old Guard).

The Old Guard

The sentinel walks exactly twenty-one steps, then turns and pauses for twenty-one seconds. The sentinel turns again and shifts the rifle to the other shoulder and waits another twenty-one seconds before taking another twenty-one steps. That is the routine for the Tomb Guard of the U.S. Army's 3rd Infantry Regiment, better known as the Old Guard.

But the infantrymen of the Old Guard do more than stand watch over the Tomb of the Unknowns. They provide funeral escorts at Arlington National Cemetery, an average of sixteen per day. They are also the official escort to the President of the United States.

The Old Guard presents historic theatrical productions in Washington, D.C., and participates in parades. During the summer they perform a "Twilight Tattoo" on the White House Ellipse. The unit also provides security for Washington in times of national emergency or civil disturbance.

The regiment is made up of two battalions, which include a Drill Team, Continental Color Guard, Tomb Guard, Caisson Platoon, a Fife and Drum Corps, a Presidential Salute Battery, a Military Police Company, five

(continued)

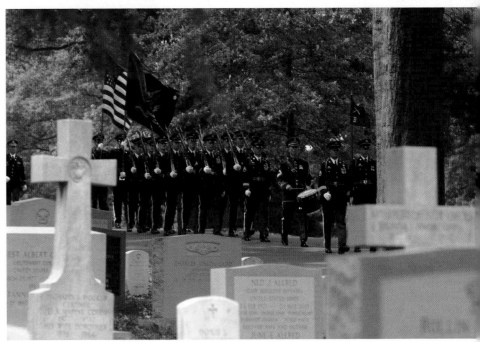

The Army Firing Party returning after rendering a salute (above).

(continued)

companies of infantry, and a support company.

The Old Guard dates back to 1784, when it was created after the Continental Army had been mostly disbanded after the American Revolution. During the War with Mexico the unit fought in a number of battles, culminating in the Battle of Chapultepec where the men of the 3rd stormed the walls of the Mexican fortress and established a foothold for other troops to exploit. After the battle General Winfield Scott, watching the regiment pass, told his staff, "Gentlemen, take off your hats to the Old Guard of the Army." The name stuck.

In 1948, the 3rd became the official unit for the protection of the nation's capital. Because of its distinction the unit constantly trains, ready as any infantrymen in the Army. That training came in use when two of the regiment's battalions were sent to Vietnam. The Old Guard also provided immediate support after the events of 9/11 and has served in several hot spots in the War on Terror as well.

Today the Old Guard has two missions: one ceremonial and the other tactical. Its training accomplishes both, whether interring a fallen soldier at the Cemetery or keeping peace around the world. ∝

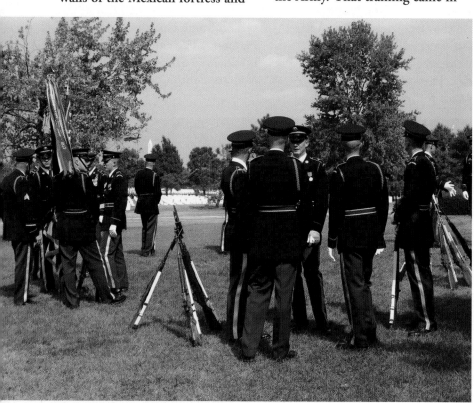

Between ceremonies, soldiers take time to review and discuss their next assignment (above).

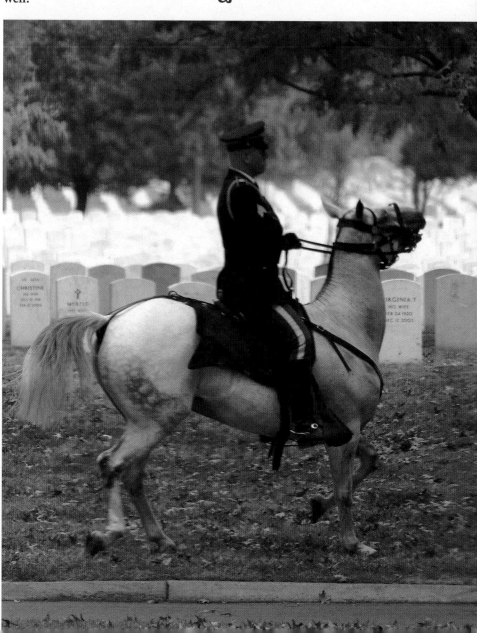

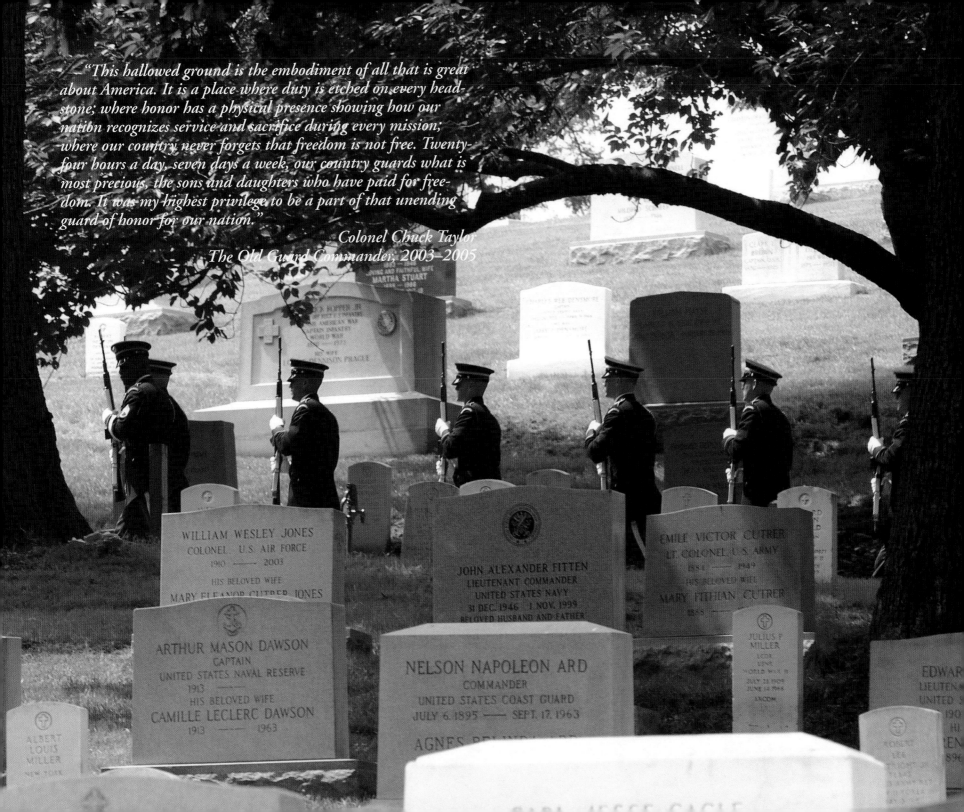

"This hallowed ground is the embodiment of all that is great about America. It is a place where duty is etched on every headstone; where honor has a physical presence showing how our nation recognizes service and sacrifice during every mission; where our country never forgets that freedom is not free. Twenty-four hours a day, seven days a week, our country guards what is most precious, the sons and daughters who have paid for freedom. It was my highest privilege to be a part of that unending guard of honor for our nation."

Colonel Chuck Taylor
The Old Guard Commander, 2003–2005

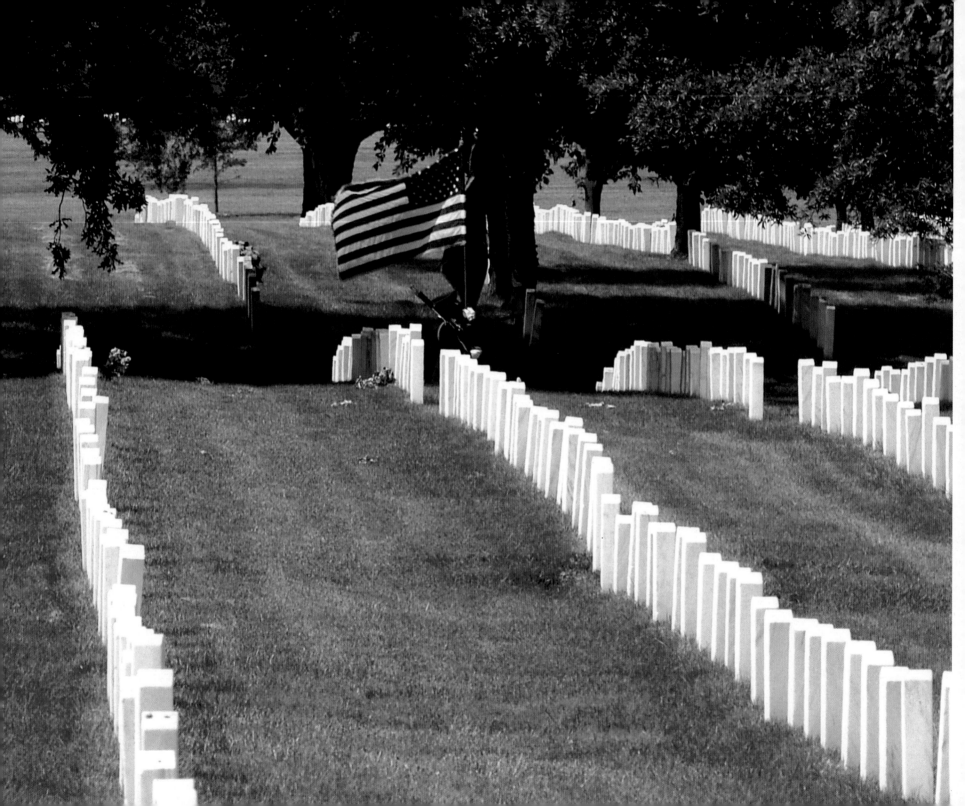

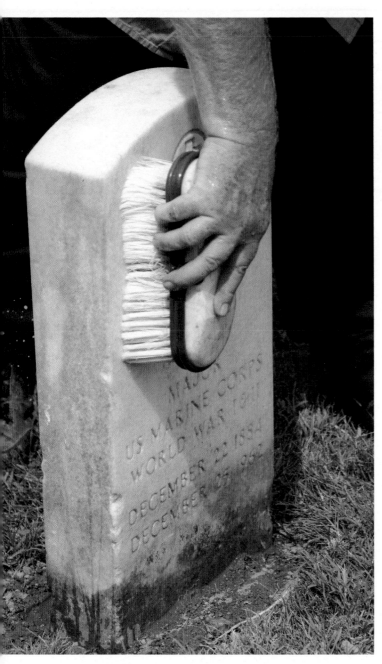

Headstones are individually cleaned.

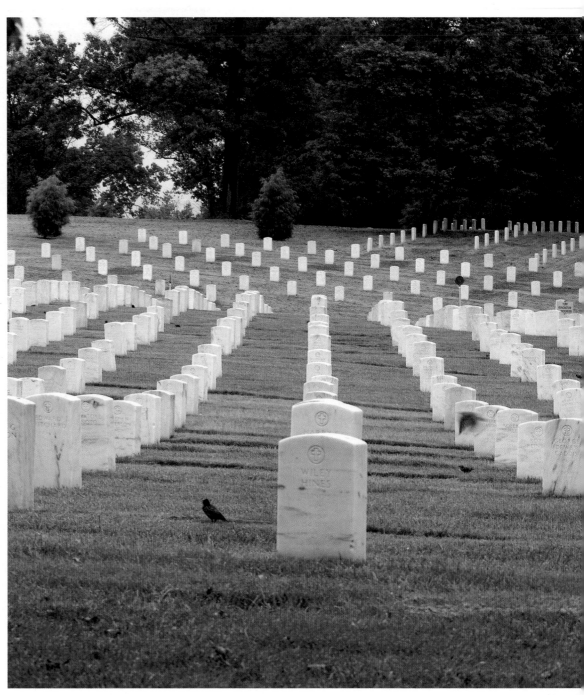

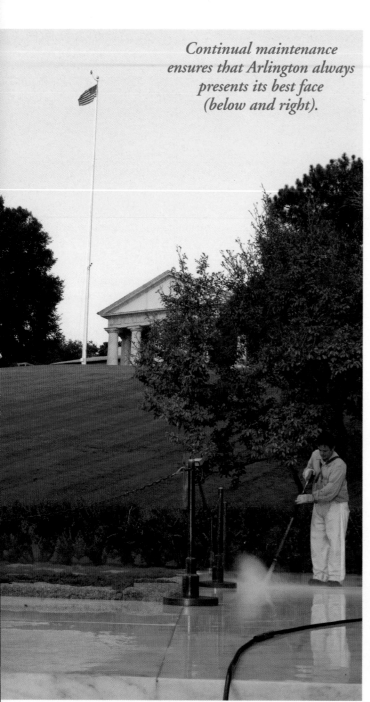

Continual maintenance ensures that Arlington always presents its best face (below and right).

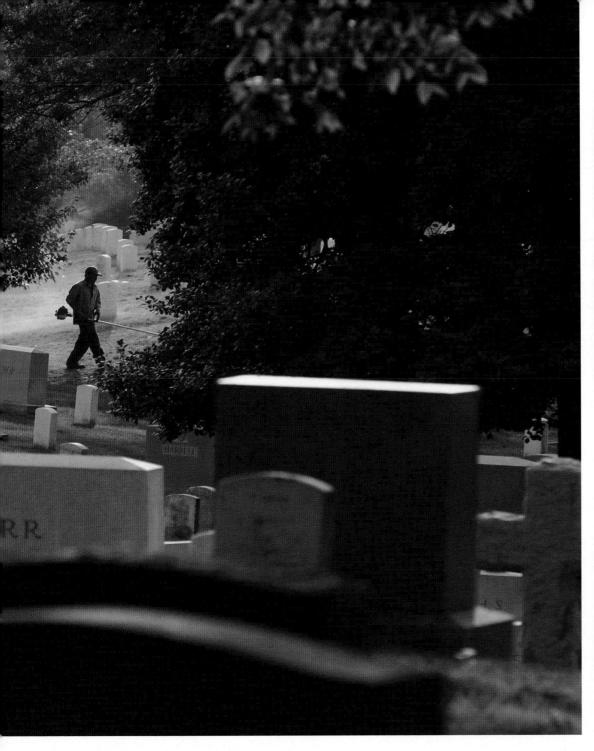

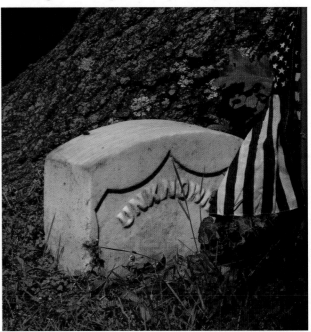

Examples of the many unusual graves located throughout the grounds of Arlington (below).

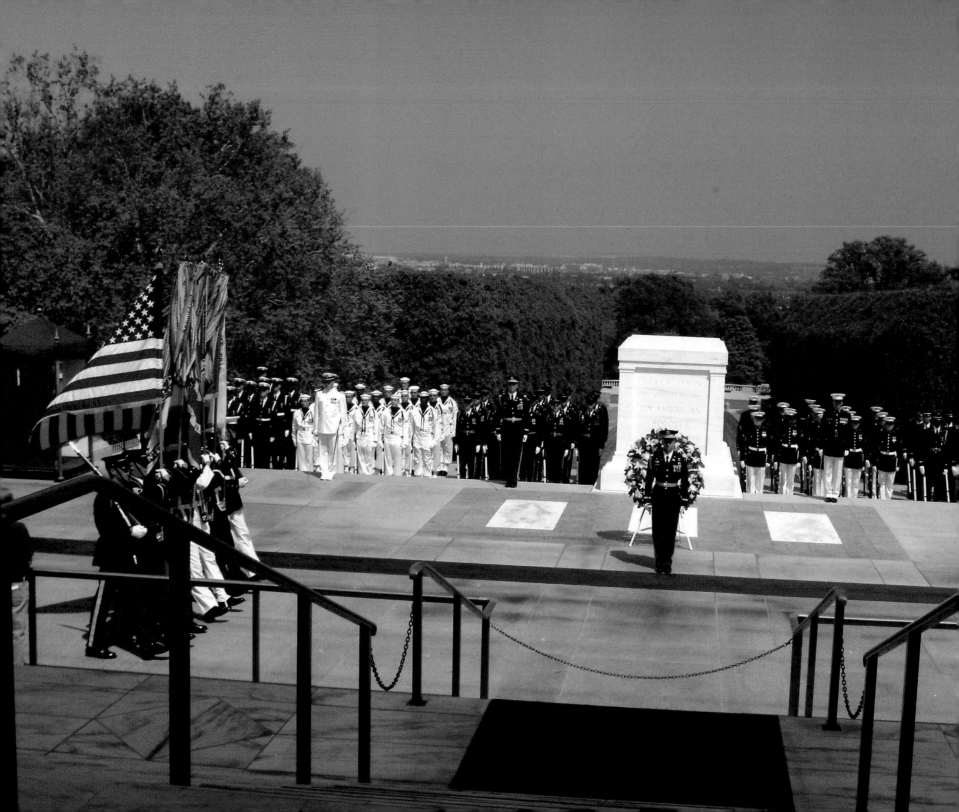

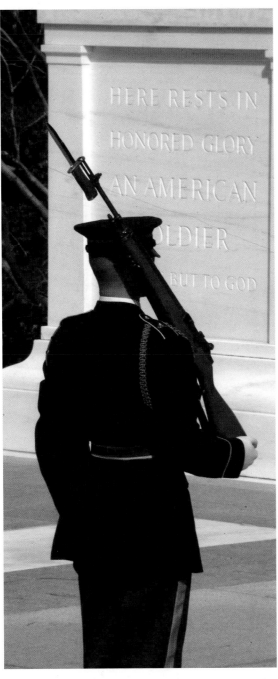

A Joint Military Wreath-Laying Ceremony is a spectacular sight for all to see.

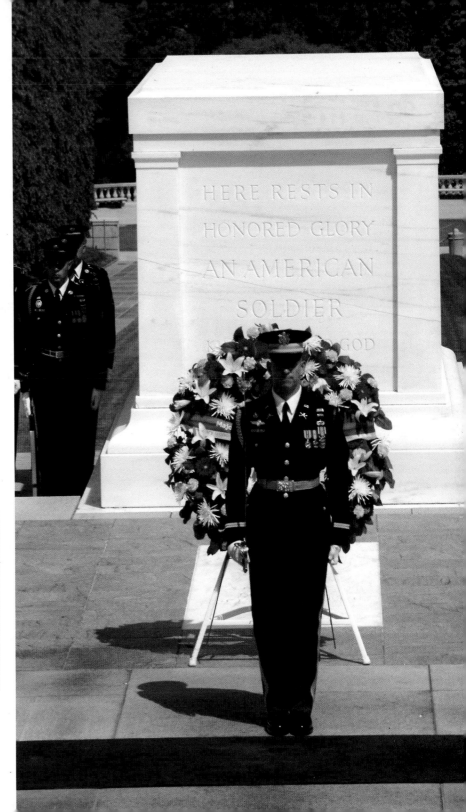

Beauty of a Summer rain reflects the colors and pageantry of a Wreath-Laying Ceremony and the Changing of the Guard at the Tomb of the Unknowns.

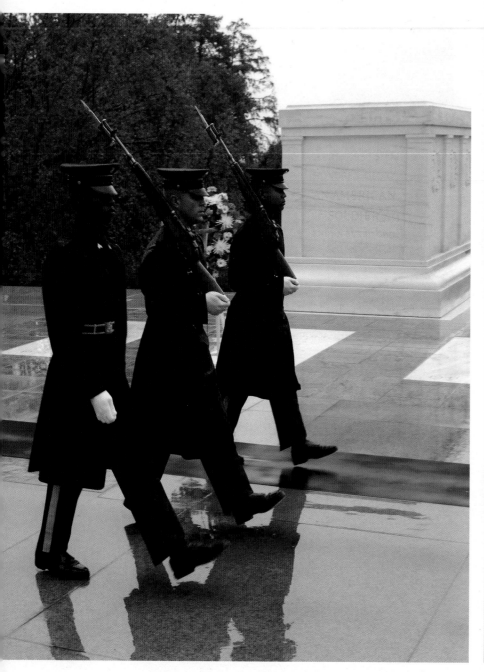
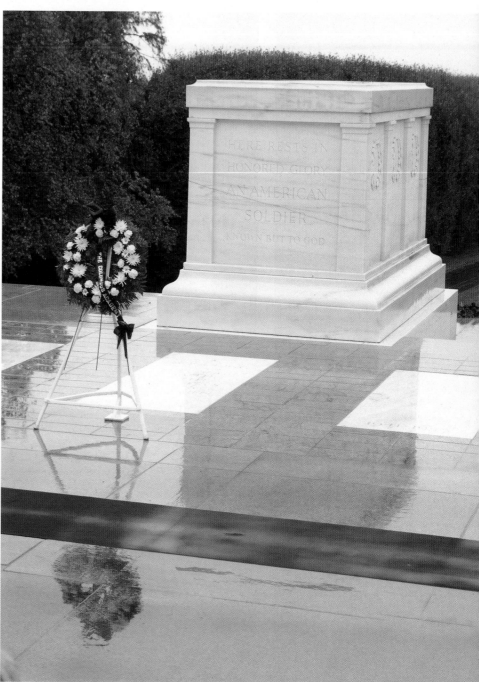

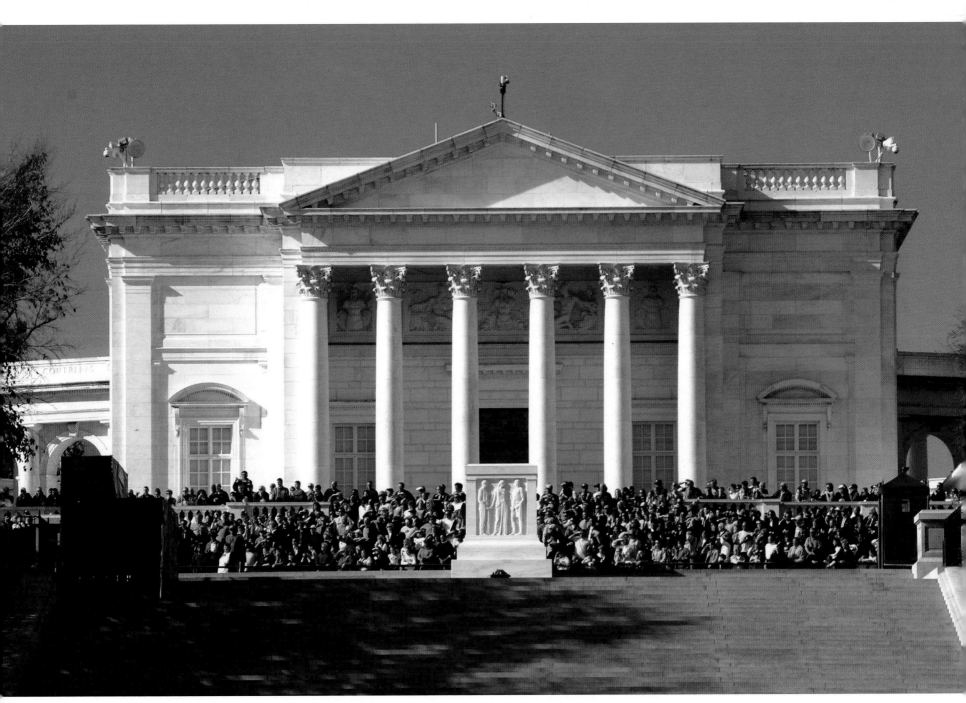

Seen from the lower plaza, the Changing of the Guard is one of the most famous ceremonies at Arlington.

Summer foliage adorns the Old Amphitheatre, where smaller official ceremonies are conducted.

Early morning mist kissed by this rainbow in Section 1.

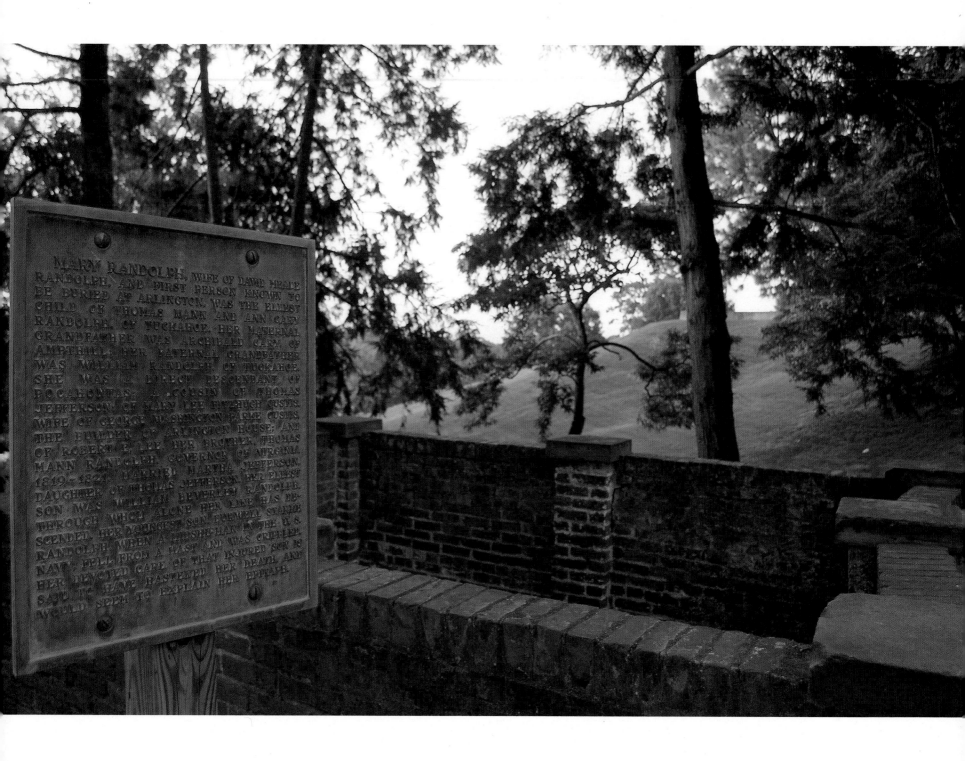

Mary Randolph, the first person to be buried in the Cemetery's Section 45 (left) in 1828, holds a very interesting story of a person and a grave no one remembered or knew existed. A walk along the same path reveals the graves of Robert Todd Lincoln; his wife, Mary Harlan; and their son, Abraham Lincoln II (below). President Lincoln wrote to General Ulysses S. Grant: "My son, now in his twenty-second year, having graduated at Harvard, wishes to see something of the war before it ends. I do not wish to put him in the ranks, not yet to give him a commission, to which those who have already served long, are better entitled, and better qualified to hold. Could he, without embarrassment to you, or detriment to the service, go into your Military family with some nominal rank, I, and not the public, furnishing his necessary means?" Robert accompanied General Grant to Appomattox and was introduced to General Lee there. He later became Secretary of War under President Garfield.

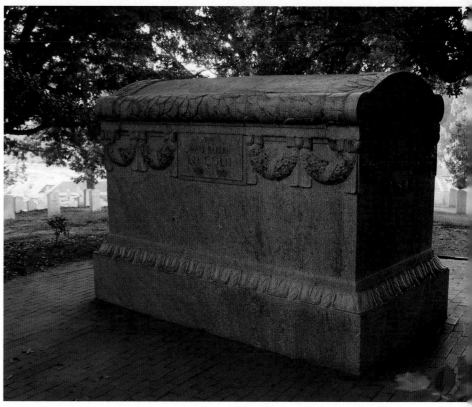

The Presidential Salute Battery of the 3rd U.S. Infantry Salute Guns Platoon is responsible for rendering honors at funerals and to visiting foreign dignitaries and heads of state. The Guns Platoon is the only unit of its kind in the Army. It takes hours of practice for the proper timing of their firing, and constant maintenance to keep their guns in pristine condition.

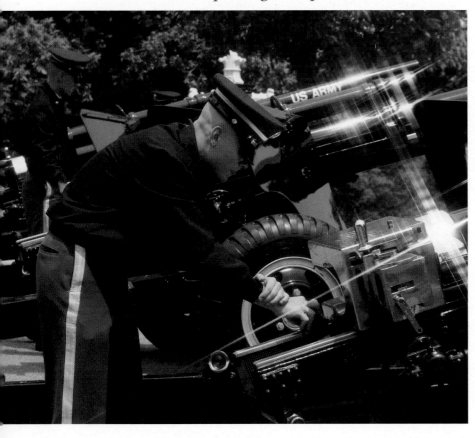

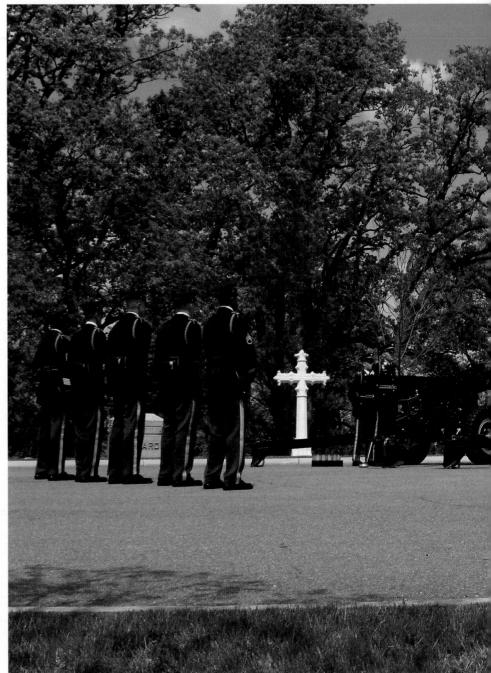

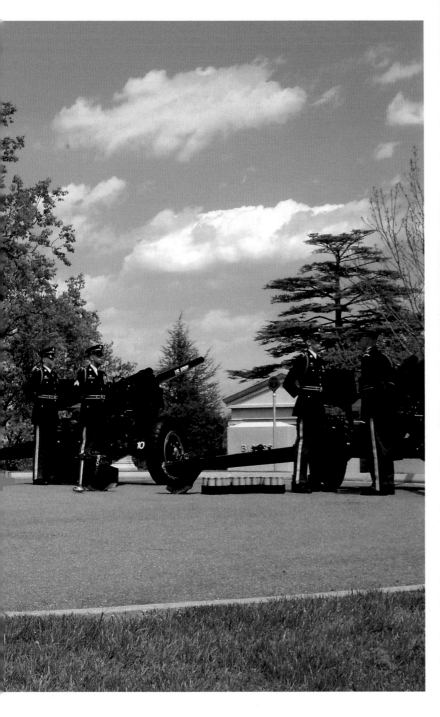
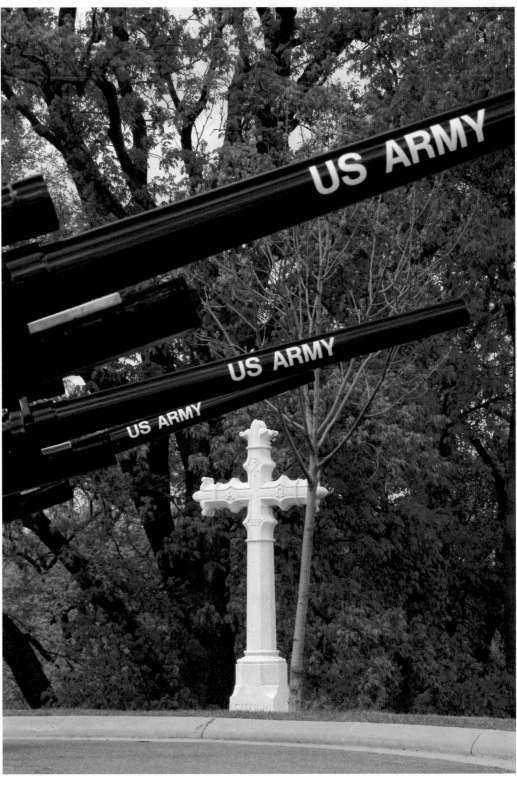

Three monuments to chaplains stand on Chaplain's Hill (below).
U.S. Navy Ceremonial Guard is the only military unit that
wears two different uniforms at Arlington.
From April through October they are seen in Summer Whites
for their ceremonies (right).

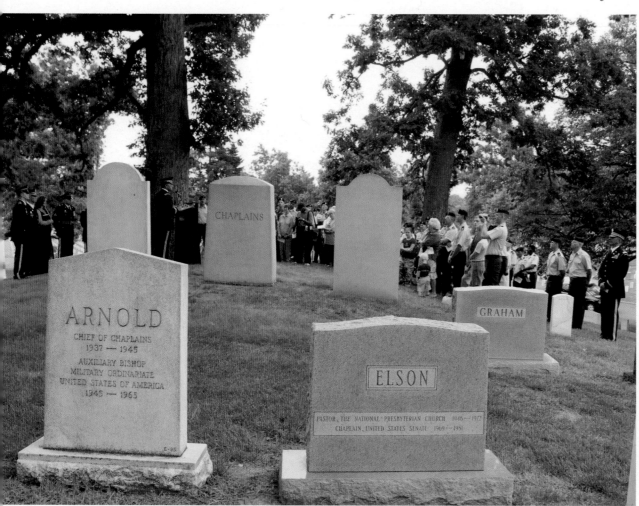

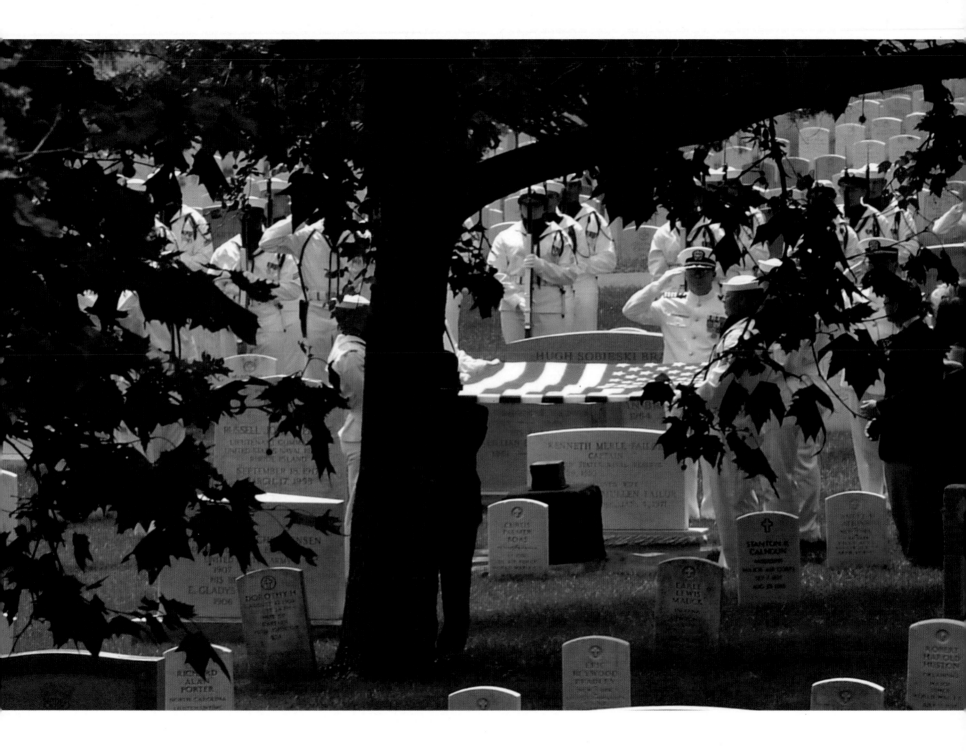

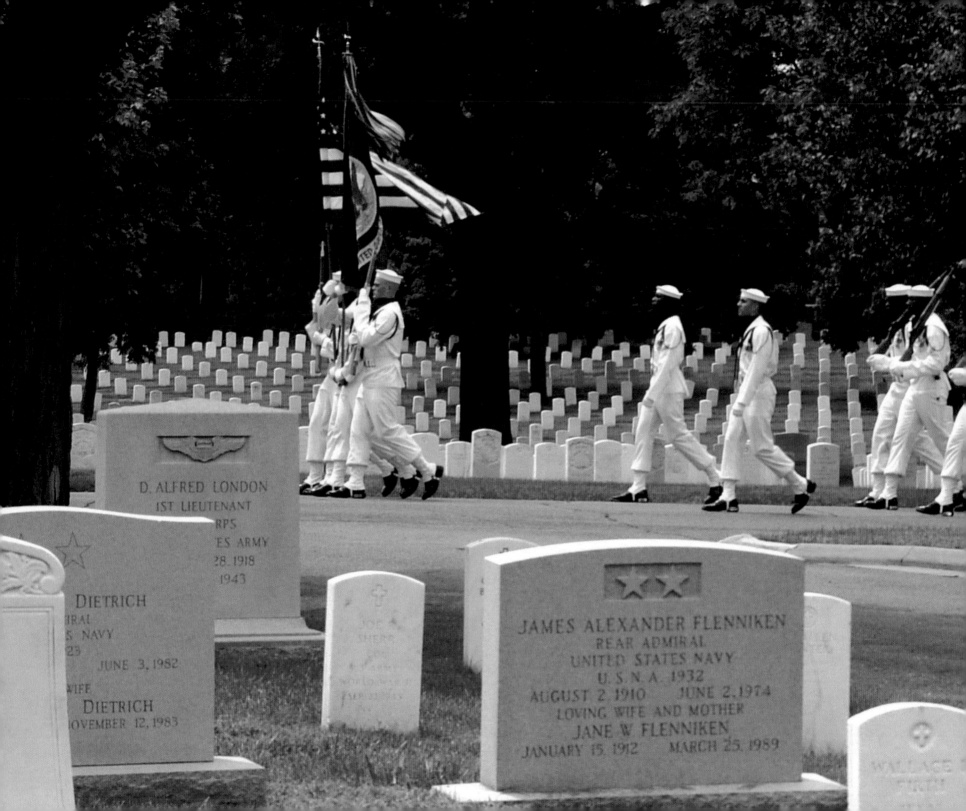

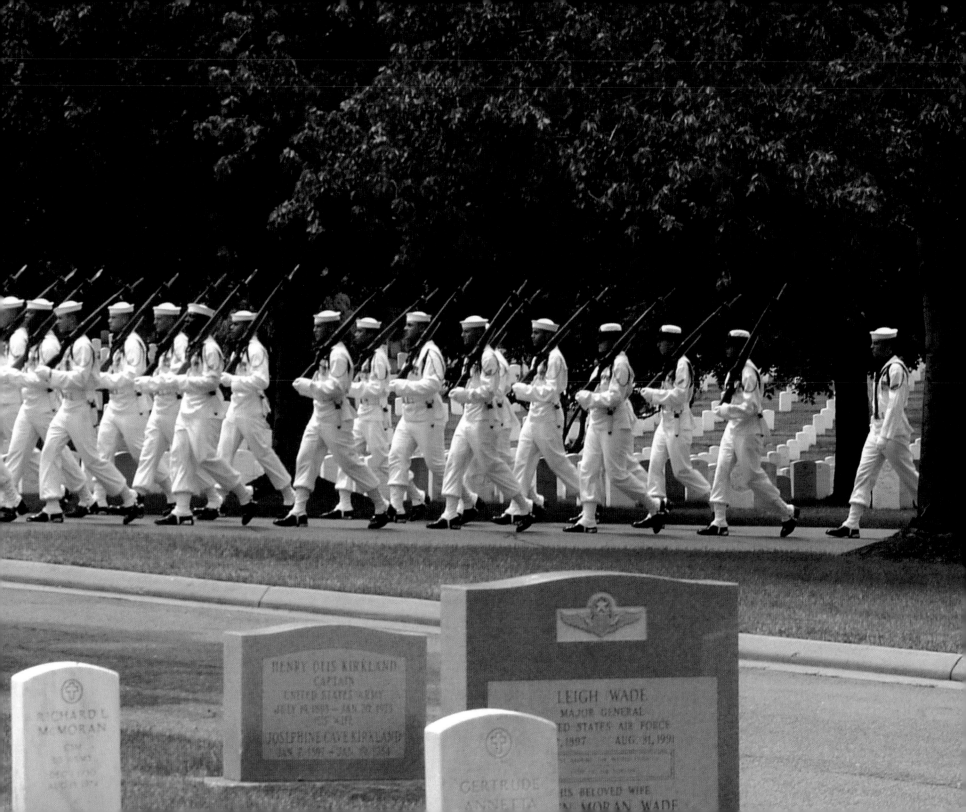

Unit Memorials

Ask any veteran what unit he or she was in and they will easily remember. Units are identities that help servicemembers bond and give them confidence, especially far from home or on a battlefield. Arlington National Cemetery is filled with memorials to military units.

One such memorial is for the Buffalo Soldiers, the African-American cavalrymen who served their country in a segregated Army and fought Indians in the West and Spanish troops in Cuba during the Spanish-American War. A simple bronze plaque on a square of stone remembers their deeds. A lone statue of a woman in a nurse's uniform pays respect to all women who took care of the sick and wounded, from the Spanish-American War to the present. Originally dedicated in 1938 to represent Army and Navy nurses, the eight-and-a-half-foot marble statue was rededicated in 1970 to include all nurses, including Air Force nurses. A dark-grey granite stone remembers the 1st Volunteer Cavalry—better known as Teddy Roosevelt's "Rough Riders," who stormed San Juan Hill in Cuba, pushing Spanish troops from its crest.

World War II saw the creation of special units that could never have been imagined in previous wars. Seabees, Navy soldiers who rapidly built airstrips on the tiny islands of the Pacific, are remembered by a statue of a Seabee making friends with a child. Underneath the statue are the words "With Compassion for Others We Build—We Fight for Peace and Freedom." The concept of soldiers jumping from the sky was the stuff of Jules Verne at the turn of the century but a reality forty years later. A bronze eagle in flight atop a grey granite base salutes the 101st Airborne Division—the "Screaming Eagles"—who fought in World War II, Vietnam, and both wars against Iraq. Another bird, this one a seagull, represents the steadfastness of the Coast Guard, flying over the Guard's motto of *Semper Paratus* (Always Prepared).

There are more than fifty living memorials to military units, everything from Army divisions to Navy ship crews and Air Force aviation units and beyond. For each memorial a tree is planted for remembrance so visitors to the Cemetery can learn about the small and large units that have kept the country safe. ❧

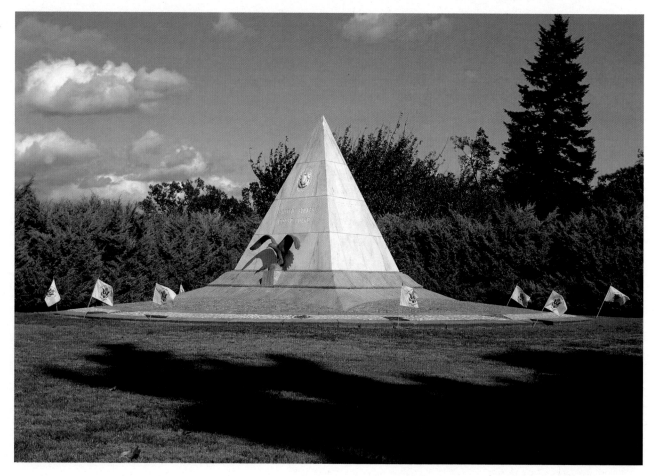

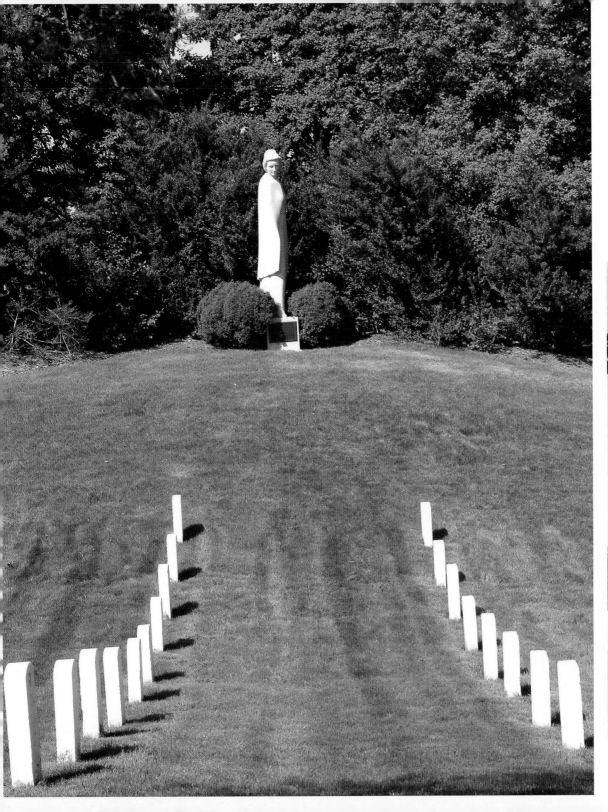

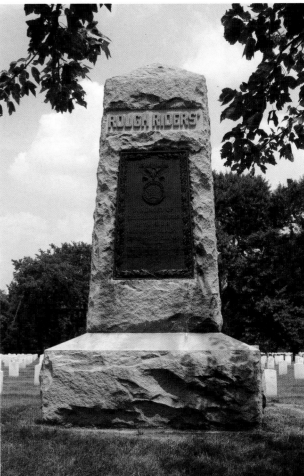

The Screaming Eagles memorial (far left), a memorial to nurses of all military branches (left), and a rough-hewn monument to the Rough Riders (below).

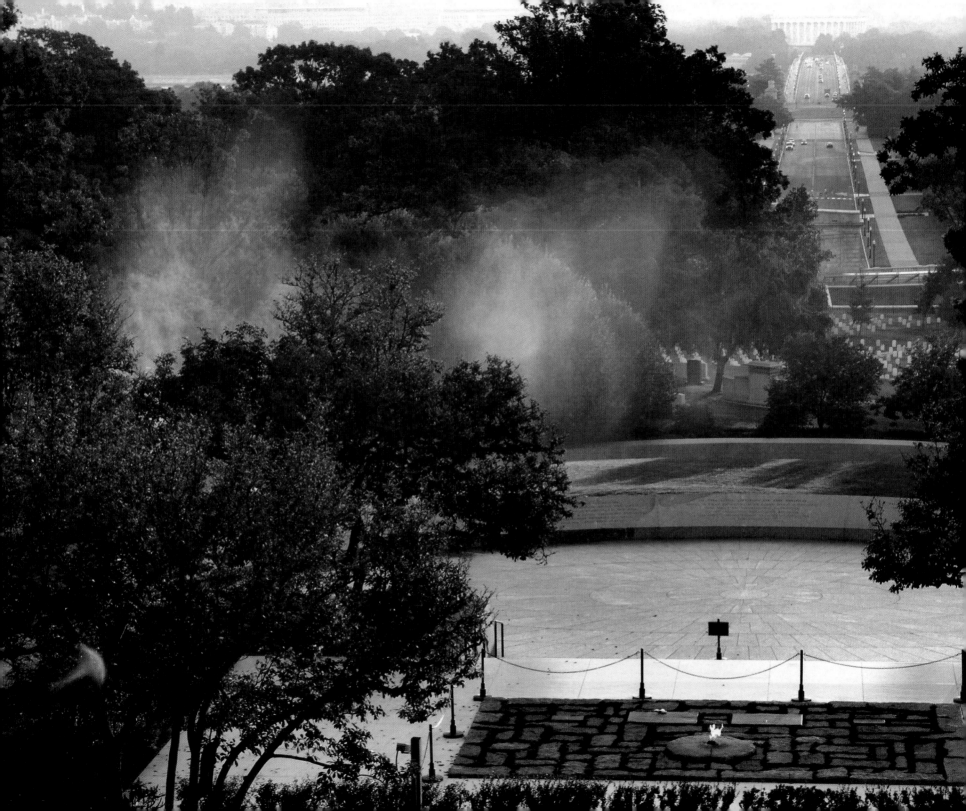

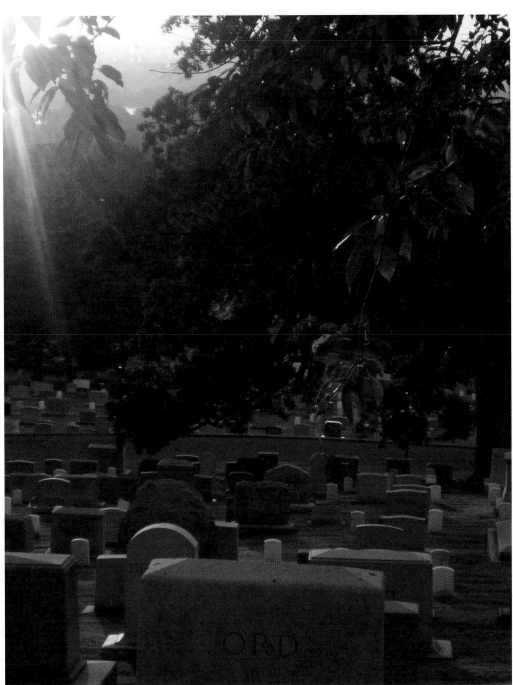

Early Summer mornings at Arlington House provide a breathtaking view across Memorial Bridge (far left) and the close-by sections (left). Pierre L'Enfant's grave sits on a slope in front of Arlington House overlooking the city he was charged with designing by President George Washington (below).

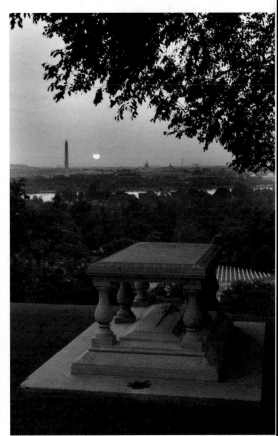

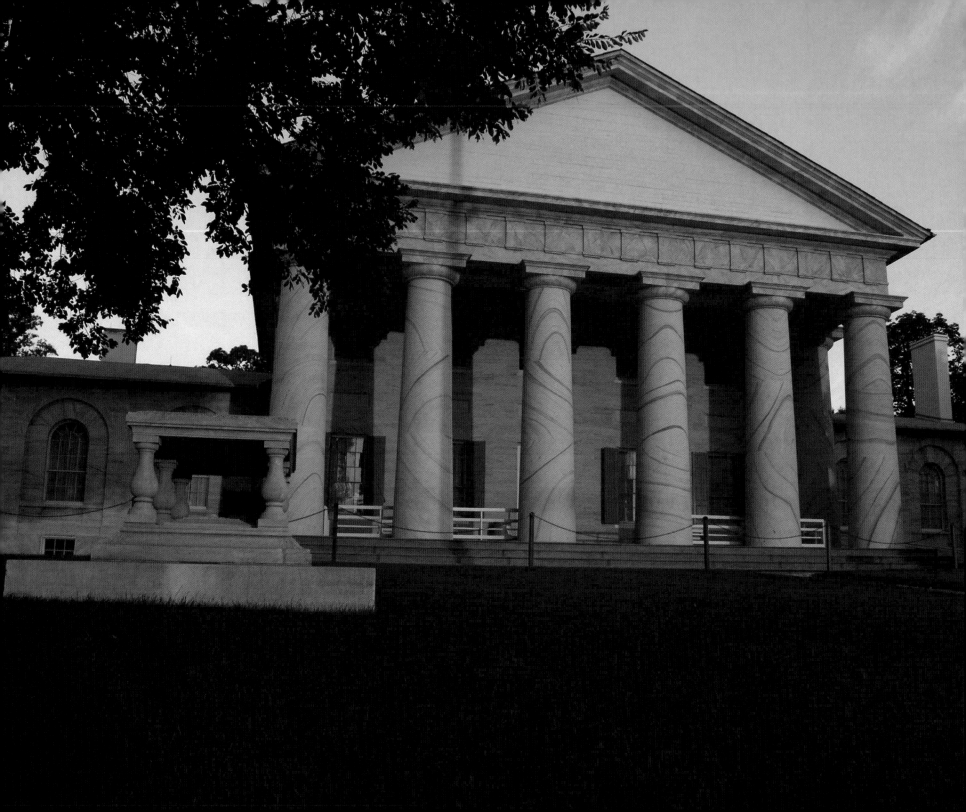

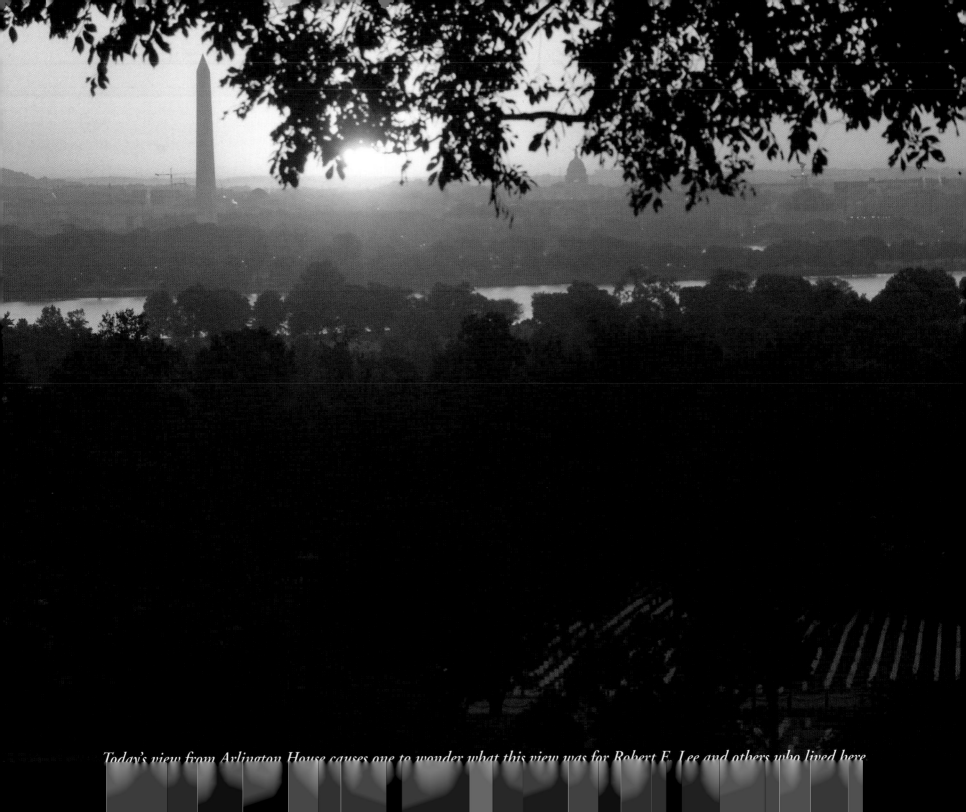

Today's view from Arlington House causes one to wonder what this view was for Robert E. Lee and others who lived here.

Autumn explodes with color at Arlington National Cemetery. Oranges, reds, and pale whites light up the trees and highlight the white marble tombstones. The bright colors of October are soon replaced with the somber clouds of bare November, when mists retard the sunlight and the foliage falls. The crunch of leaves underfoot accentuates the daily rituals.

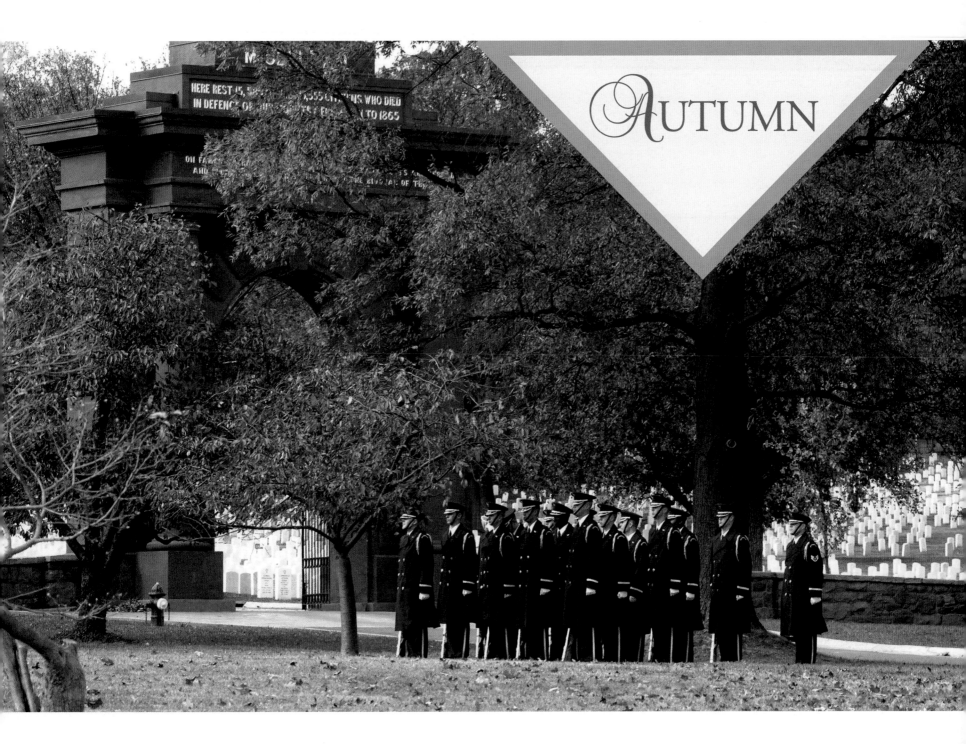

AUTUMN

HERE REST 15,58... ...4,555 CITIZENS WHO DIED
IN DEFENCE OFLTO 1865

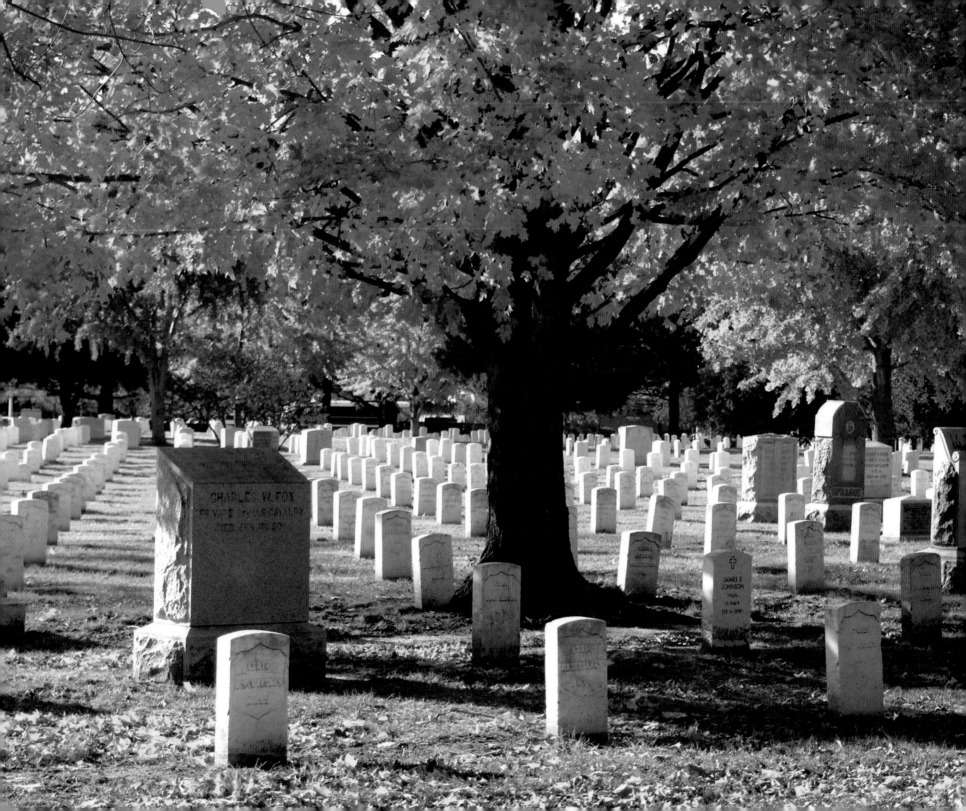

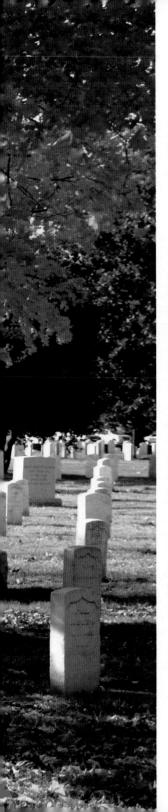

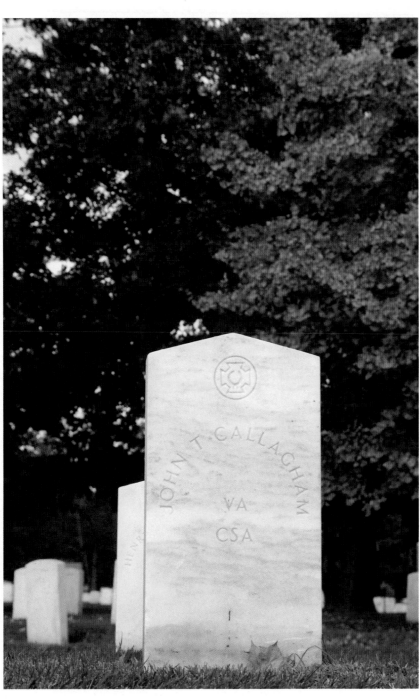

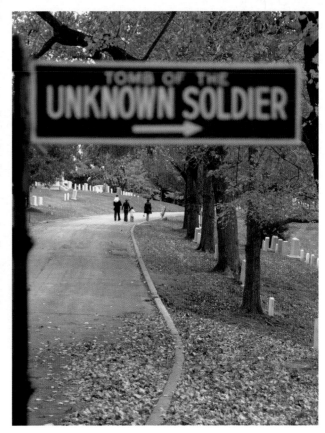

Autumn beauty along McPherson Drive (far left). Confederate graves are easily identified by their pointed headstones in Section 16 (left). A family enjoys a leisurely walk through the Autumn foliage on McClellan Drive (below).

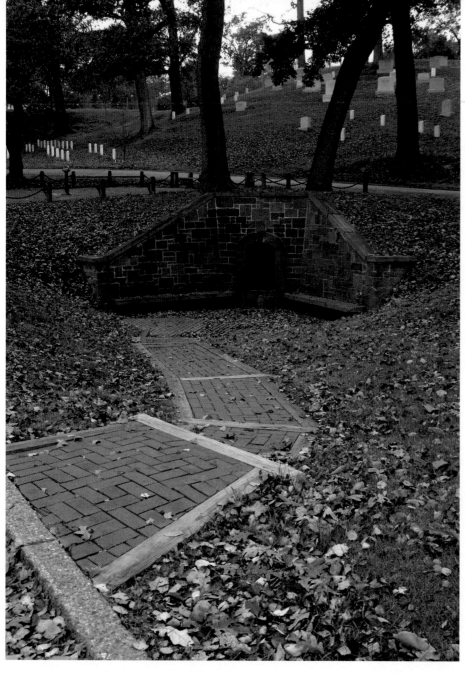

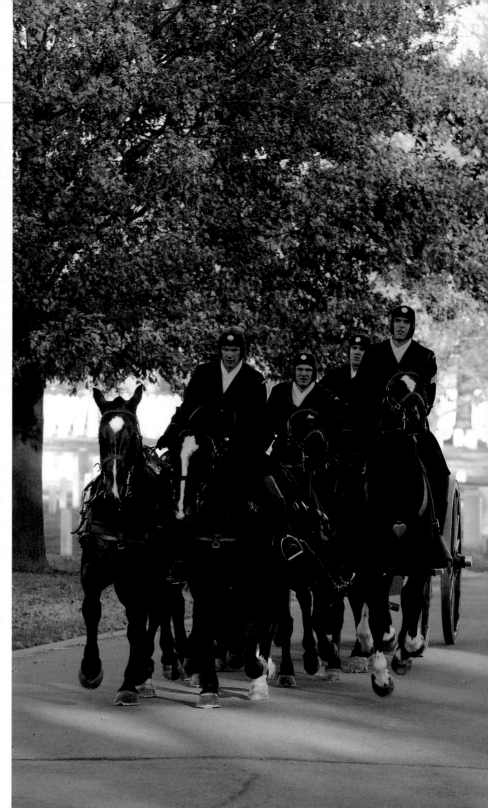

Red Spring, an original spring used by the Custis family for water while living at Arlington House, is found at the end of McClellan Drive (above). Soldiers of the Caisson Platoon return after a long day of ceremonies (right).

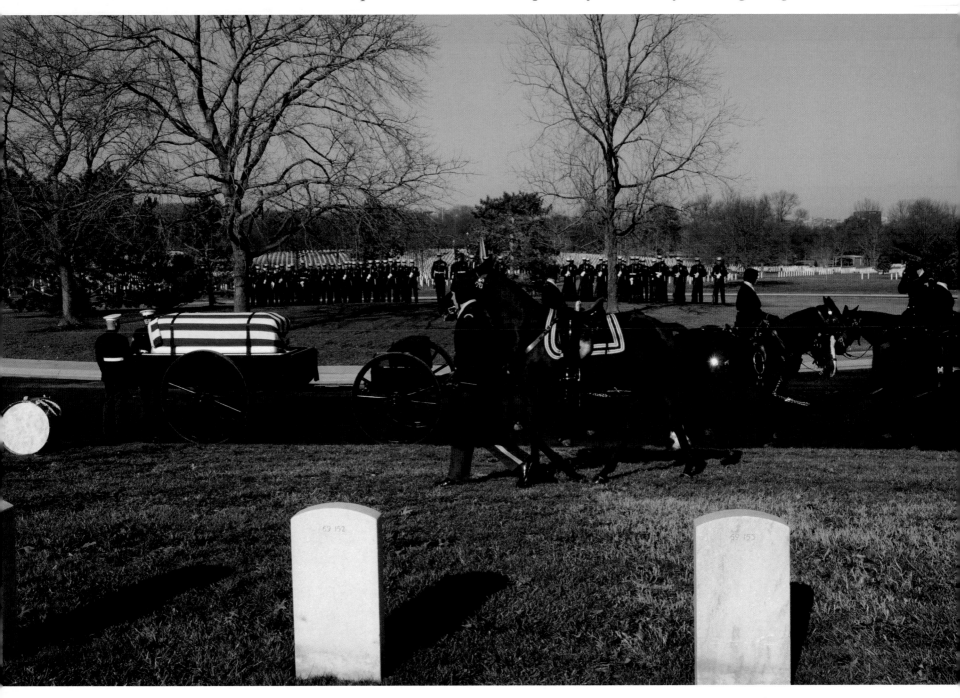

A Caparisoned Horse is led into position for a Marine funeral beginning at Patton Circle.

A Caparisoned Horse trots down McPherson Drive (below). The grave of Walter Reed, one of the well known military medical individuals buried in Section 3 (left center). William Christman, the first soldier buried in Arlington, on May 13, 1864. His headstone can be found in Section 27 (right center). The beauty of the red stone wall separating Jefferson Davis Highway and Section 52 is paled when compared to the Autumn foliage in this view of Arlington (far right).

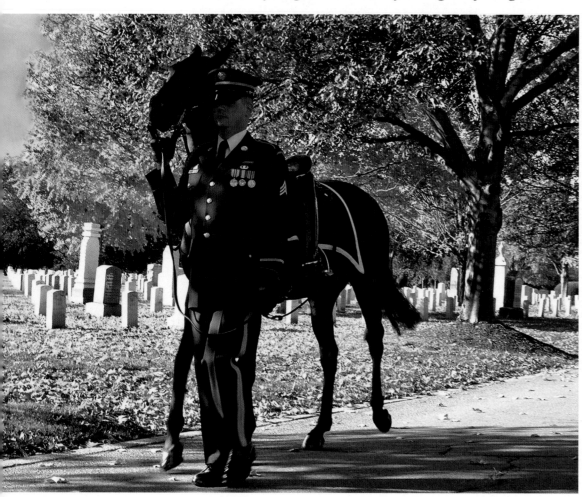

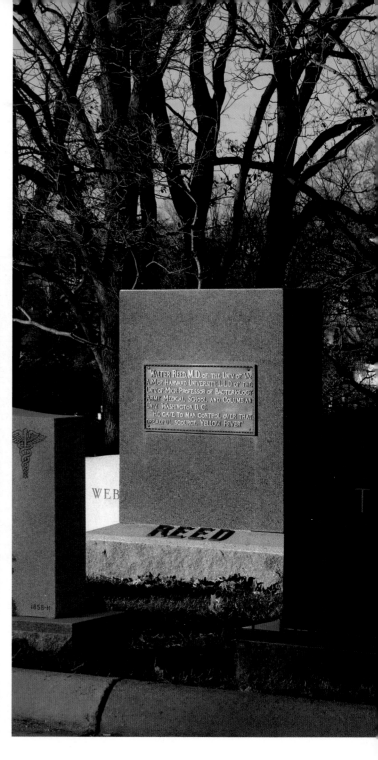

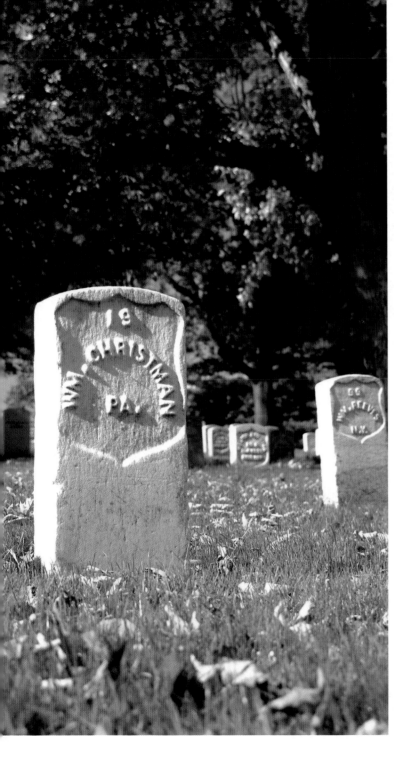

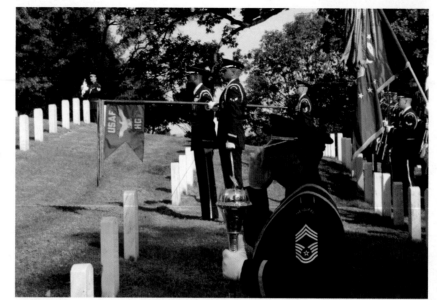

Members of the Air Force Honor Guard lower their colors as the bugler prepare to play "Taps" (right). The Air Force Firing Party has its own unique way of firing the three-round volley at Air Force funerals (below). The Air Force Honor Guard bring a comrade to the final resting place in the Columbarium (far right).

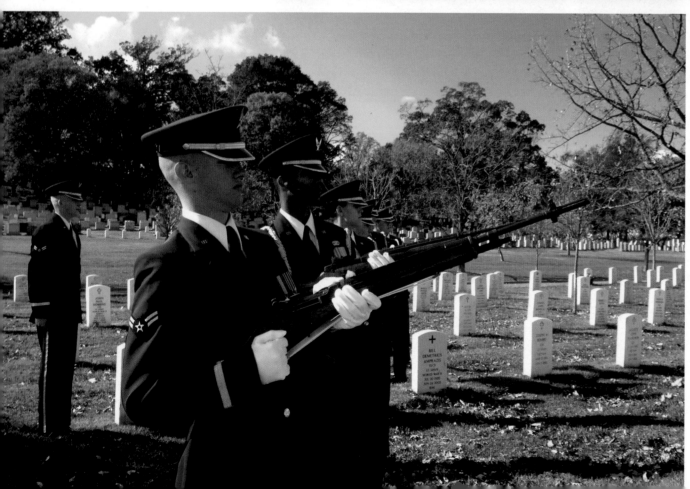

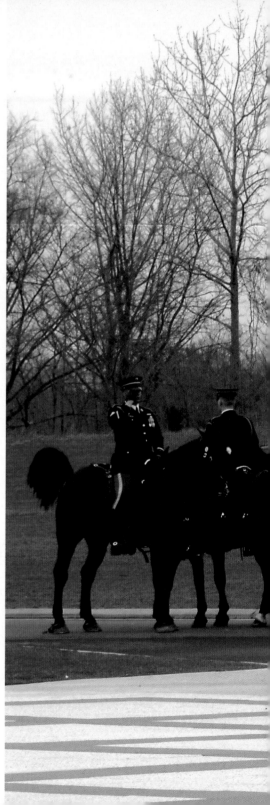

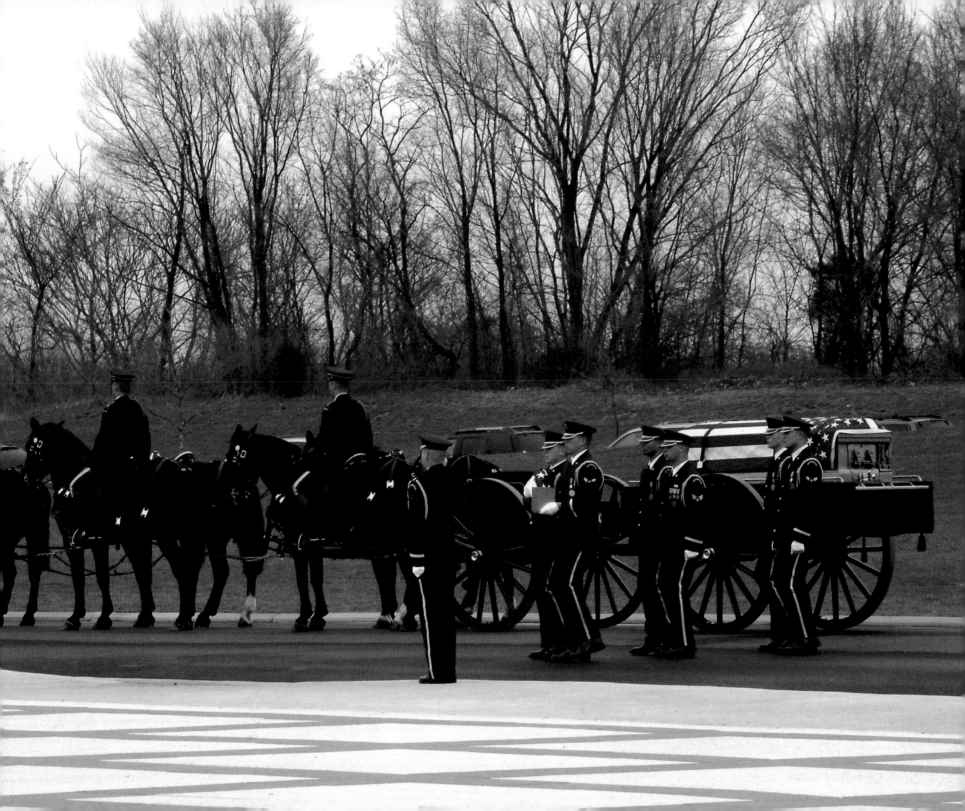

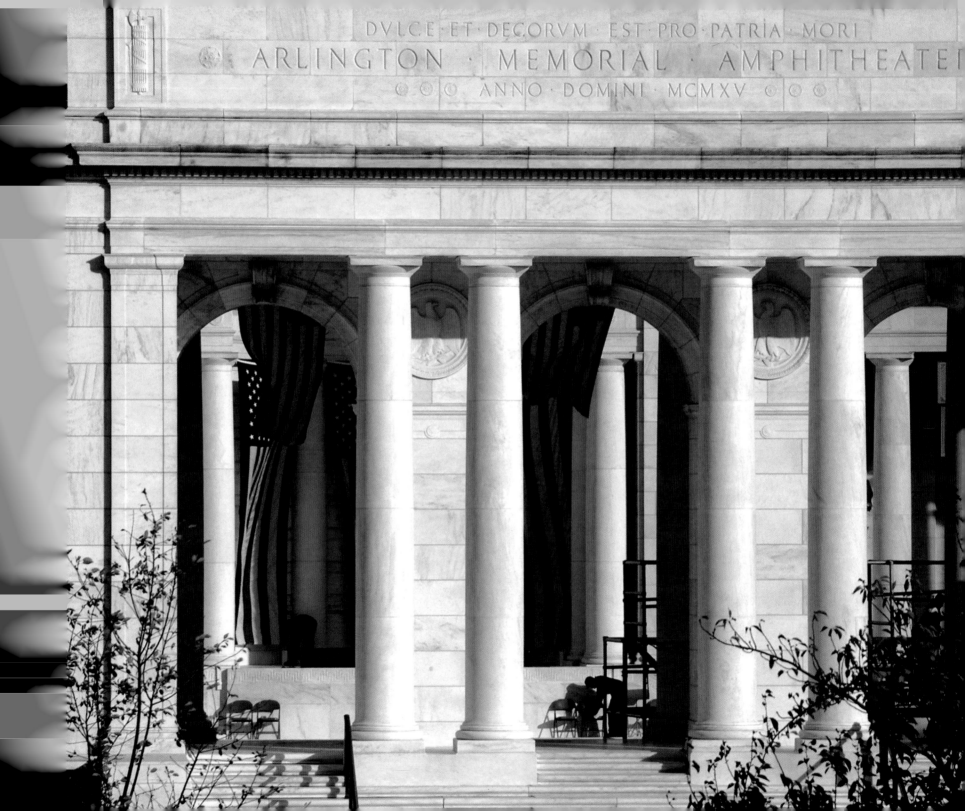

Preparation begins at the Amphitheatre for Veterans Day ceremonies (left).
Removal of the fallen colors in the season is a must in order to keep the grounds of
Arlington in their well-groomed appearance (below).

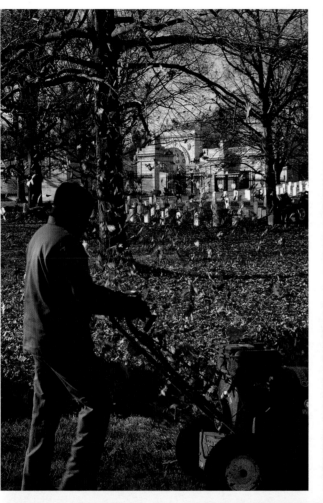

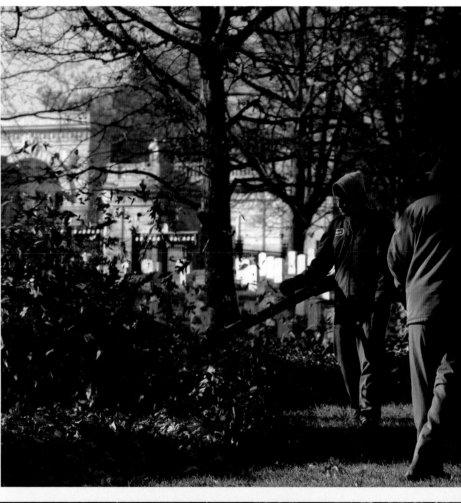

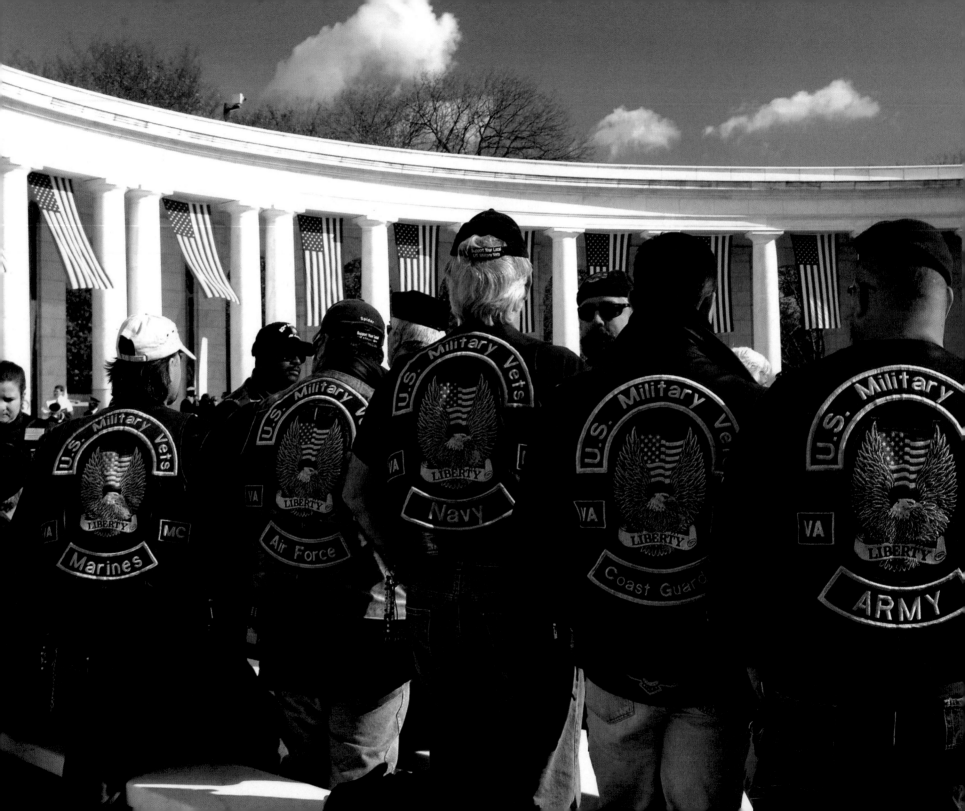

Veteran's Day at Arlington

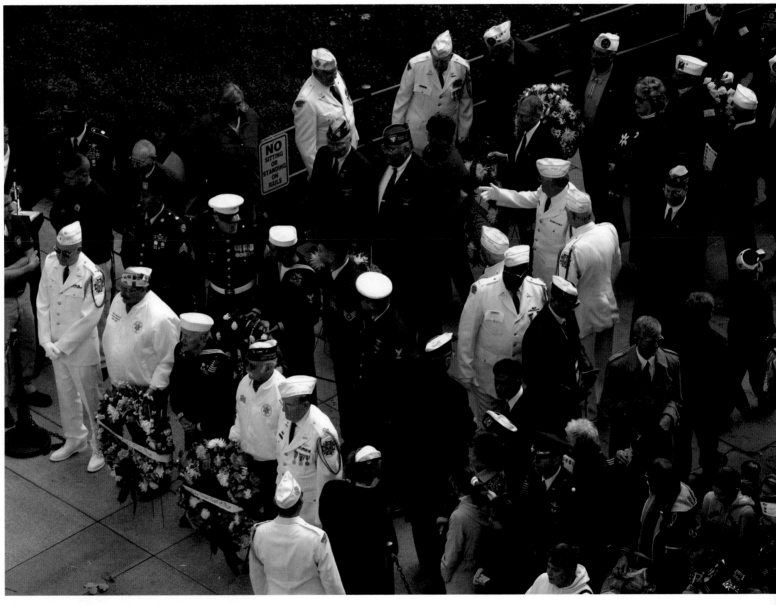

Flagbearers representing the Veterans Service Organizations mark the beginning and end of the Veterans Day ceremony in the Amphitheatre with the Parade of Flags. Veterans gather from across the country to attend these ceremonies.

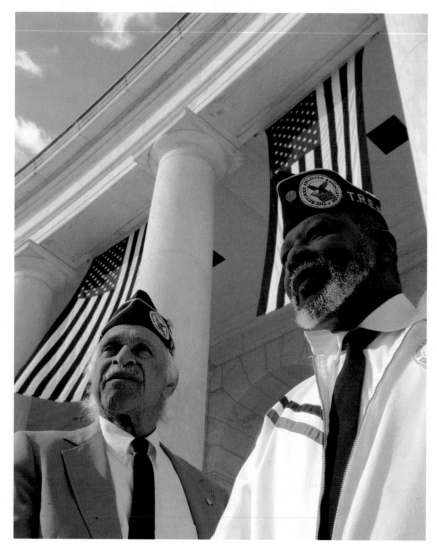

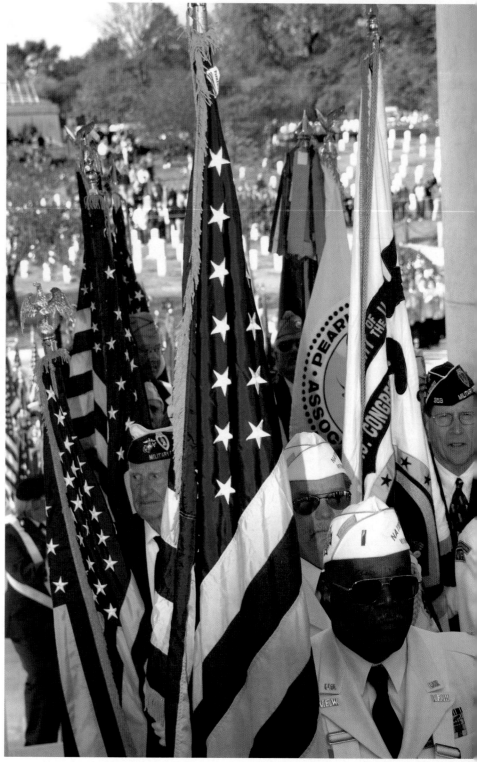

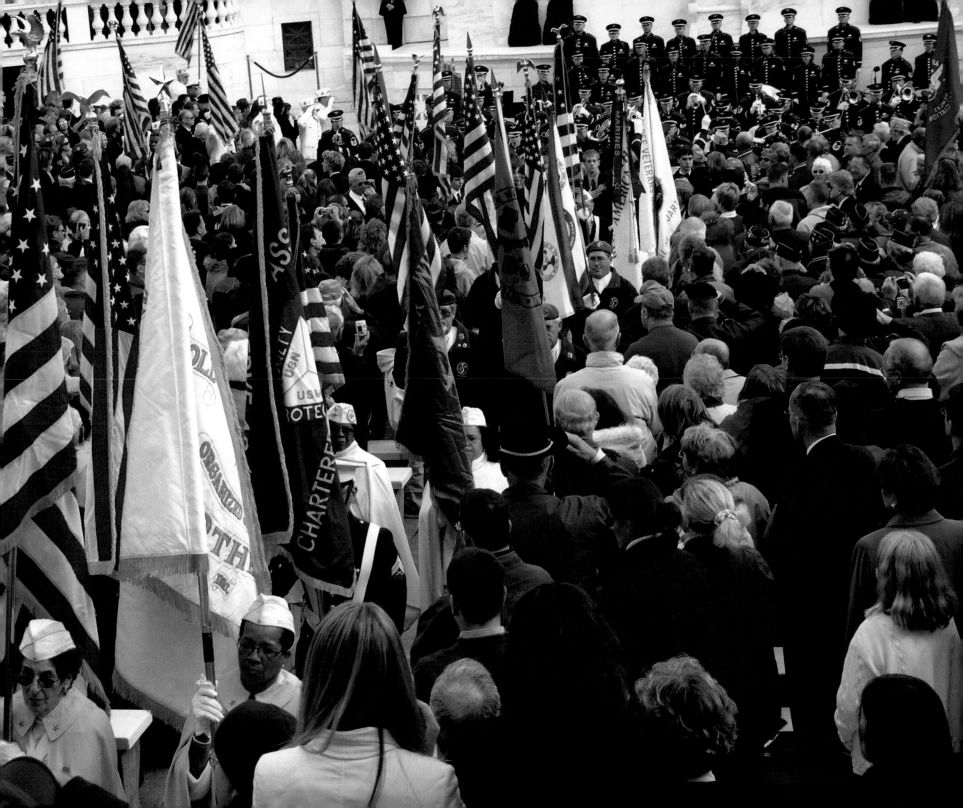

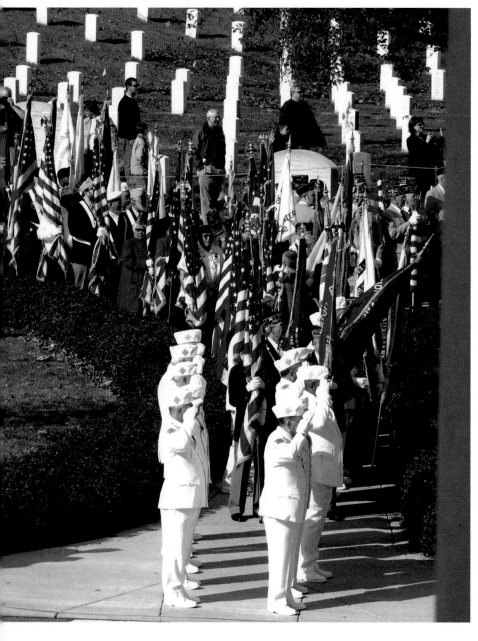

Members of the Veterans of Foreign Wars prepare to leads the Parade of Flags into the Amphitheatre (below). Approximately thirty-six veterans and grass roots organizations, officially called Veteran Service Organizations, lay wreaths at the Tomb of the Unknown each Veterans Day and take part in other official duties around Arlington (right).

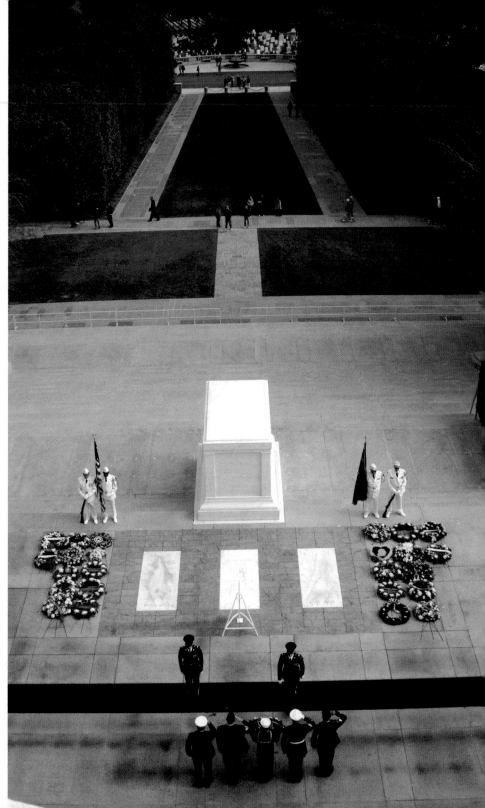

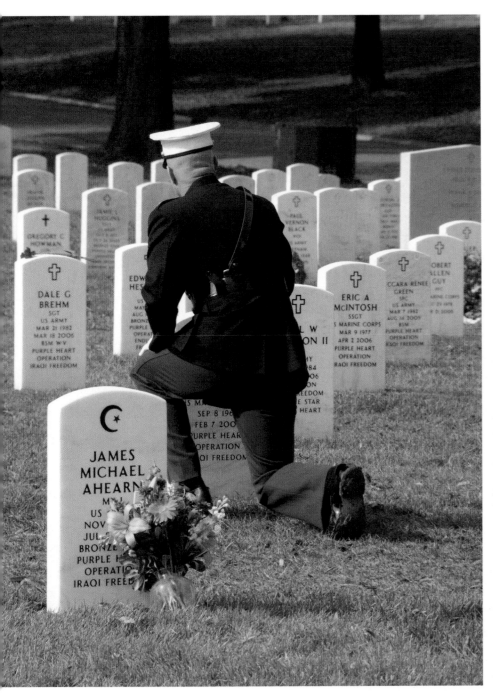

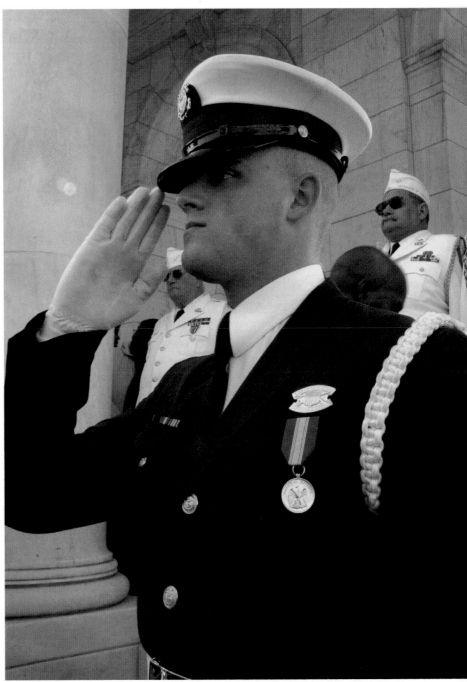

Many active-duty servicemen and -women come to Arlington to pay their respects at organized events and as they walk the hallowed grounds. This is especially evident on holidays like Veterans Day.

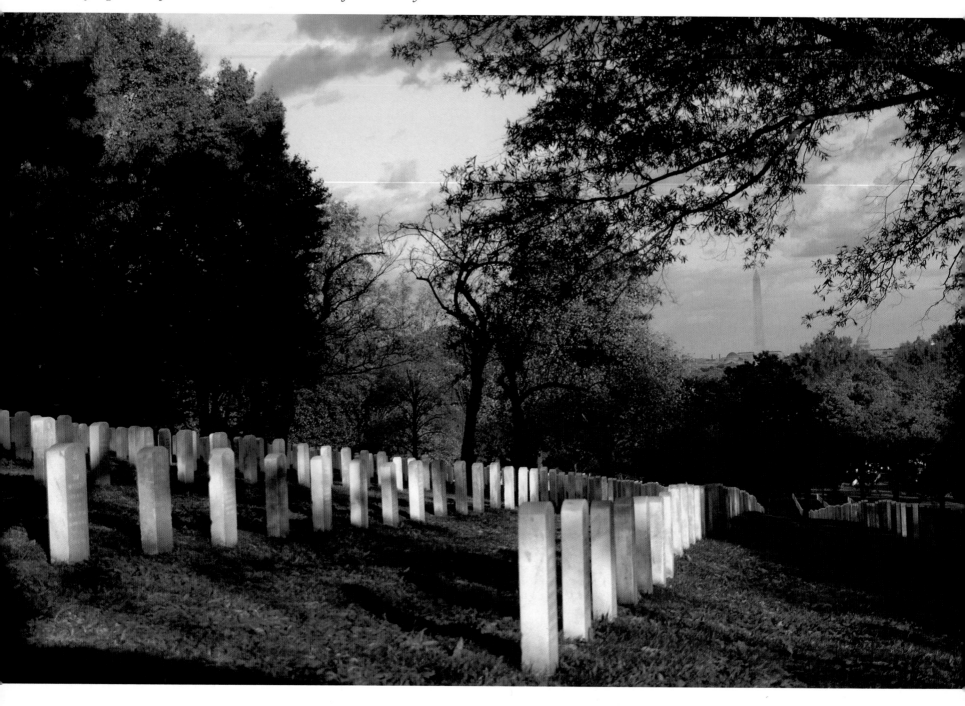

The Washington Monument and Capitol Building are beautifully framed in this colorful palette of Autumn colors in the late afternoon sky.

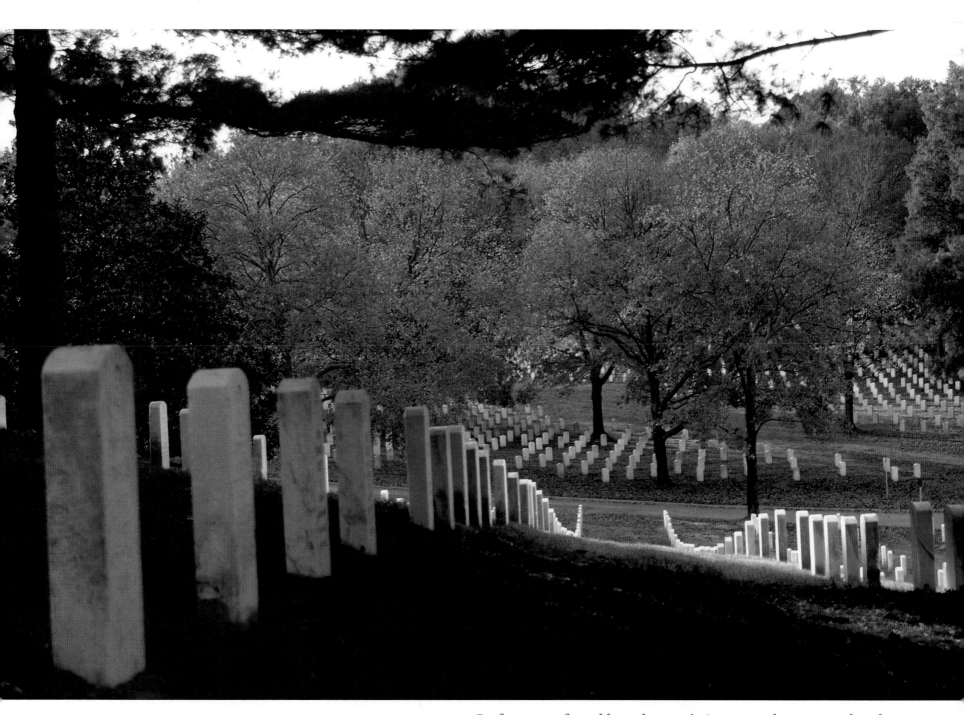

Perfect rows of marble and nature's Autumn colors are in abundance across Sections 38 and 43.

Wars

Carl Von Clausewitz defined war as an extension of politics, but to the people of the United States, wars mean sacrifice both abroad and at home. Those sacrifices are remembered all over Arlington National Cemetery.

The United States fought the Spanish-American War to stop Spain's harsh rule of Cuba and to avenge the deaths from the destruction of the USS *Maine* in Havana harbor. To honor the war's veterans, a Corinthian column of Barre granite, topped with an bronze eagle on a globe, stands over fifty feet tall on the Cemetery grounds. The memorial was dedicated by President Theodore Roosevelt, the war's most famous veteran. Another memorial, "The Hiker," remembers the veterans of the Spanish-American War as well as the Philippine-American War of 1899. It consists of a solitary soldier from the turn of the century holding a rifle. A bronze cross at the base of the statue bears the names of Cuba, Puerto Rico, the United States, and the Philippine Islands, the major theaters of the war.

World War I was supposed to be the war to end all wars. The stalemated trench warfare that killed so many Europeans seemed endless until the United States entered the war, led by General John J. Pershing. Today, near

Pershing's gravesite, a charcoal-grey stone with an American "Doughboy" helmet engraved on it remembers the 116,516 Americans who gave their lives for peace. Another memorial salutes those Americans who fought in the war before the United States officially entered. A twenty-foot grey granite cross bearing a bronze sword commemorates the large number of Americans who fought with the Canadian forces during the war.

When North Korea invaded South Korea on June 25, 1950, the United Nations, spearheaded by the American forces, pushed out the invaders. The war lasted until July 27, 1953, when an armistice was signed. A simple granite bench in Arlington remembers the 54,246 killed, 8,177 missing, and 389 unaccounted-for prisoners of war.

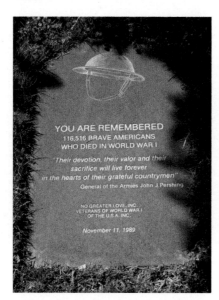

When Iraqi forces invaded Kuwait on August 2, 1990, the United States and her coalition allies routed the Iraqis in a lightning-quick attack that lasted only four days. On May 7, 1996, former President George H.W. Bush dedicated a grove and a pink granite stone with a tribute to everyone who served in the Persian Gulf War.

While there are monuments all over Washington, D.C., and the country commemorating America's wars, the monuments in Arlington National Cemetery, with its secluded quiet places, offer a profound remembrance of America's past and the sacrifices of its citizens. ⊗

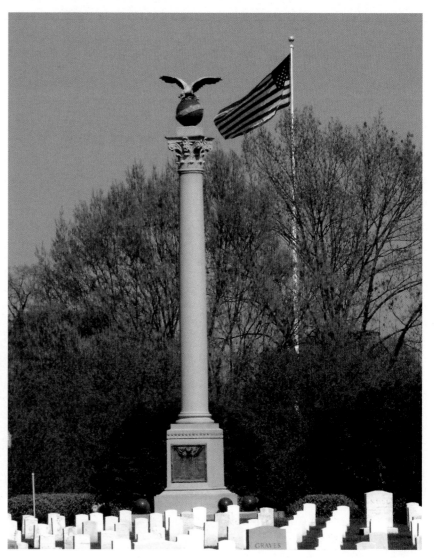

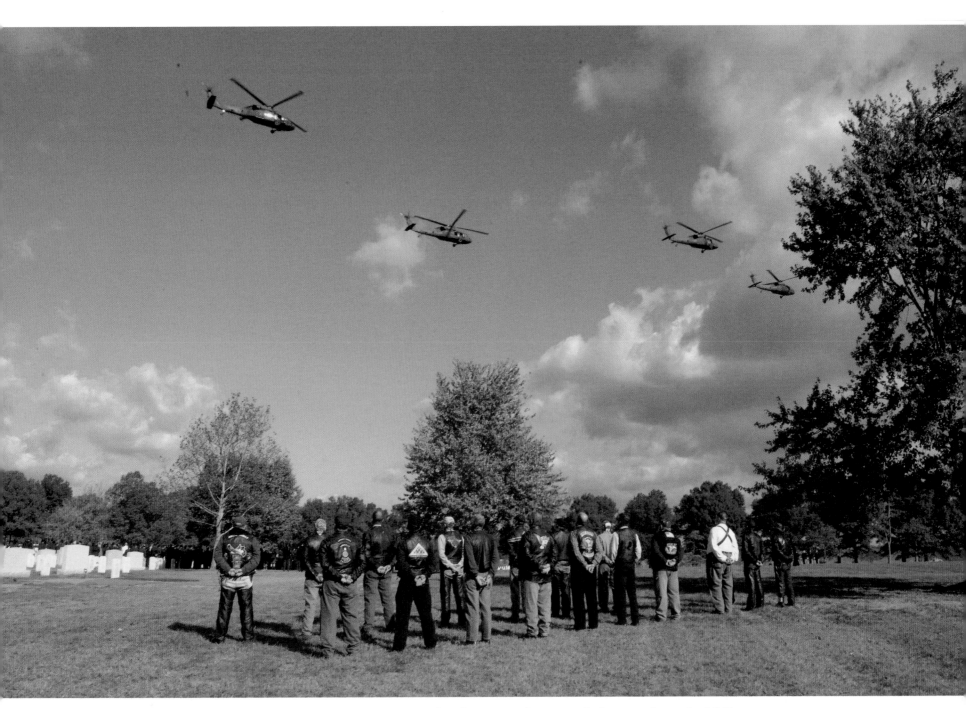

Veterans from several different service organizations stand in honor as they attend the mass burial of fallen comrades from a National Guard helicopter downed in combat.

*A salute of respect for a fallen soldier
is given at the Ten Star intersections (below).
The white marble rows and Autumn colors
reflect crisply in the windows of the Old Guard's bus (right).
Individuality, dignity, and respect is given to each person
buried in a group at Arlington. This is represented and conveyed
through the service, and visually as the flag presenters each take a
different route away from the graves after they present
the flag to the family (far right).*

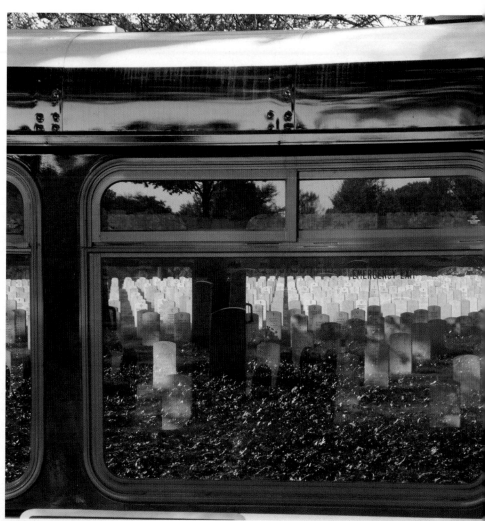

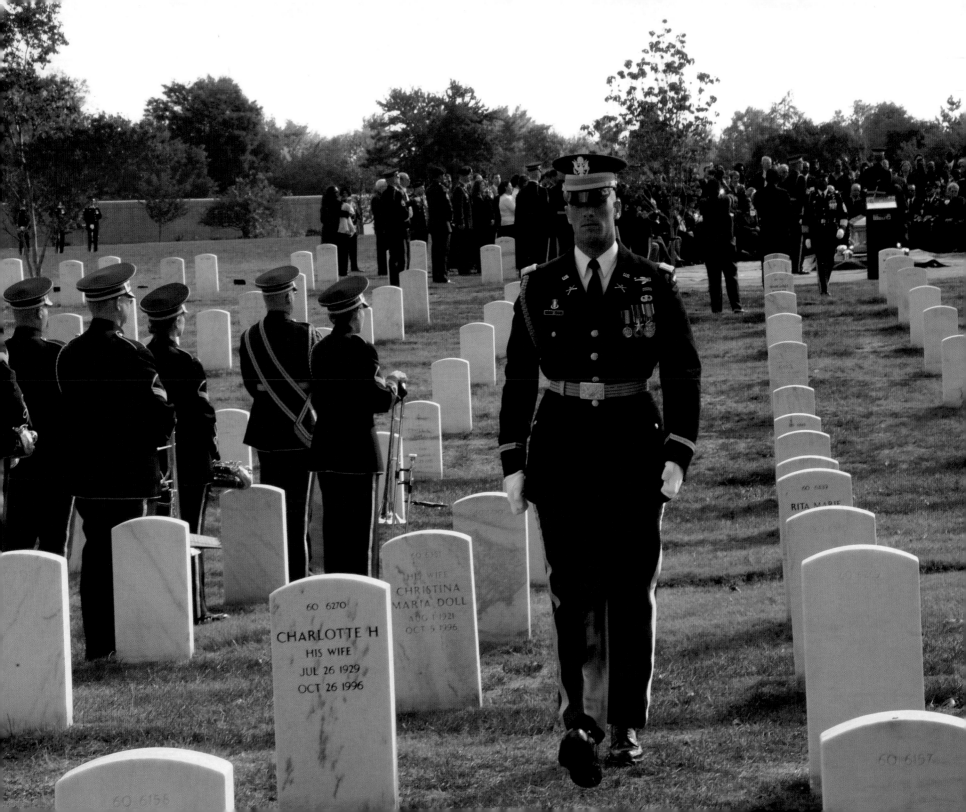

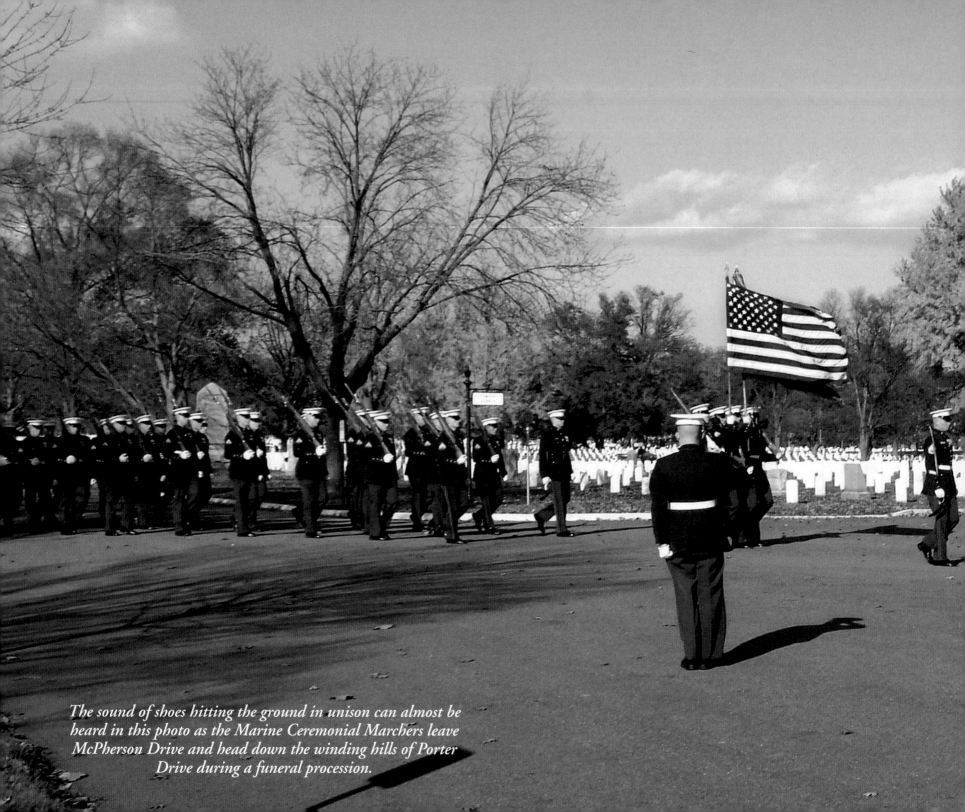

The sound of shoes hitting the ground in unison can almost be heard in this photo as the Marine Ceremonial Marchers leave McPherson Drive and head down the winding hills of Porter Drive during a funeral procession.

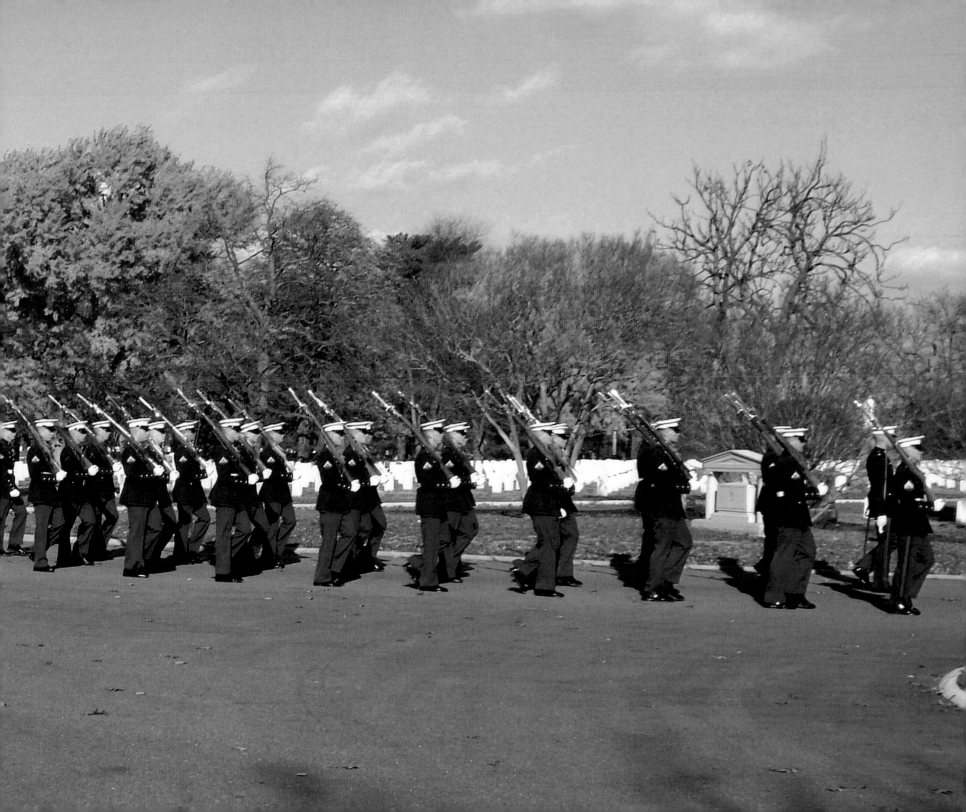

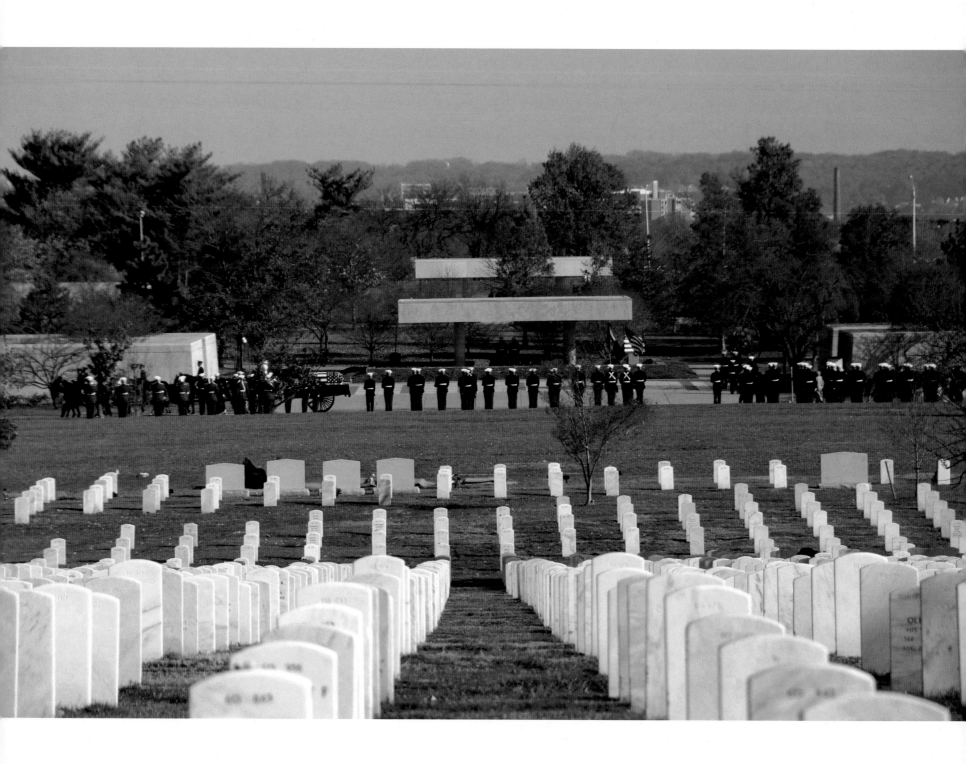

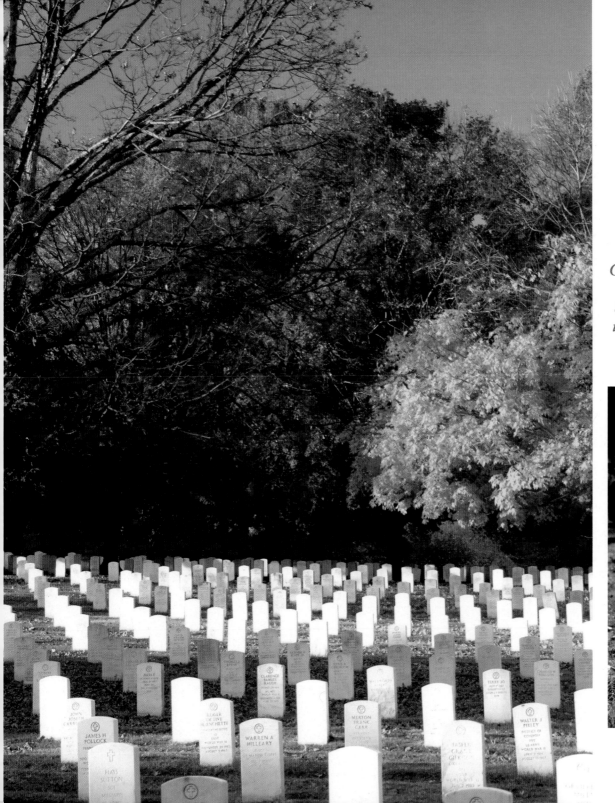

The Marine band, Caissons, Ceremonial Marchers, Color Guard, Firing Party, and Body Bearers take part in a Full Honors service at the Columbarium (left). Section 43 is draped in the full colors and blue sky on this Autumn day (center). This headstone of one of the many unknown casualties of the Civil War found in Arlington (below).

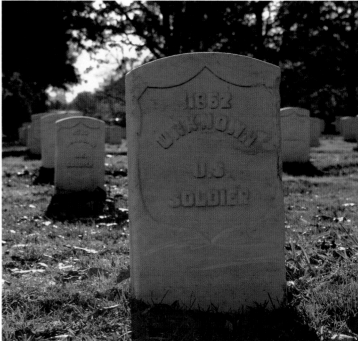

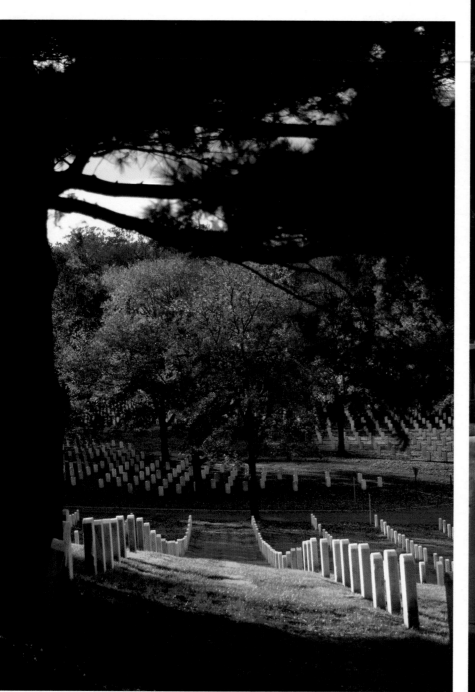
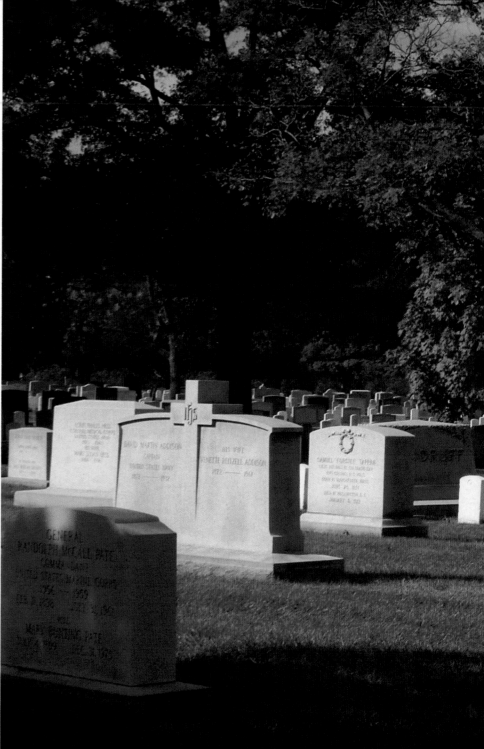

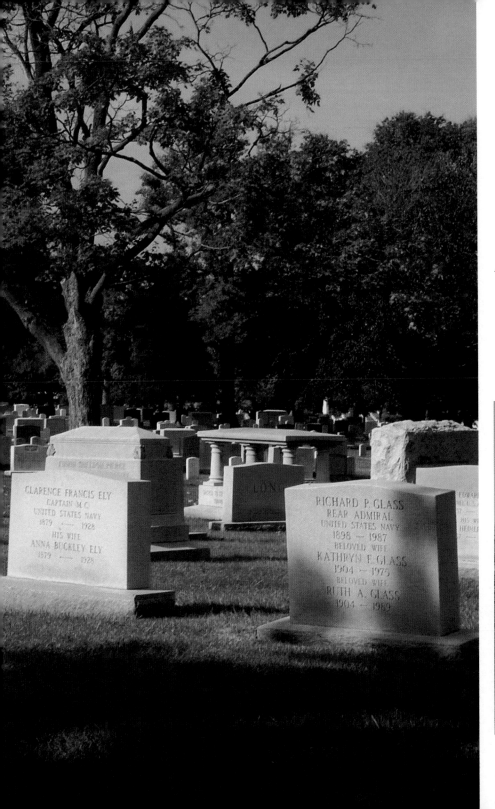

Whether looking down the rolling hills or across the grounds in Arlington, the fresh-cut grass and white marble headstones make the colors of Autumn even more vibrant (left and center). Gathered from the fields of Bull Run and along the route to the Rappahannock, 2,111 soldiers became the first "Unknown Soldiers" buried in Arlington in September 1866. Arlington at the time was only for the Union soldiers, but both Union and Confederates are believed to buried in this Monument (below).

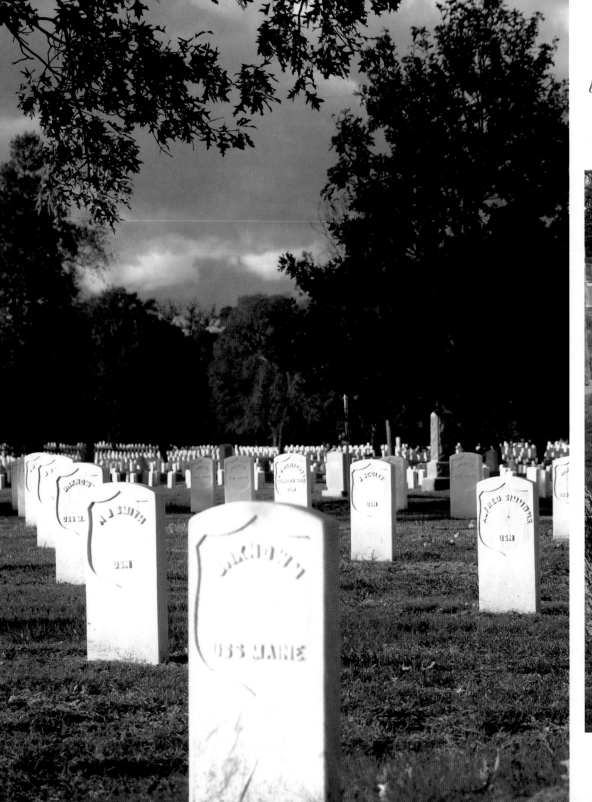

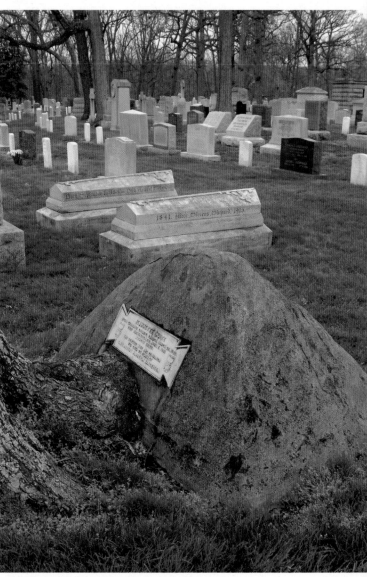

One of the 167 unknown sailors and Marines buried in Section 24 (left). All are from the sinking of the USS Maine in Havana Harbor on February 15, 1898. Some of the unusual grave markers found in Section 1 (below).

Grave markers of any design were originally allowed in Arlington (below). Once an individual is buried at Arlington, they are not moved, even if a tree grows too close to the grave. Here a tree wraps around this headstone as if to protect the grave site (right).

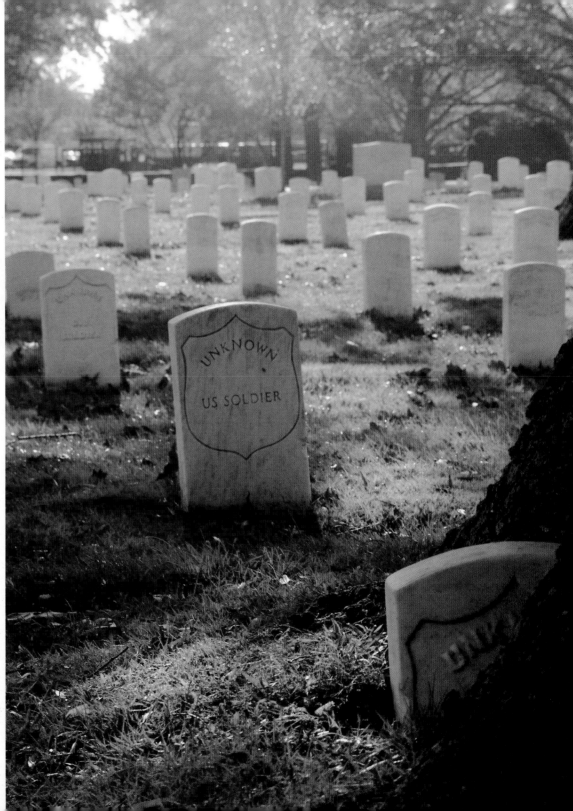

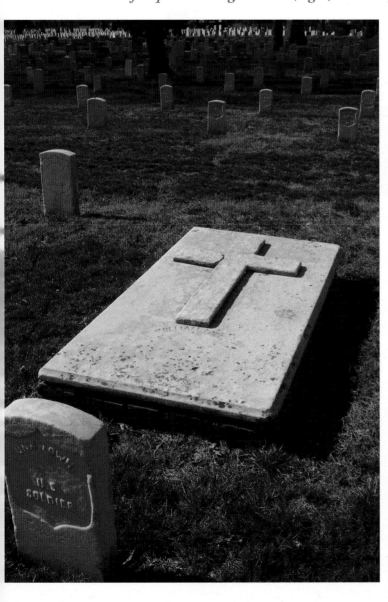

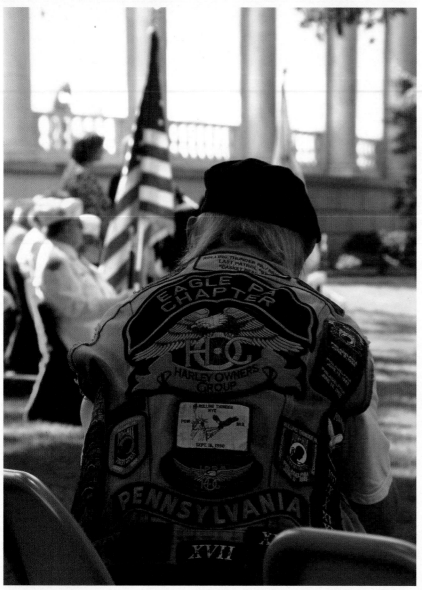

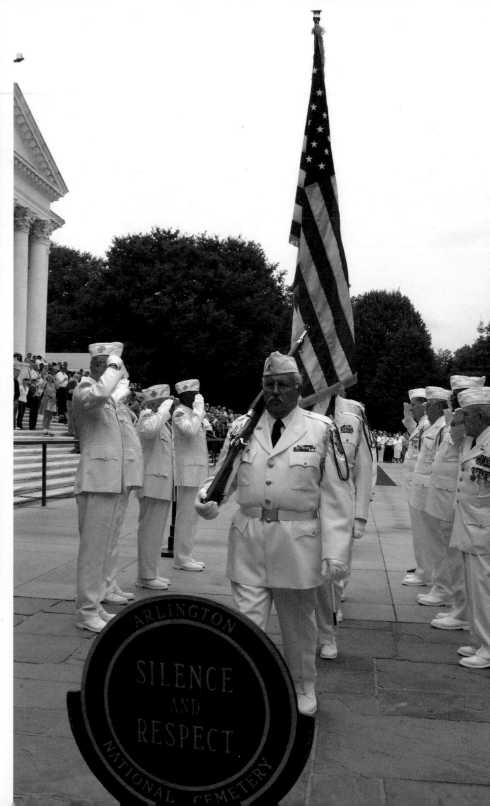

"Stretch," as his friends call him (above), attends the Annual Gold Star Mothers Ceremony each year and travels down with a organization he helped form called Friends of the Forgotten, from Pennsylvania. Members of the Veterans of Foreign Wars Honor Guard carry the colors at this wreath-laying ceremony for the Gold Star Mothers, as well as for many other Veteran Service Organization events held at Arlington (right).

Support From the Heartland

Although Arlington National Cemetery provides excellent services for the fallen, there are several grass-roots organizations, officially called Veterans Service Organizations, that help during funerals and other events. They also help keep alive the memory of those who made the ultimate sacrifice. Among these groups are the Arlington Ladies, Gold Star Mothers, Gold Star Wives, and the Friends of the Forgotten.

No soldier is buried alone. This simple motto guides the Arlington Ladies in their duty of attending funerals for any servicemember buried at Arlington National Cemetery. Begun in 1948 by the U.S. Air Force, today the Army, Navy, and Air Force all have Arlington Ladies. The Marine Corps sends a representative from the commandant to every Marine funeral. The Arlington Ladies are all volunteers who work one day a month and must be married to a servicemember. Sometimes they are the sole mourners at the grave, such as when a veteran's family cannot attend. Escorted by a member of a service Honor Guard, they stand behind the chaplain during the eulogy, put hand on heart during the ceremony, and hold a widow's hand if needed.

Despite attending so many funerals, many of the Arlington Ladies still leave the ceremonies misty-eyed.

Gold Star Mothers and Gold Star Wives are two groups deeply associated with the Cemetery. Both are groups with a unique membership: They are the mothers and wives of the fallen, given their "gold star" status from the blue-star flags displayed by families whose relatives are in the military. Once any of those serving are killed, the blue star is replaced by a gold star. During our nation's wars gold and blue star banners are often hung in windows to denote sacrifice. The two groups help families with their painful loss. During Gold Star Mothers weekend—the last weekend of September—the mothers and wives of the fallen gather for ceremonies at the Cemetery, including a wreath laying at the Tomb of the Unknowns.

Friends of the Forgotten is a Pennsylvania-based organization whose primary purpose is to remember prisoners of war and soldiers missing in action. At Arlington National Cemetery they show support for Gold Star Mothers at funerals and ceremonies. They also escort them from Pennsylvania to the Washington, D.C., area. ♋

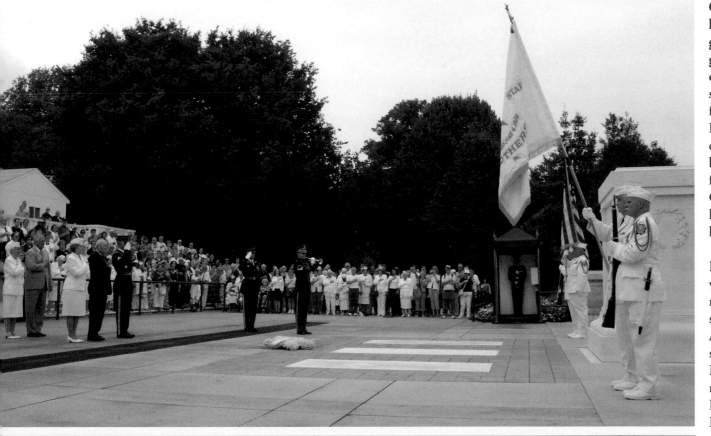

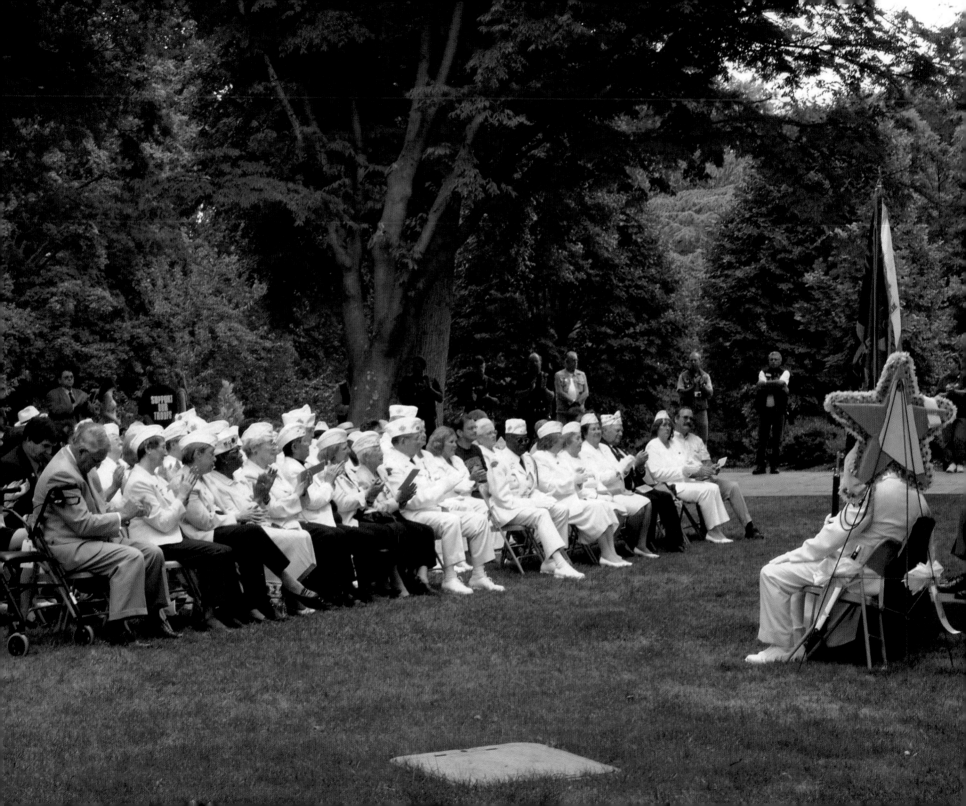

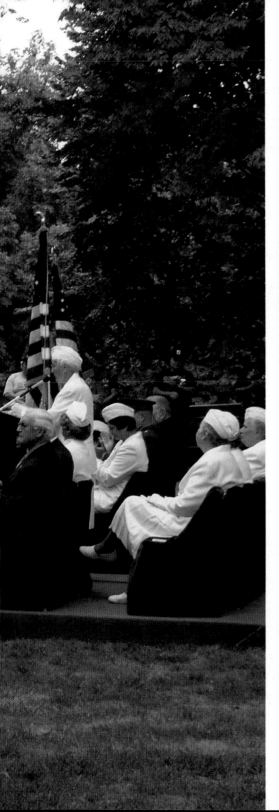

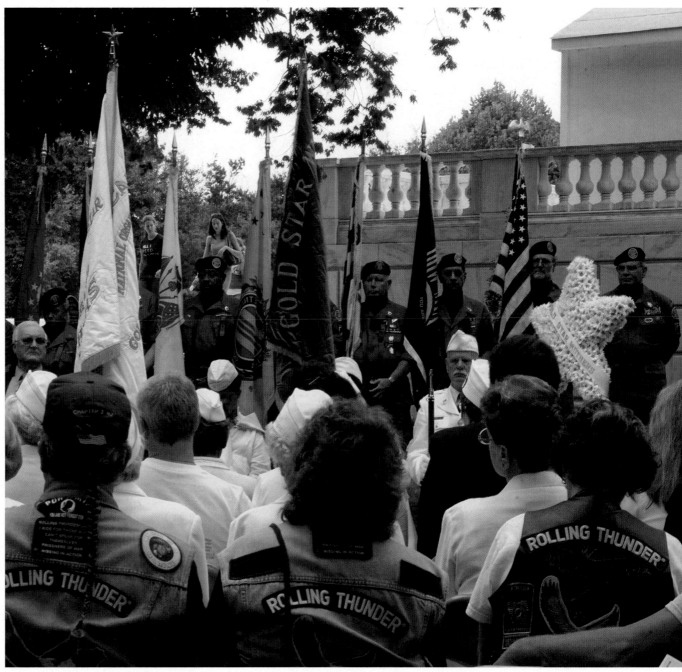

Many people, including veterans groups and other patriotic groups, attend the Gold Star Mothers event held at the end of September each year at Arlington.

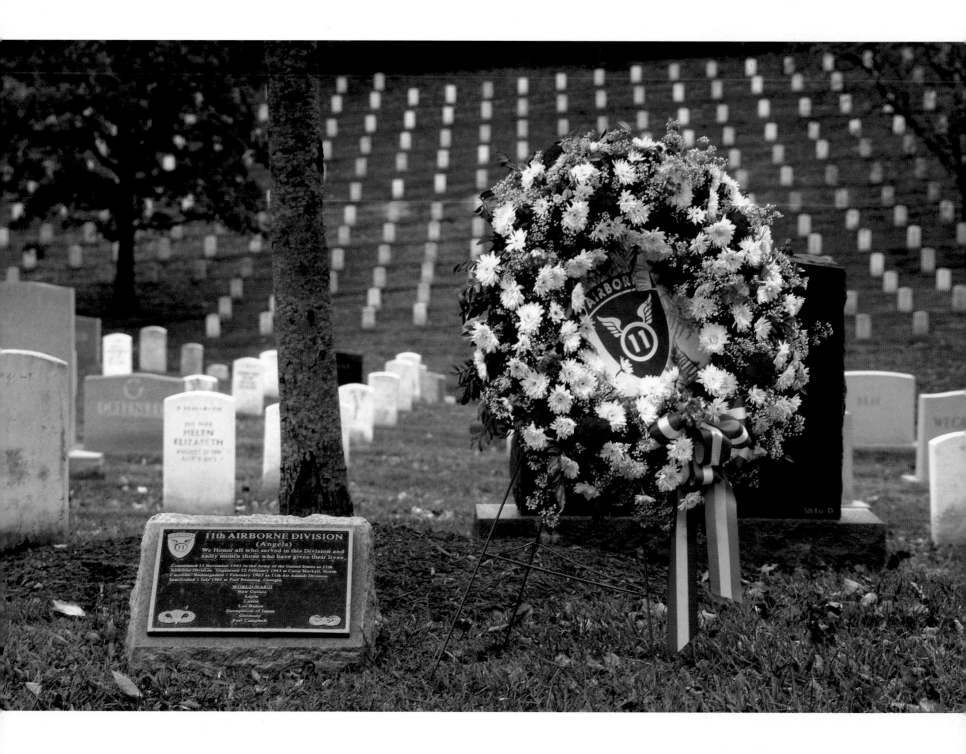

Wreaths can be seen throughout the year in Arlington.
They are placed at memorials and other special locations in Arlington to
mark a special date or event by both individuals and groups.

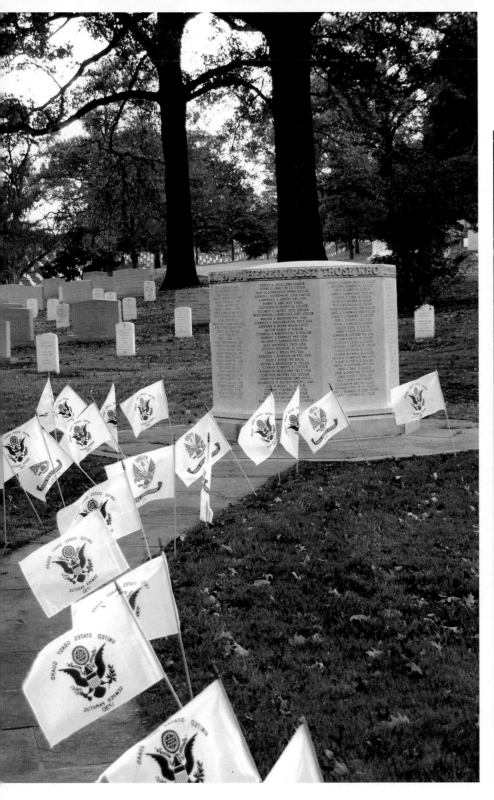

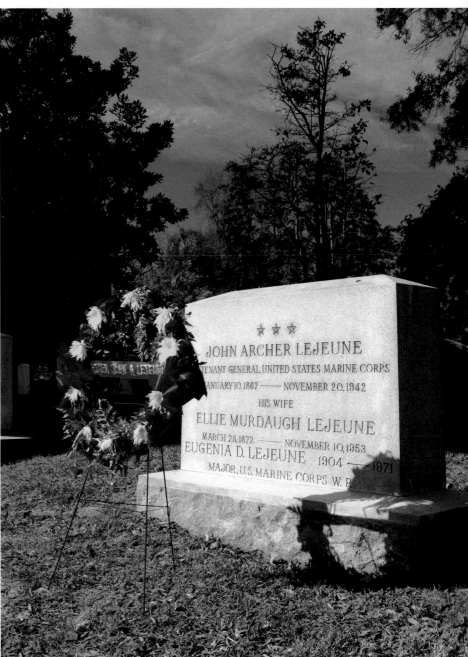

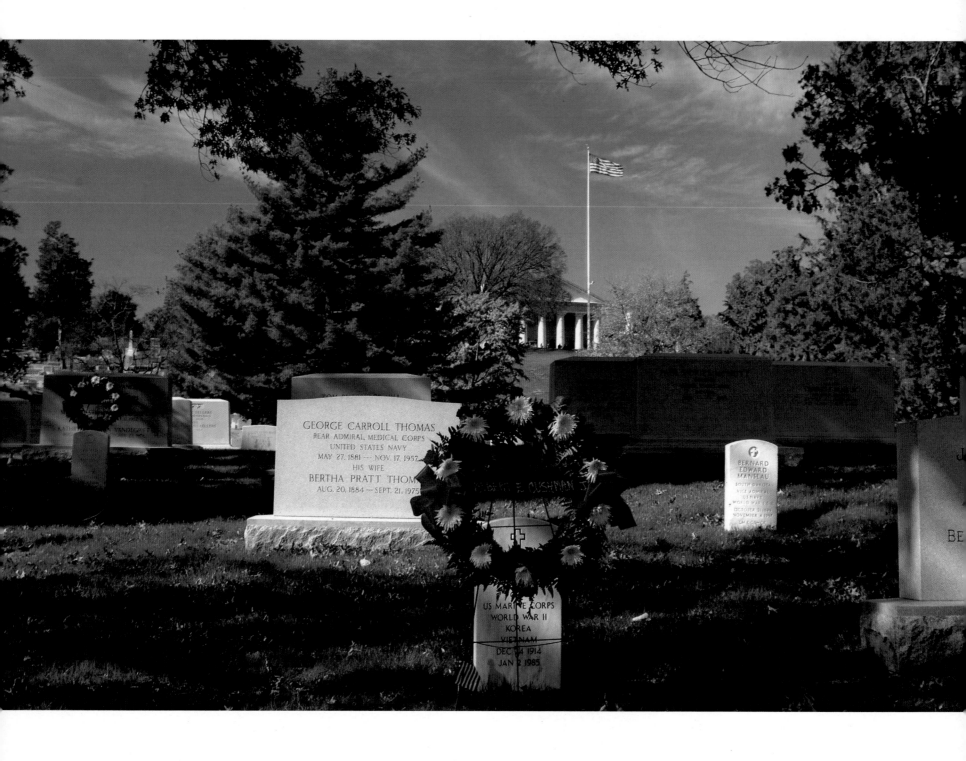

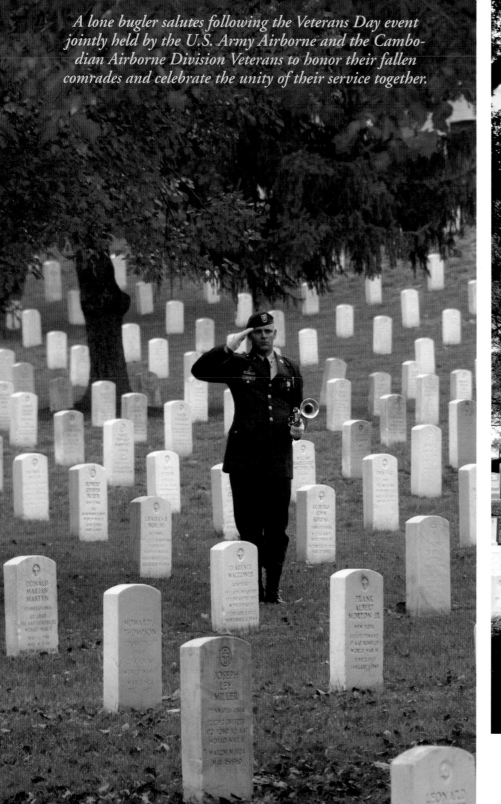

A lone bugler salutes following the Veterans Day event jointly held by the U.S. Army Airborne and the Cambodian Airborne Division Veterans to honor their fallen comrades and celebrate the unity of their service together.

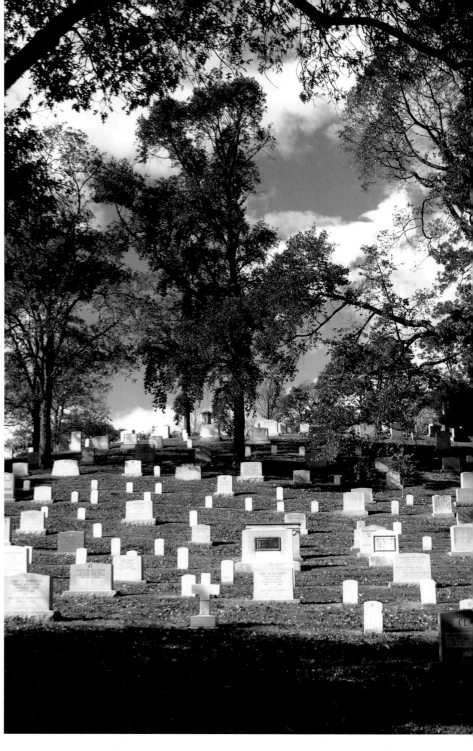

This memorial honoring the "Indigenous People of America" who fought in Vietnam is one of the many memorial plaques throughout Arlington honoring different groups and units who gave military service to our nation (below). A Purple Heart Medal marker by the headstone of one of its recipients is another type of memorial found throughout Arlington (center). The headstone of Admiral Porter and his wife still bears the inscription, "Temporarily Erected" even though it was placed there many years ago (right).

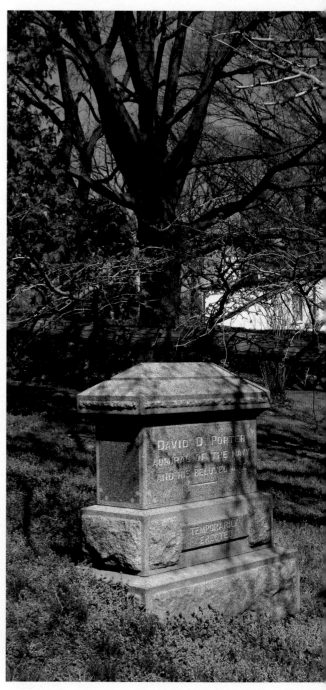

Foreign Nationals

Not every person buried in Arlington National Cemetery is an American. Throughout our history, the United States has relied on friends and allies to keep the country safe. Those individuals who helped the country at a time of need are given special due within the walls of Arlington National Cemetery. Altogether, sixty-four foreign nationals rest under the ground at the Cemetery. Most, twenty-four of them, are British. Other countries whose war dead are buried in the Cemetery include Australia, Canada, China, Holland, France, Germany, Greece, Italy, Iraq, South Africa, and South Vietnam. There is also one person of unknown origin. The foreign nationals from Germany and Italy were prisoners of war.

While the British Army, Royal Navy, and Royal Air Force all have servicemen and women buried at the Cemetery, the highest ranking of them all is Field Marshall Sir John Dill, who served as the senior British representative on the Combined Chiefs of Staffs. He developed a close relationship with U.S. General George C. Marshall, the Army Chief of Staff, and was described by President Franklin D. Roosevelt, as "The most important figure . . . in the combined operations of our two countries." When Dill died in Washington, D.C., on November 4, 1944, he was buried in the Cemetery under only one of two equestrian statues (the other statue belongs to Civil War Major General Philip Kearny).

The Iraqi buried in the Cemetery is Air Force Captain Ali Hussam, who died on May 30, 2005, when an Iraqi plane crashed with him and four Americans onboard. They were on a training mission in support of Operation Iraqi Freedom when the plane went down in Iraq's eastern Diyala province. Hussam was buried with the four other Americans on August 13, 2005.

And not all the nationals are warriors. Britain's Stewart Emeny was a war correspondent for the *London News* who was killed in an American plane crash in India during World War II on March 25, 1944. He died in the same crash that took the life of British Major General Ord Wingate, best known for his raids behind Japanese lines in Burma. Scotsman Robert Watt, a powerful leader in the American Federation of Labor who died onboard a ship to Washington, D.C., on July 25, 1947, is also buried in the Cemetery. He had served with the Canadian army during World War I.

These are just an example of some of the foreign nationals at the Cemetery. As long as this country has friends, there will always be a place for their sons and daughters at Arlington National Cemetery. ❧

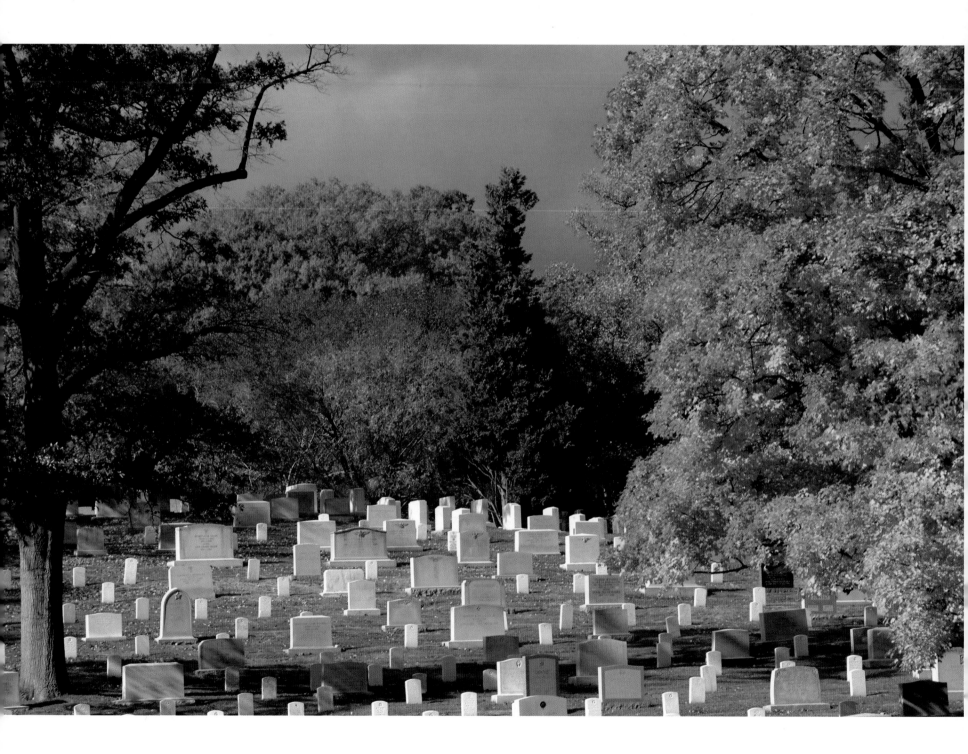

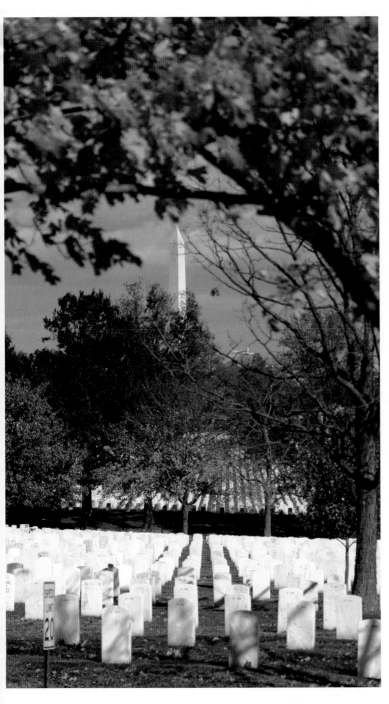

Some of the beautiful Autumn views that can be seen from locations throughout Arlington.

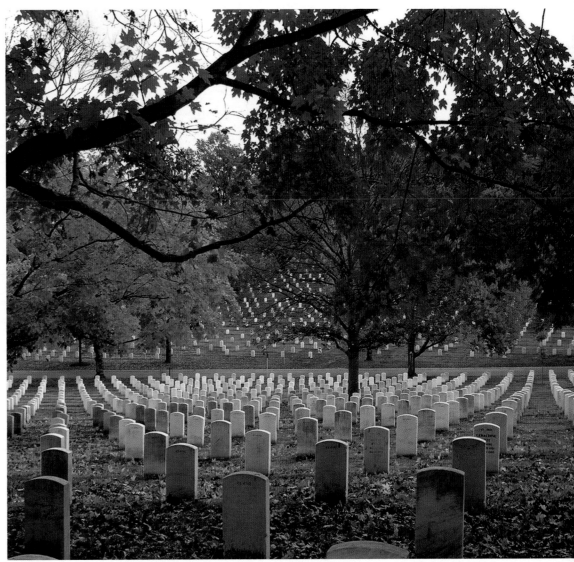

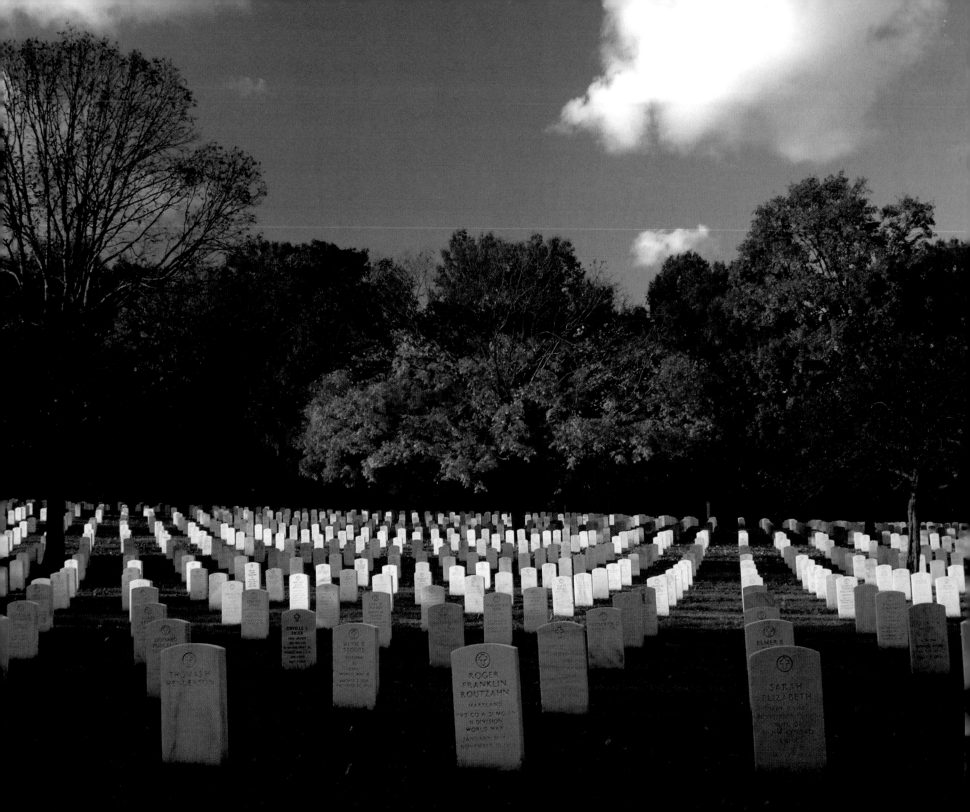

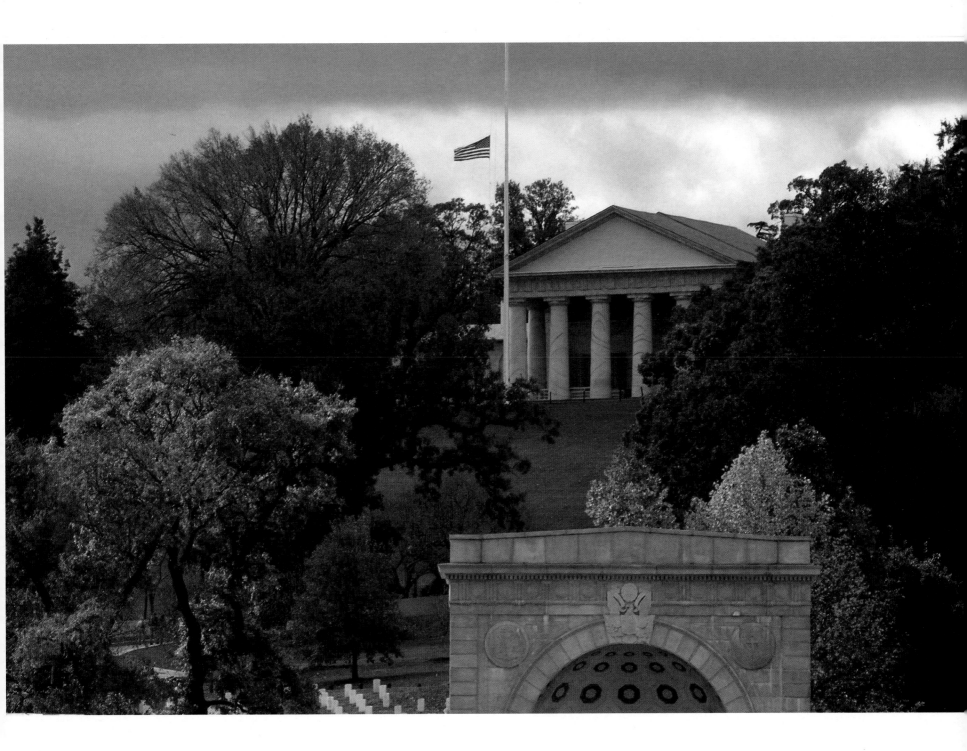

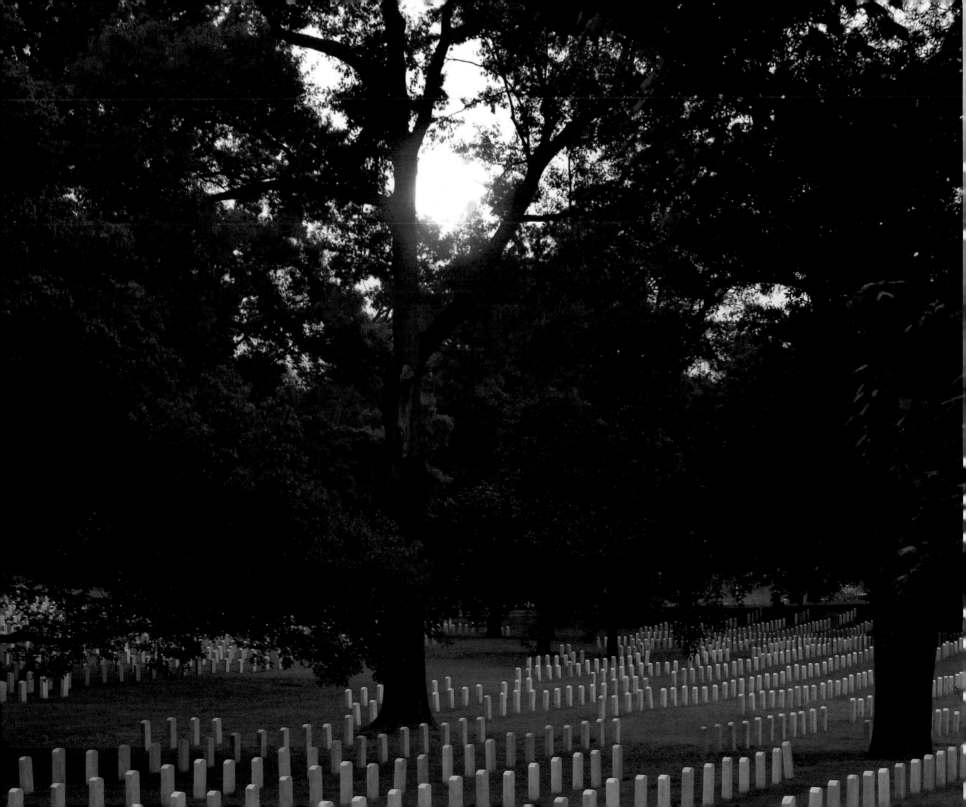

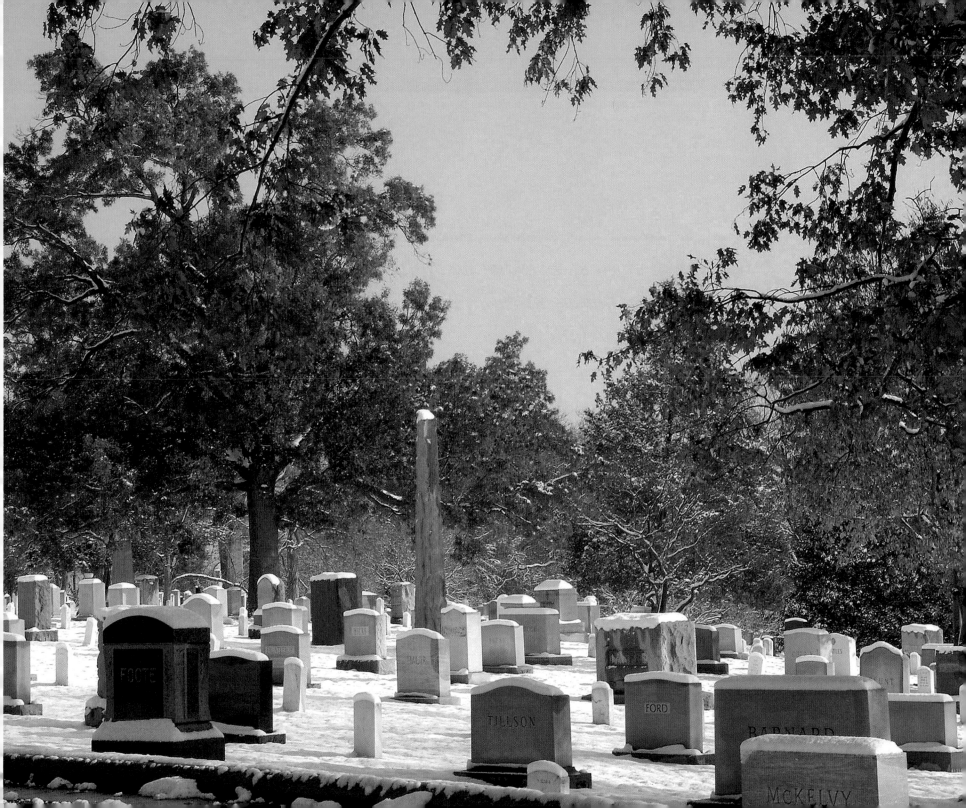

───── ଊ—ଊ ─────

Blankets of snow cover Arlington National Cemetery in Winter as flakes fall against the pale sky. Yet there is no hibernation on the rolling hills. Honor Guards continue to lay their fallen comrades to rest, making shadowy tracks in the snow as they proceed to their destinations. Icicles form on trees and buildings, adding to the picturesque scene.

WINTER

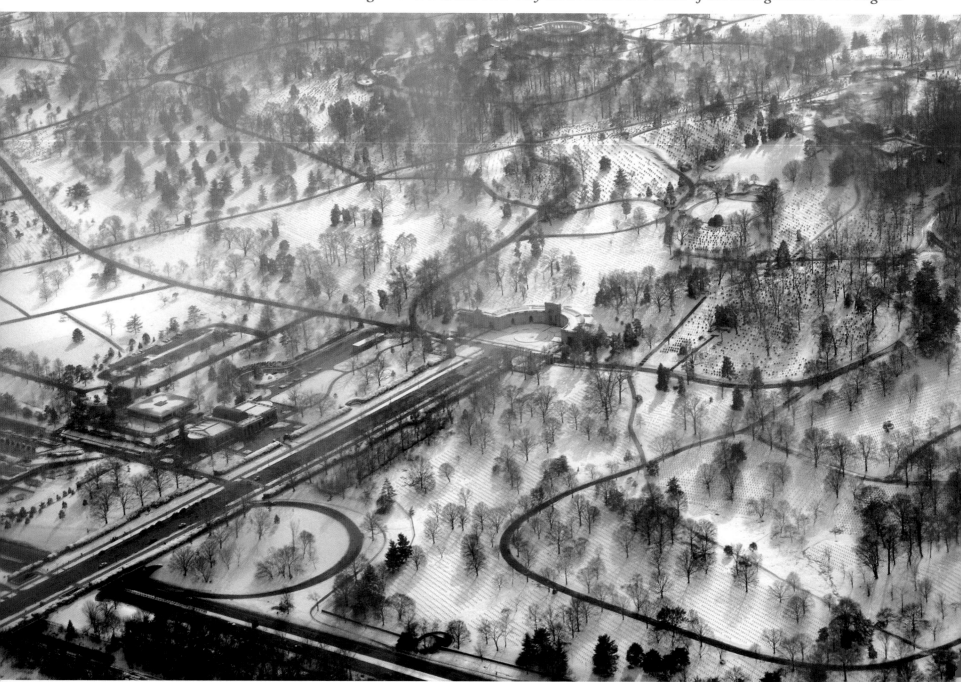

A Winter view of Arlington blanketed with snow, as seen from a commercial airline. The Amphitheatre, Arlington House, the Kennedy family grave site, and the Women's Memorial are just a few points of interest seen here. As large as it looks, this view only shows about one-third of the total grounds in Arlington.

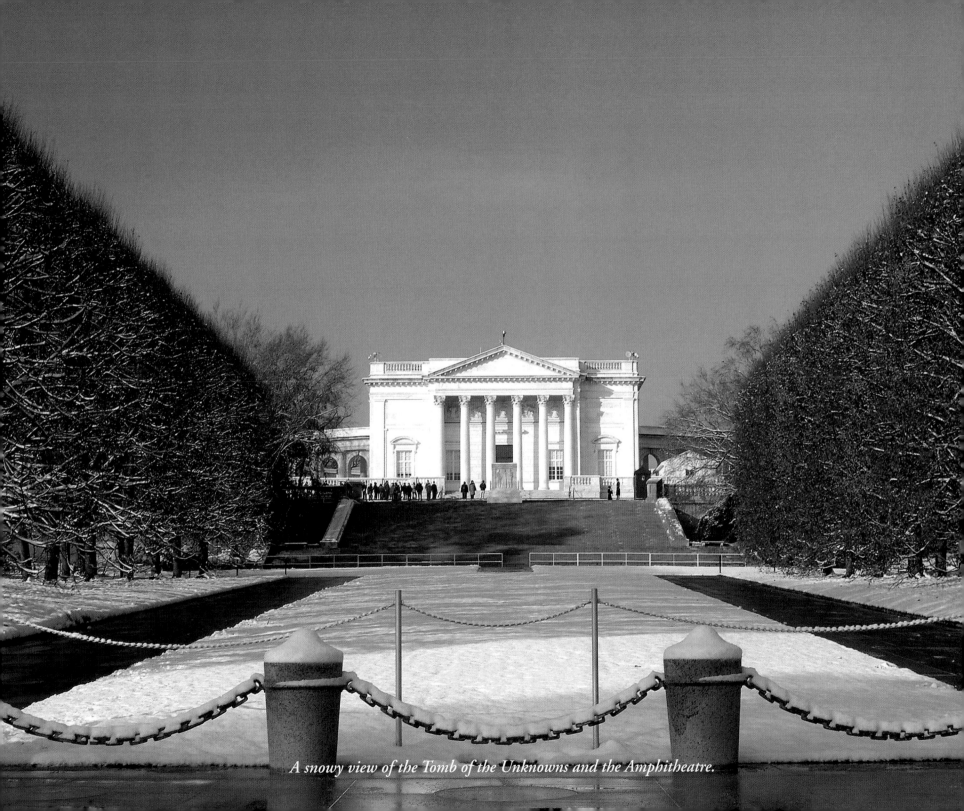

A snowy view of the Tomb of the Unknowns and the Amphitheatre.

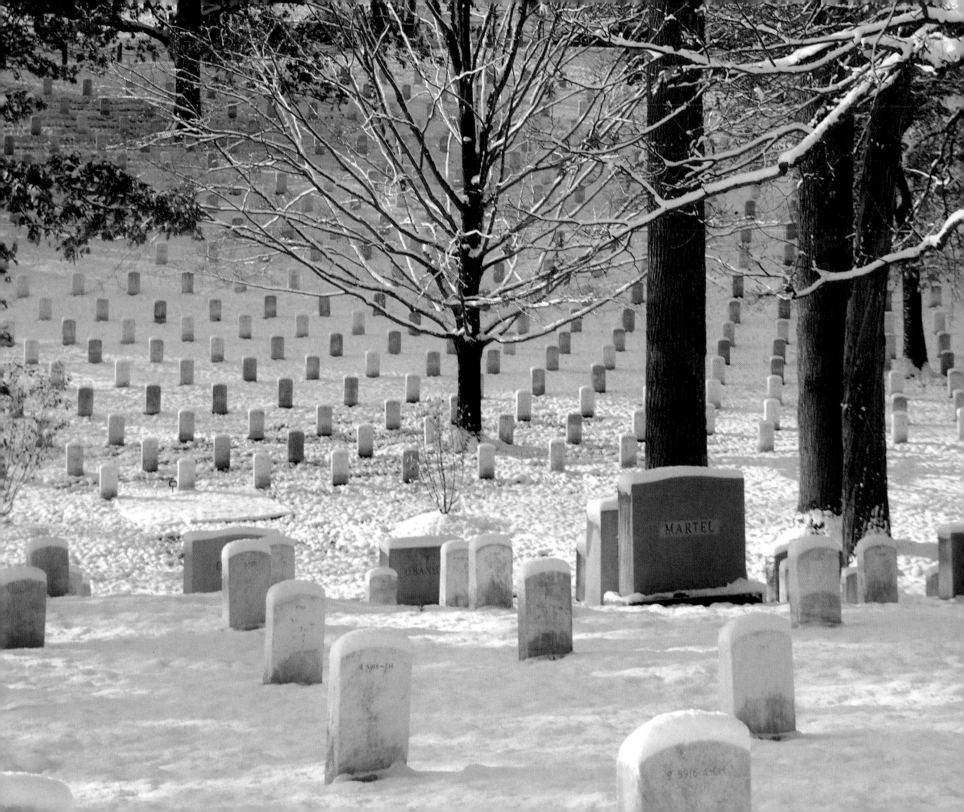

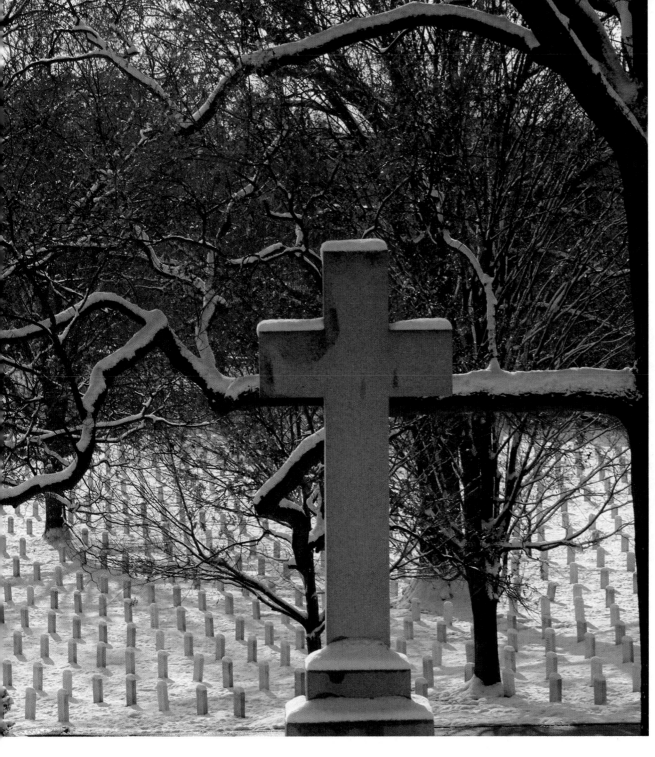

It seems only fitting that the gravesites of Rear Admiral Robert E. Perry and key member of his party Mathew Henson should be shown in a snowstorm. Mathew Henson, originally hired as a valet, became a trusted partner and was credited with having the main ideas leading to the successful discovery of the North Pole. They rest together in Section 8 as co-discoverers of the North Pole (below).

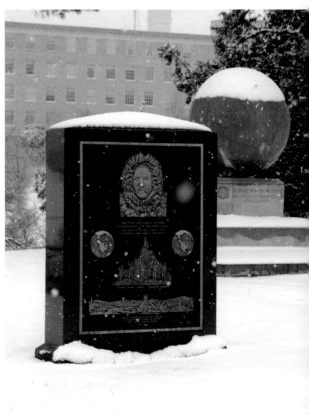

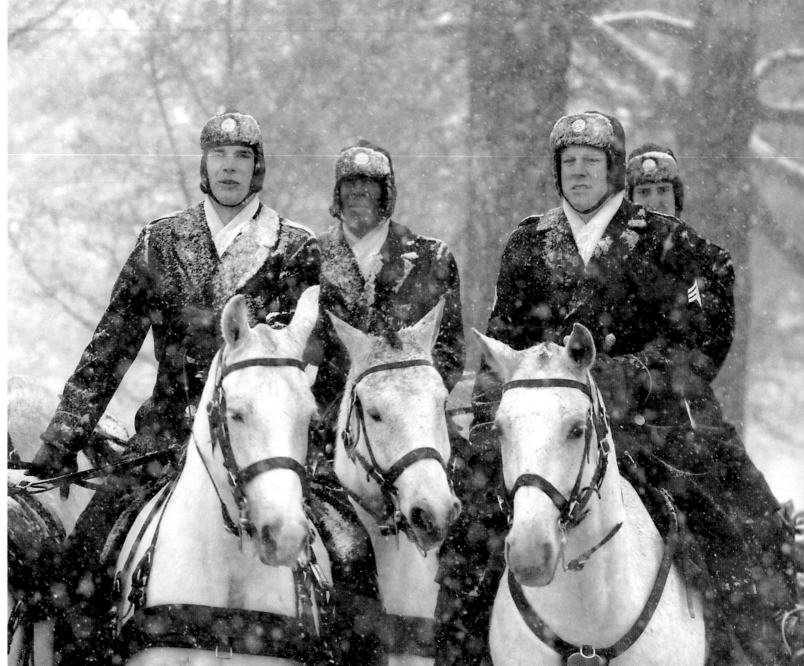

Members of the Caisson Platoon stay out in the field all day with their horses. This includes eating two meals outside every day, regardless of the weather. Instilled with pride and professionalism by their training, they show their unselfish dedication to country and disregard for personal comforts, especially in the harsh Winter. These soldiers have what some consider the hardest and most personally grueling assignment in Arlington.

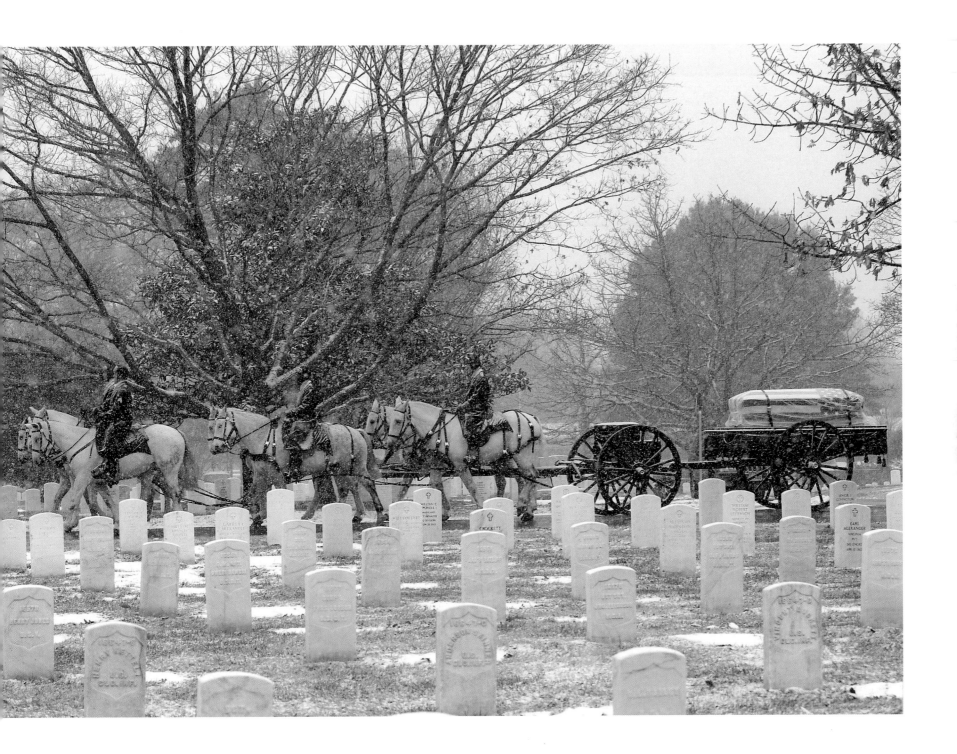

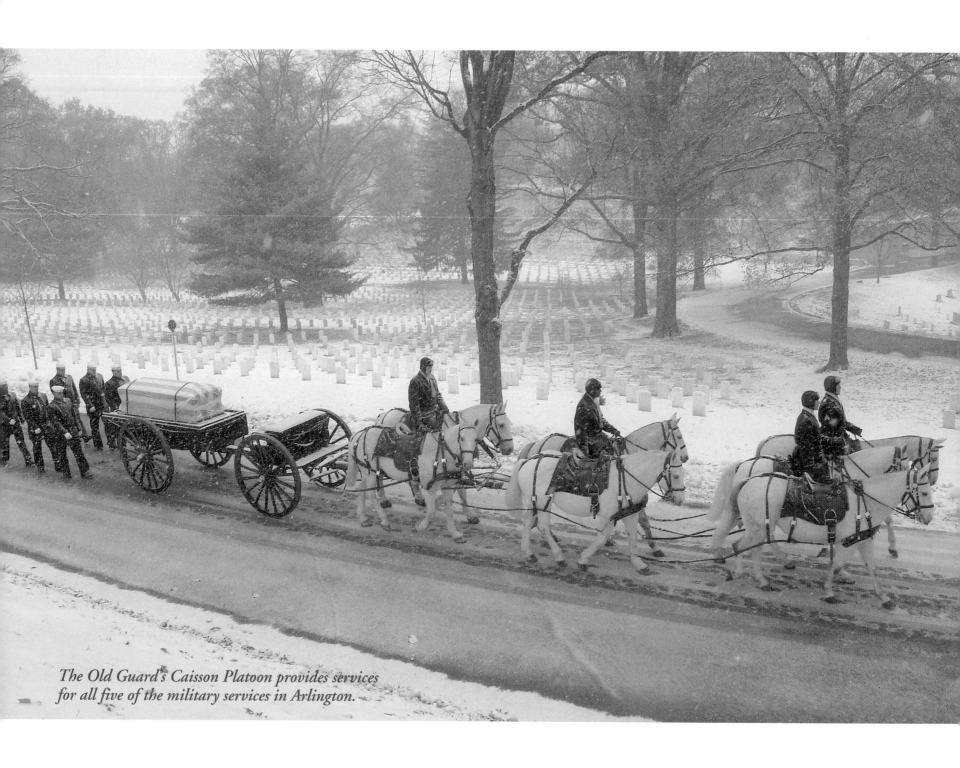

The Old Guard's Caisson Platoon provides services for all five of the military services in Arlington.

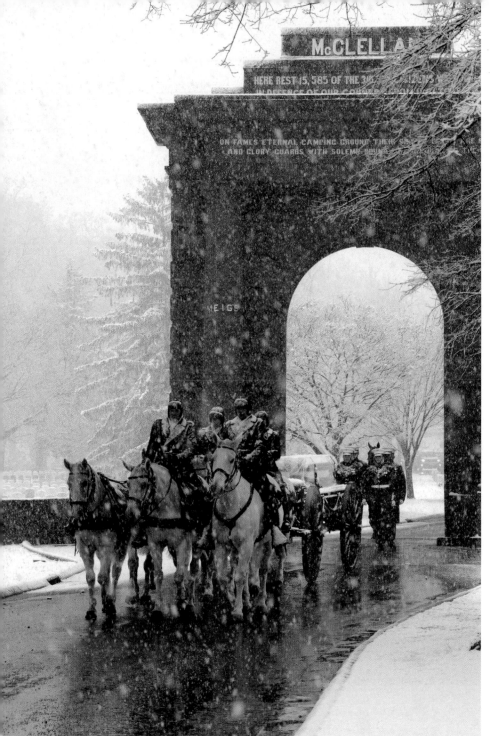

U.S. Marine Corps Honor Guard

Semper Fidelis—always faithful—is the central philosophy in the U.S. Marine Corps, and that concept extends to Arlington National Cemetery.

The Marine Corps has a presence of up to 500 Marines at the Cemetery, split into two companies, Alpha and Bravo. Alpha Company includes Ceremonial Marchers, the Silent Drill Platoon, and Color Guard, while Bravo Company includes its own Ceremonial Marchers and Body Bearers.

Headquartered at the Marine Barracks in Washington—better known as "8th and I" for its street intersection—Alpha and Bravo Company Marines help transfer fallen Marines who arrive at Dover Air Force Base in Dover, Delaware, and render final honors at funerals. During the Summer, they march in Sunset Parades on Tuesday nights at the Marine Corps War Memorial and Friday nights at the Marine Barracks.

The Silent Drill Team started performing in 1948 and soon became so popular that hundreds of thousands of people attended—

(continued)

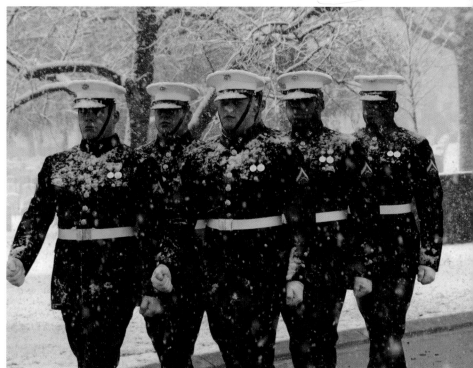

(continued)

and continue to attend—their performances. The Marines of Bravo Company are considered infantry and have to remain proficient in combat skills during their tour at the Barracks. The Body Bearers conduct funeral ceremonies for Marines, former Marines, and Marine family members. They are also called upon to travel to different locations around the country to conduct funerals for congressmen and congresswomen, heads of state, and former presidents.

The Marine Corps' finest as well as its fallen are well represented at the Cemetery. Gunny Sergeant William J. Dixon, the Marine Corps Funeral Director, commented that, "If ever in your life you feel that your country has let you down, come to Arlington National Cemetery and let the rows and rows of the perfectly aligned white marble stones encourage you to hold on. Freedom comes at a price." ❧

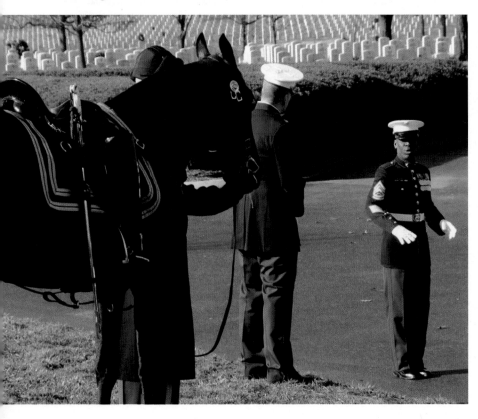

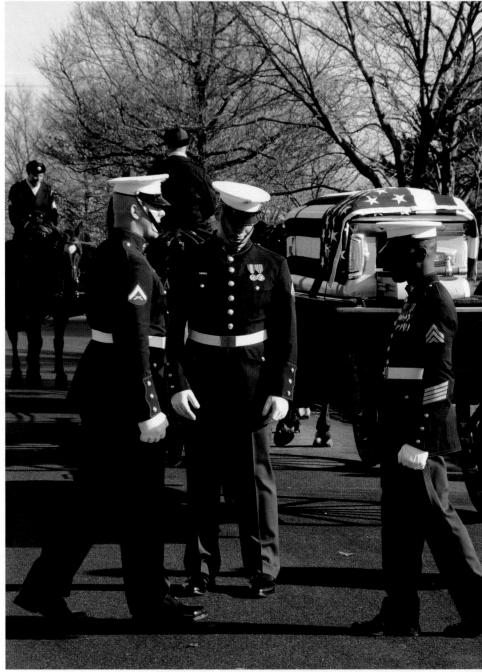

GySgt. William Dixon briefs the Commandant's Representative on placement and procedures prior to a full honors funeral.

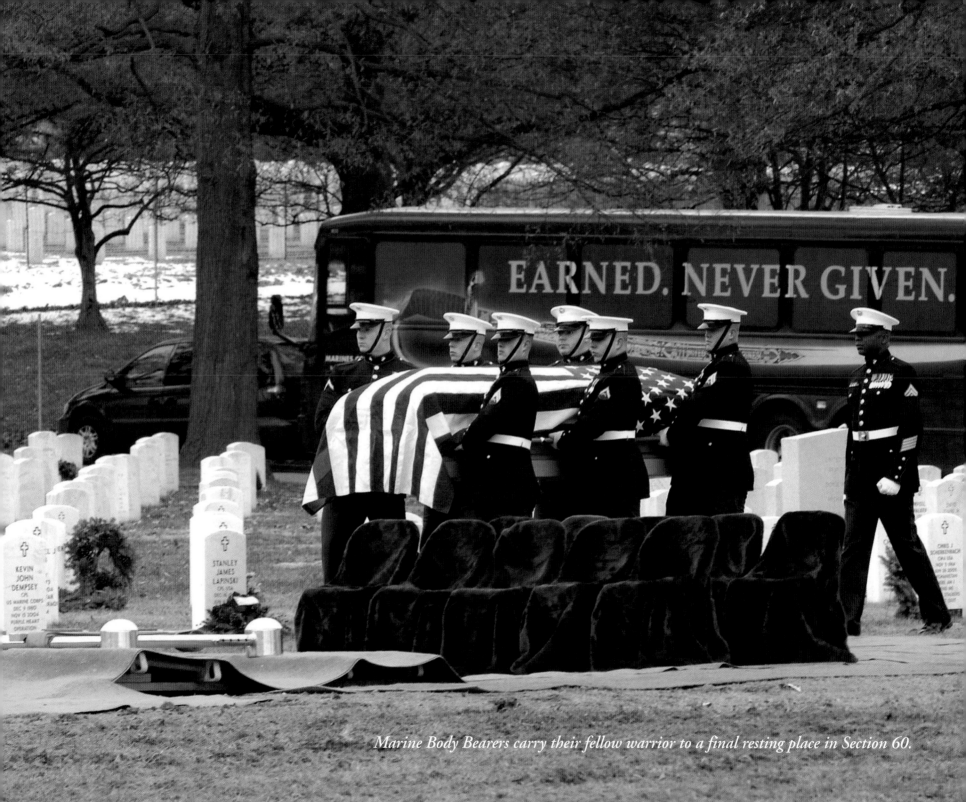

Marine Body Bearers carry their fellow warrior to a final resting place in Section 60.

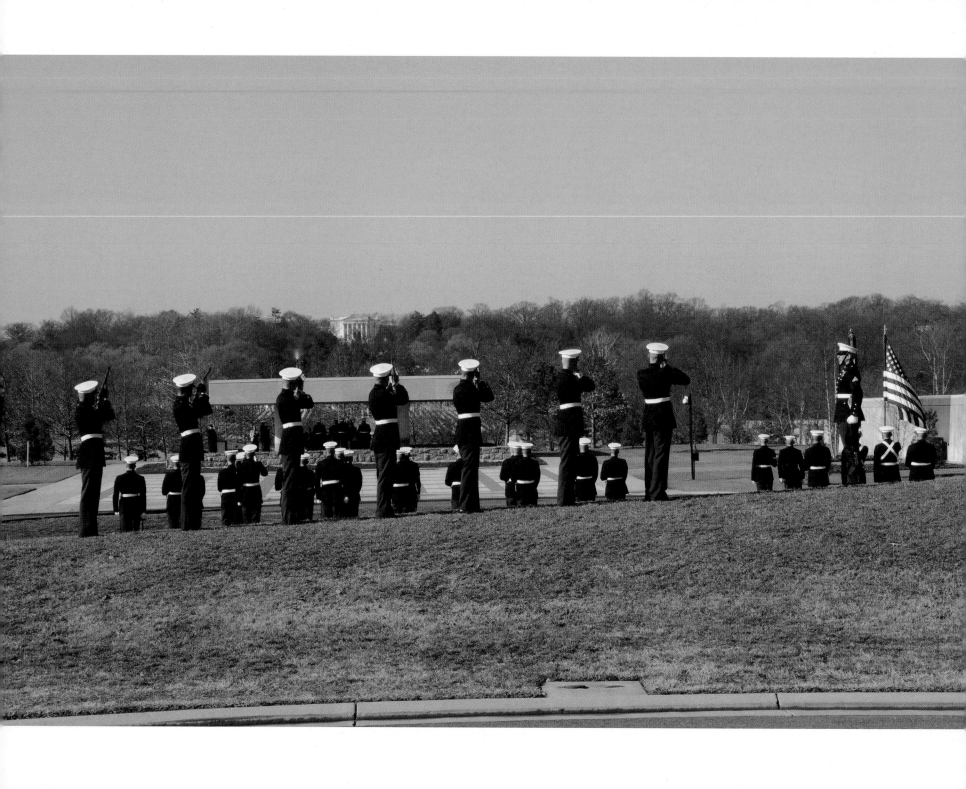

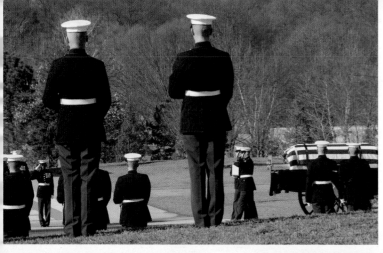

A Marine Firing Party shoots the traditional three volleys from seven Marines for a full honors funeral (far left). LCpl. Darrell J. Schumann, USMC, is laid to rest in Section 60 (below). Schumann was on his last mission in Iraq when he was killed in a helicopter crash. Born to career Air Force parents, he would sign his letters home with, "Air Force by birth, Marine by choice, American by the grace of God."

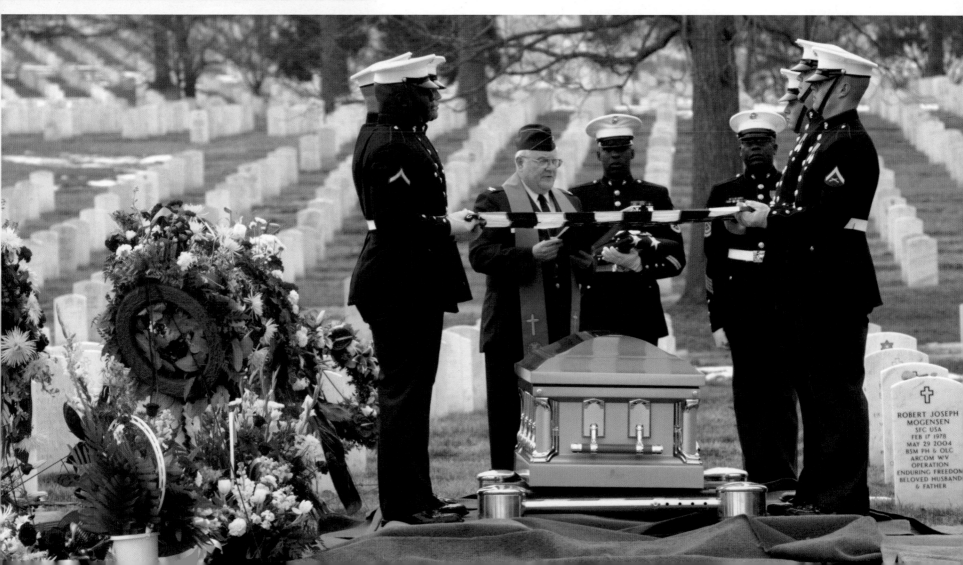

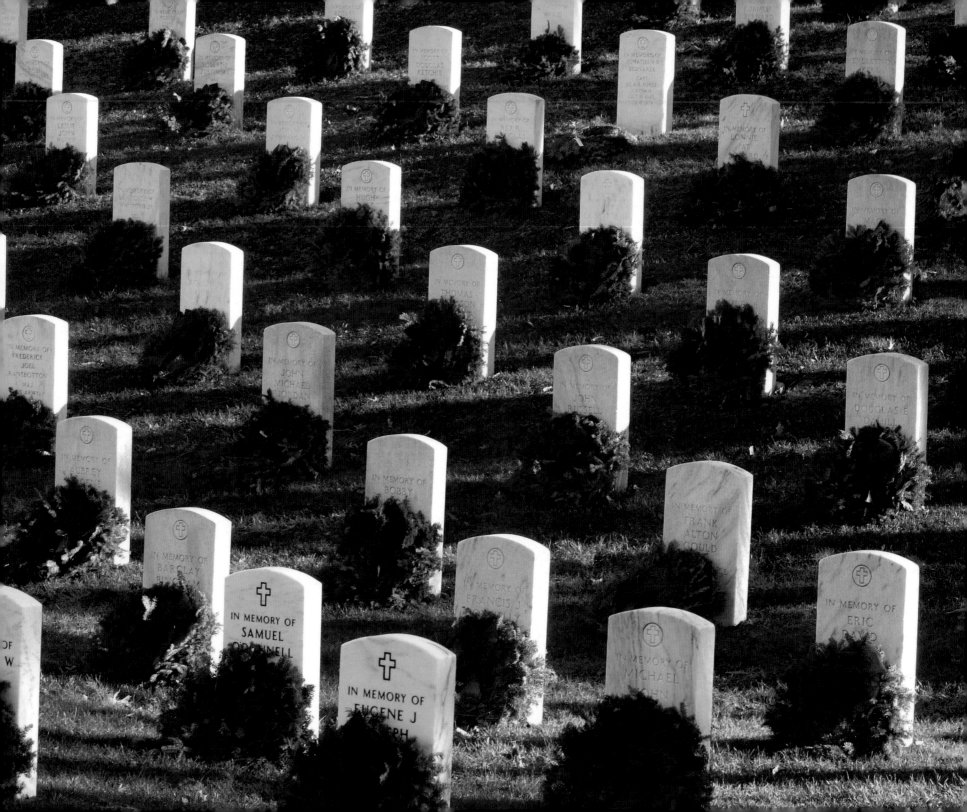

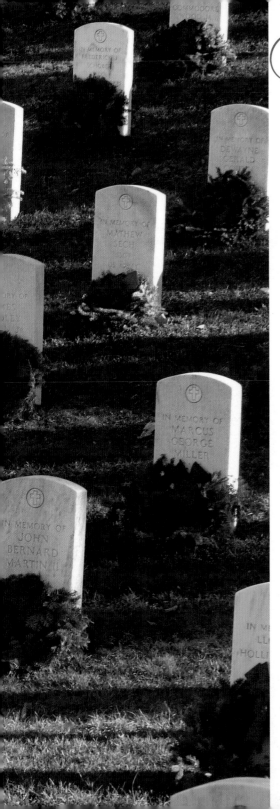

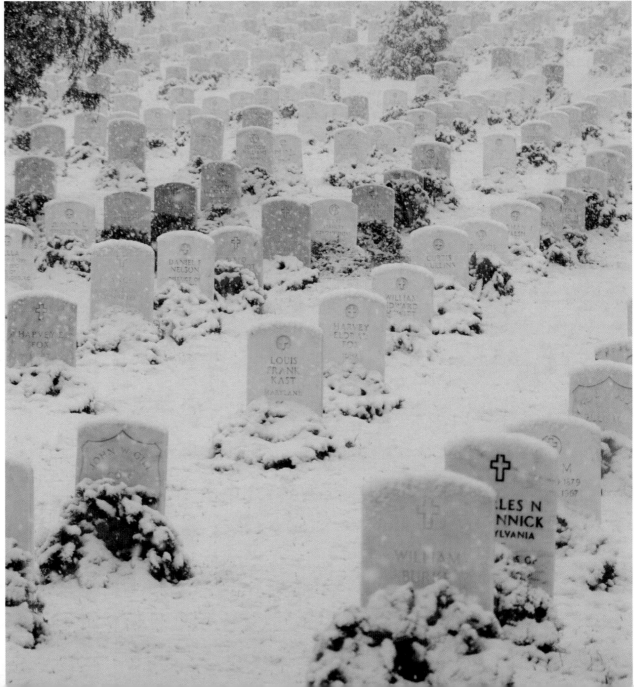

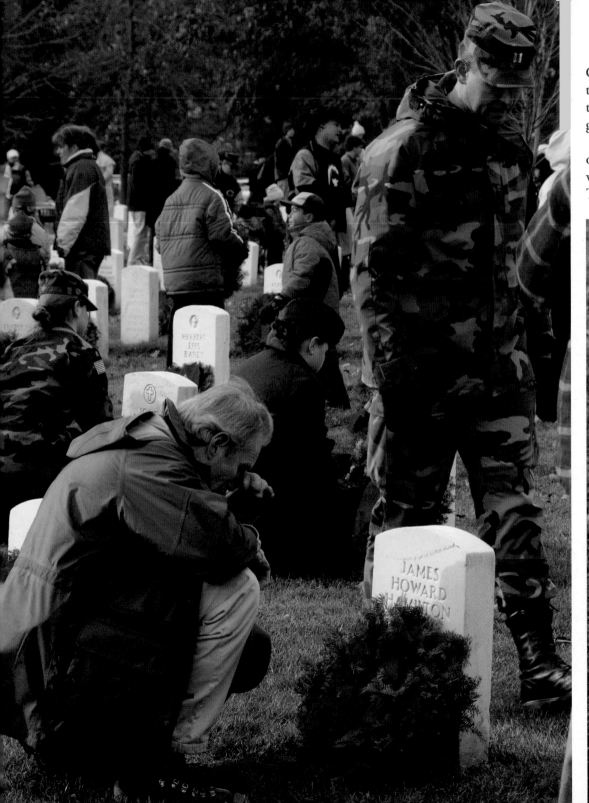

Owner Morrill Worcester and workers at Worcester Wreath Company in Harrington, Maine, began the Christmas wreath tradition in December 1992. With 5,000 surplus wreaths, they traveled down to Arlington National Cemetery that year to adorn grave sites.

Worcester said, "The first year there were just about a dozen of us and it took five to six hours. This past year we had lots of volunteers and it took about one hour to place 10,000 wreaths." The Superintendent of Arlington selects a different section or

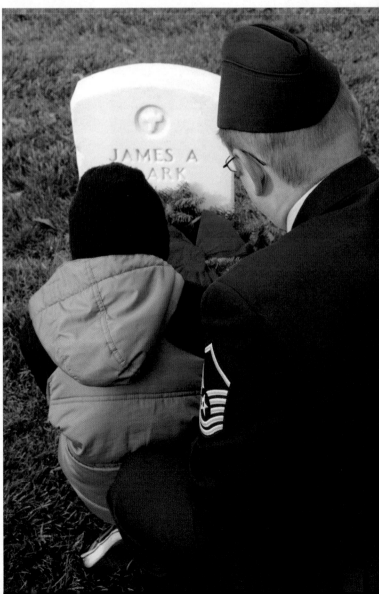

ections in which the wreaths are placed each year.

When asked why he undertakes this annual endeavor, Worcester answered, "We couldn't do anything in this country if it wasn't for the people who gave their lives to protect us. It's a great honor to be able to come here and pay our respects." In addition to placing the Christmas wreaths on graves in the selected sections, wreaths are also placed at the Tomb of the Unknowns, the Kennedy graves, and Senator Edmund Muskie's grave site.

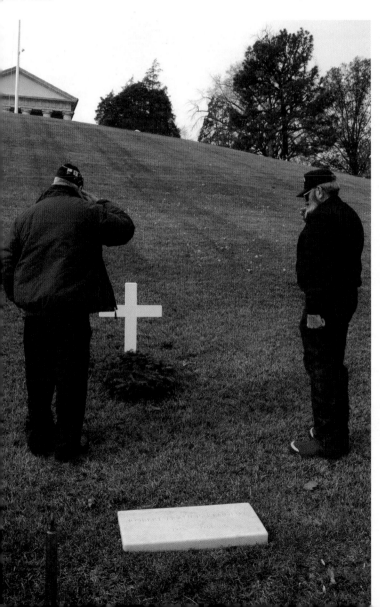

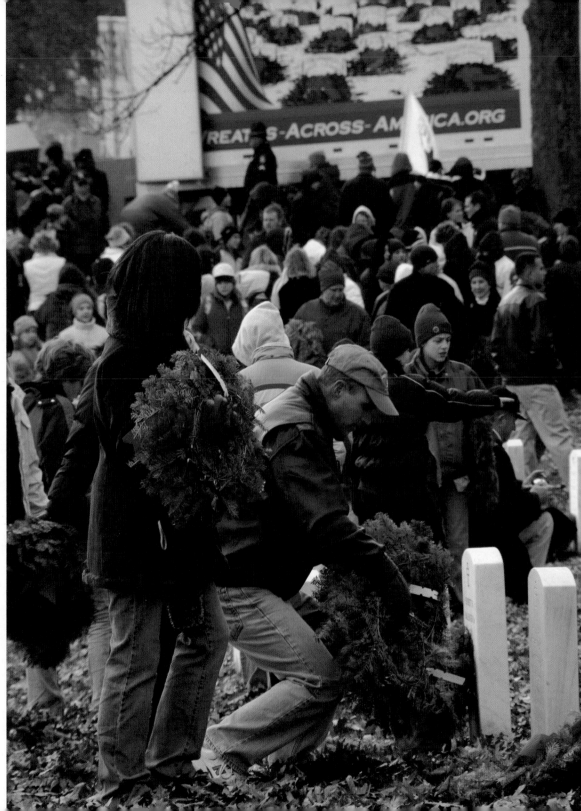

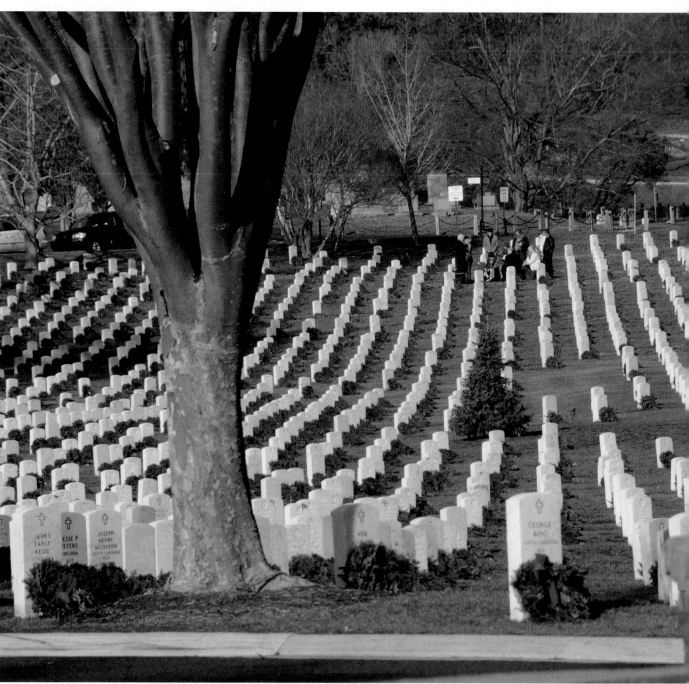

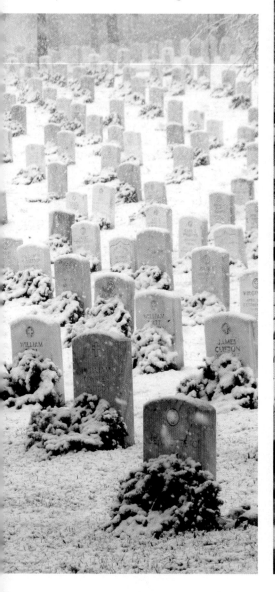

The Christmas wreaths add to the beauty of the light snow covering Section 27.

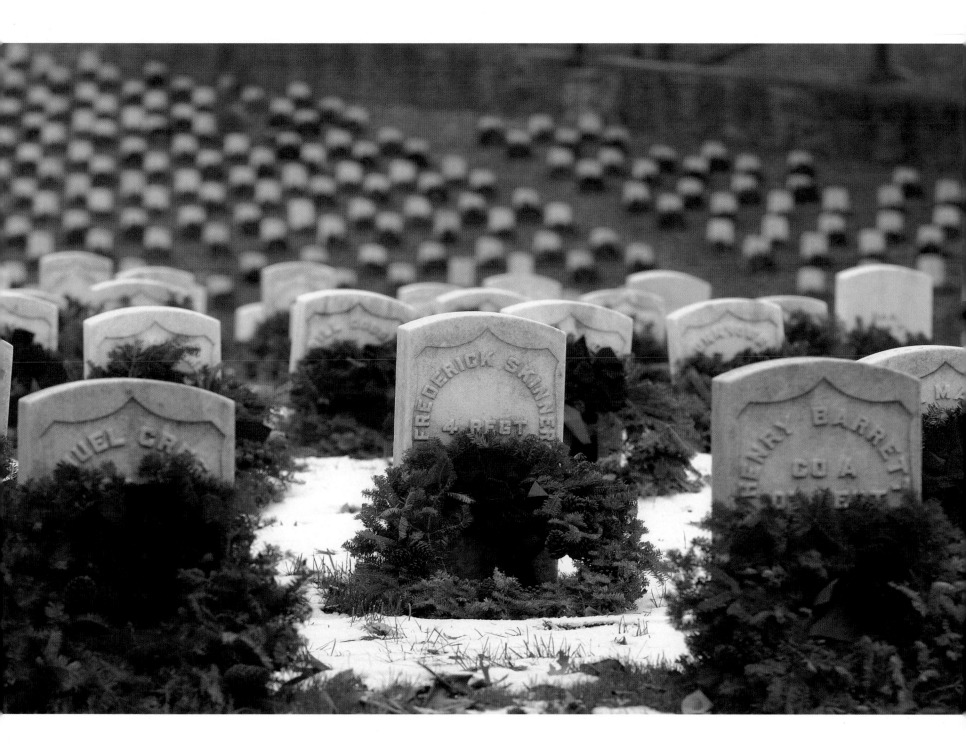

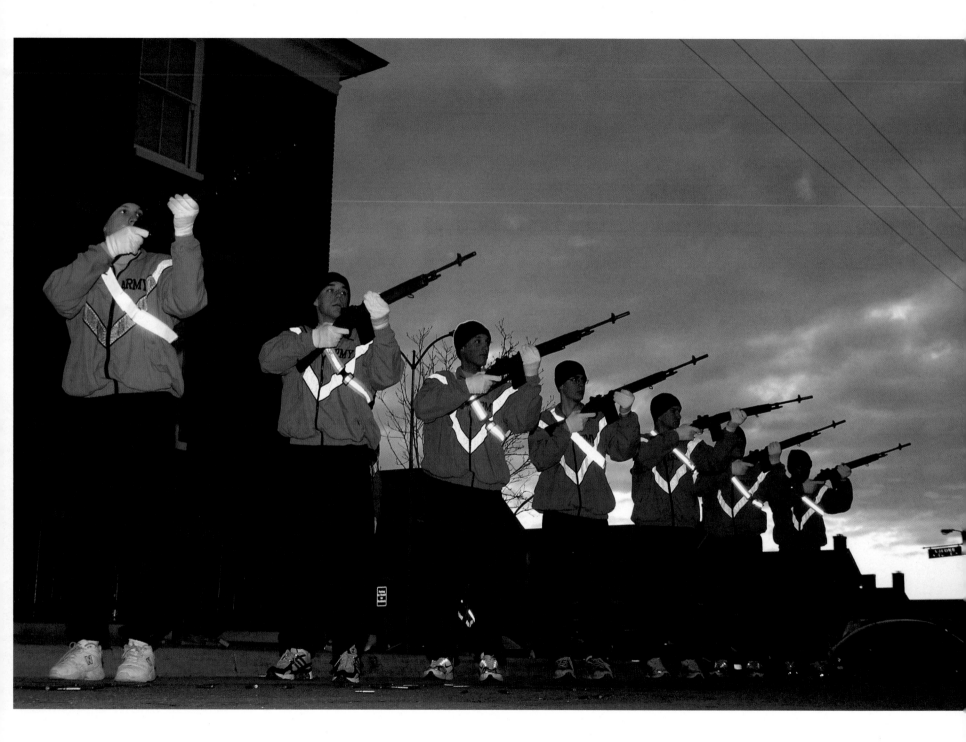

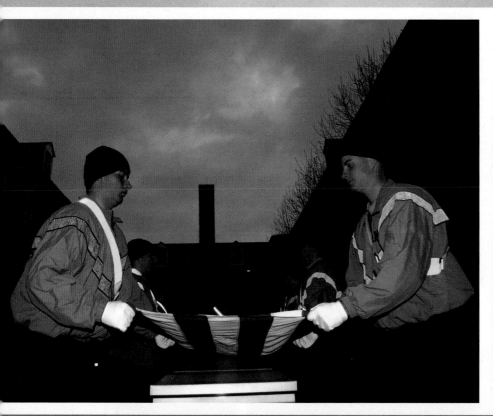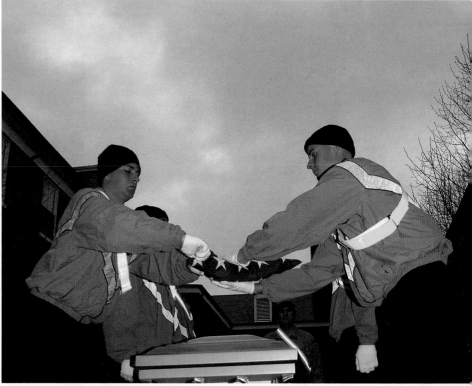

Pre-dawn practice is normal and not an exception for all members of the Old Guard. Here soldiers practice folding the flag in the cold and dark so that during the warmer hours of the day this task will be virtually perfect (above).

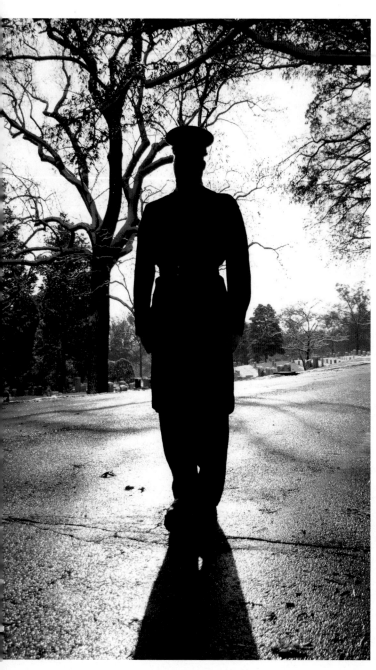

Soldiers must stand motionless at their assigned post even in the coldest of Winter days (above).

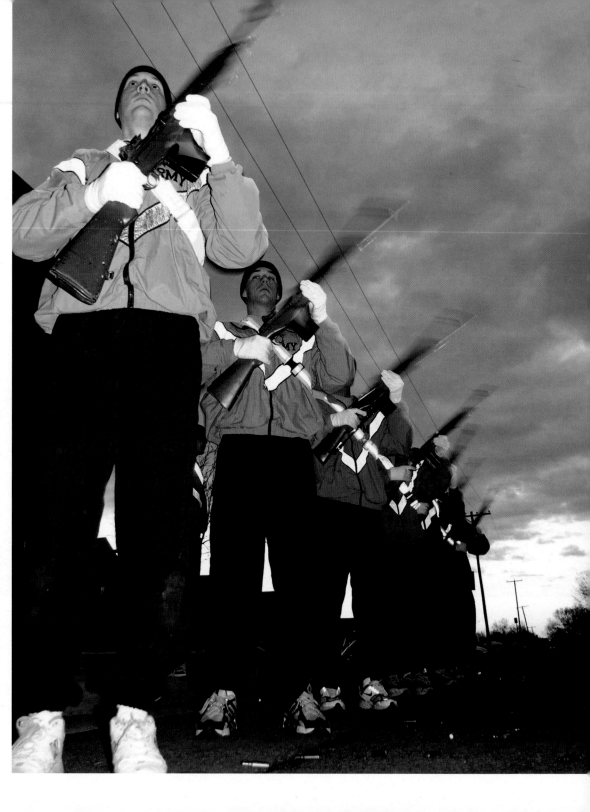

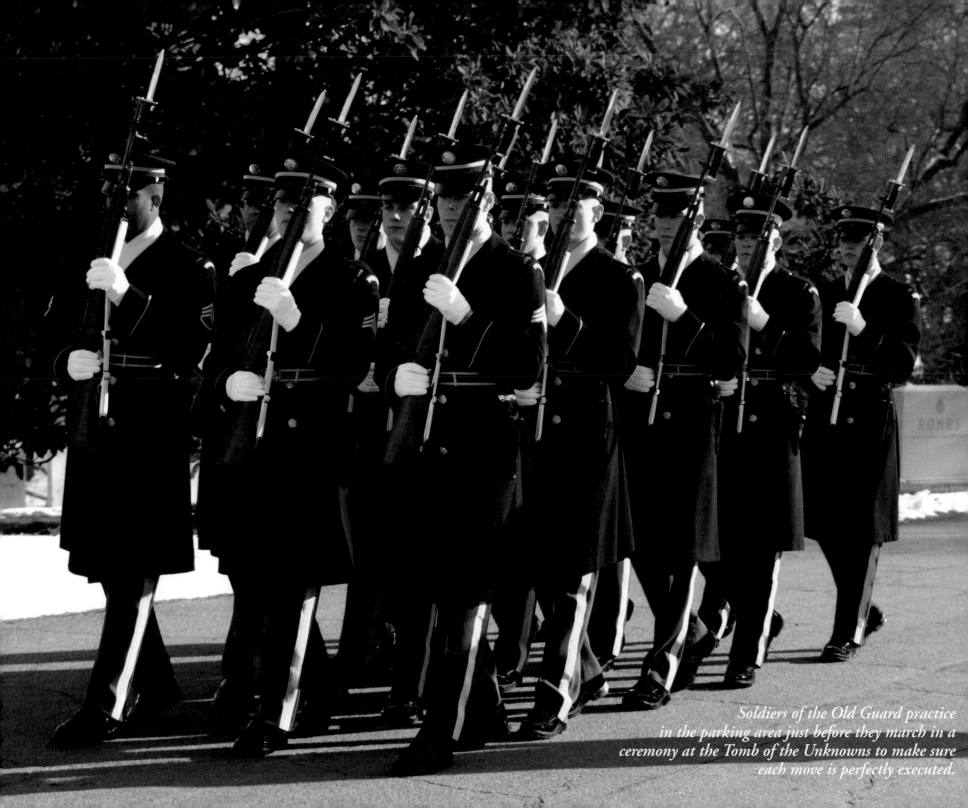

Soldiers of the Old Guard practice in the parking area just before they march in a ceremony at the Tomb of the Unknowns to make sure each move is perfectly executed.

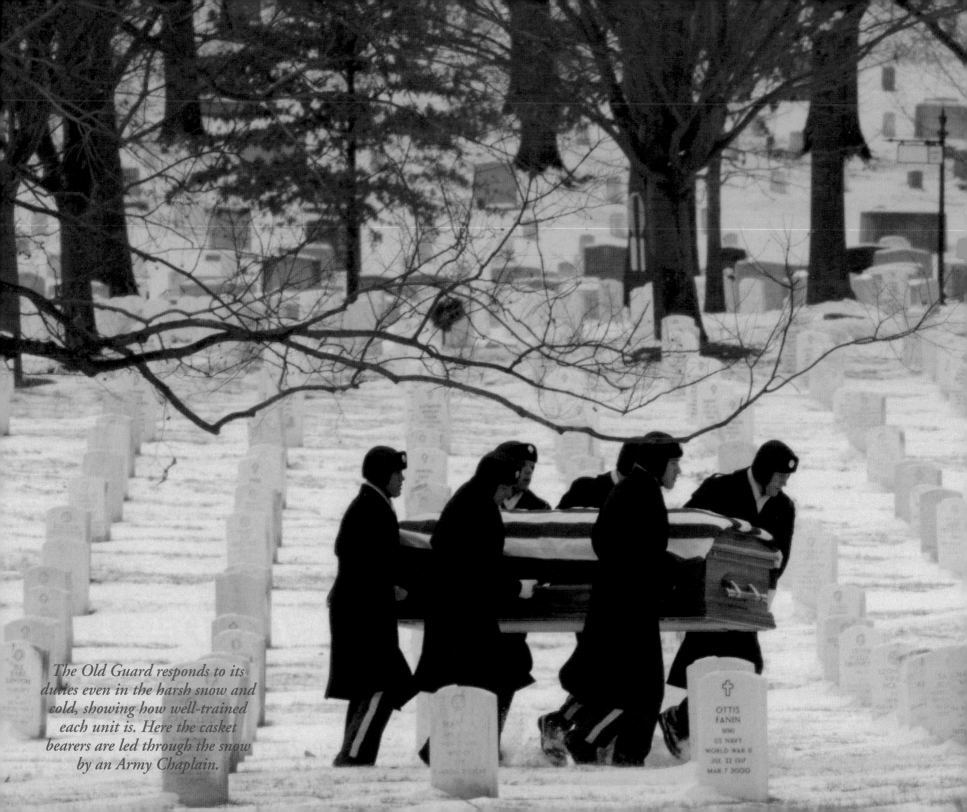

The Old Guard responds to its duties even in the harsh snow and cold, showing how well-trained each unit is. Here the casket bearers are led through the snow by an Army Chaplain.

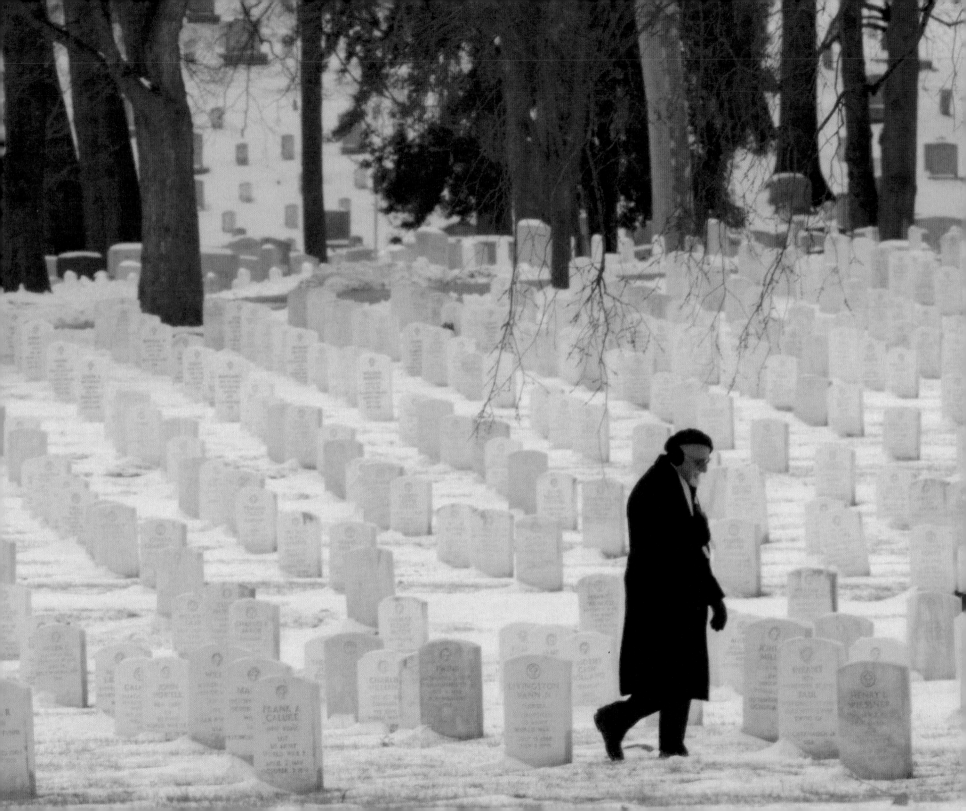

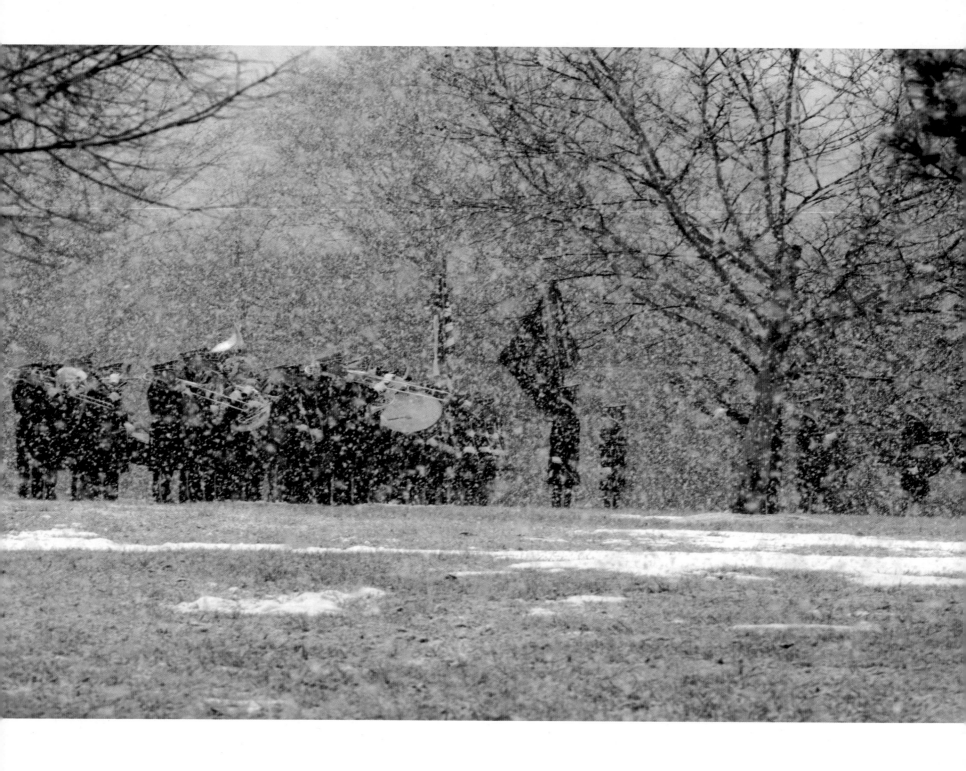

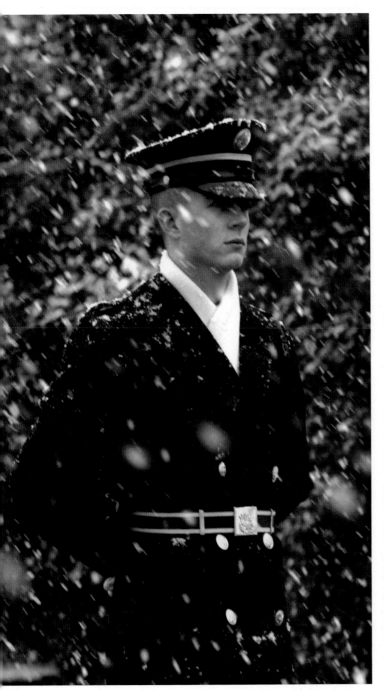

This soldier stands at his post seemingly unaffected by the falling snow, an attribute known and expected of all in the Old Guard (left). The U.S. Army Band plays a very important role in all the ceremonies and services in Arlington. They are expected to play flawless notes regardless of the snow (far left) and brutally cold conditions in winter (below).

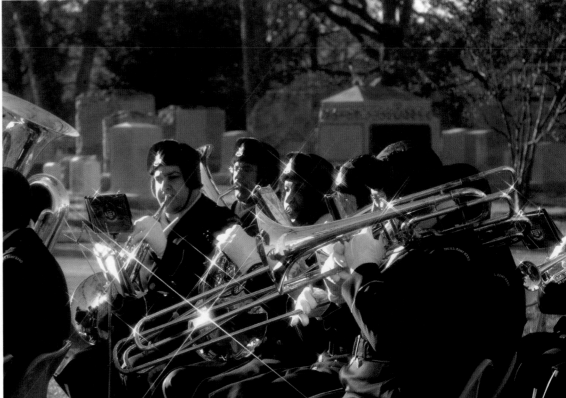

Members of the Old Guard Fife and Drum Corps (below) perform at the annual Remembrance of the Gulf War held on February 27, playing musical instruments while wearing uniforms similar to those used by military musicians of the Continental Army in the American Revolution. This event is sponsored by the White House Commission on Remembrance and the Embassy of the State of Kuwait in appreciation of the forces who freed the people of Kuwait.

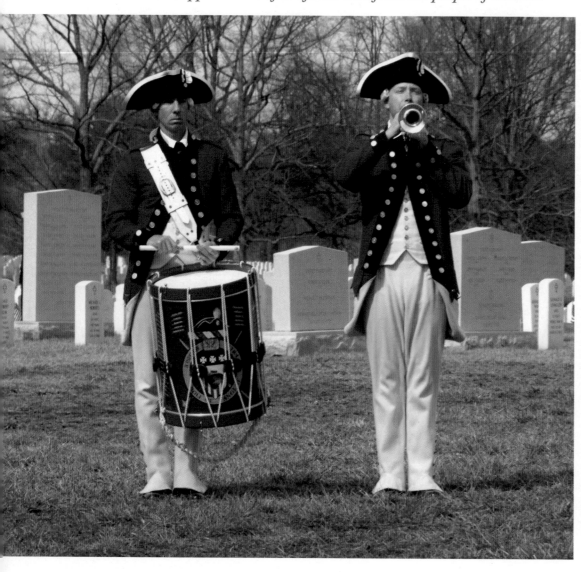

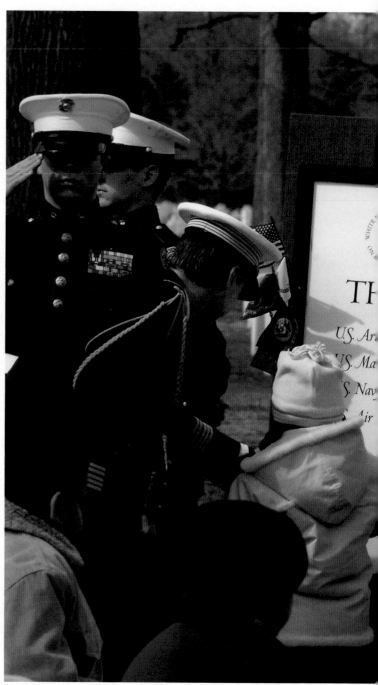

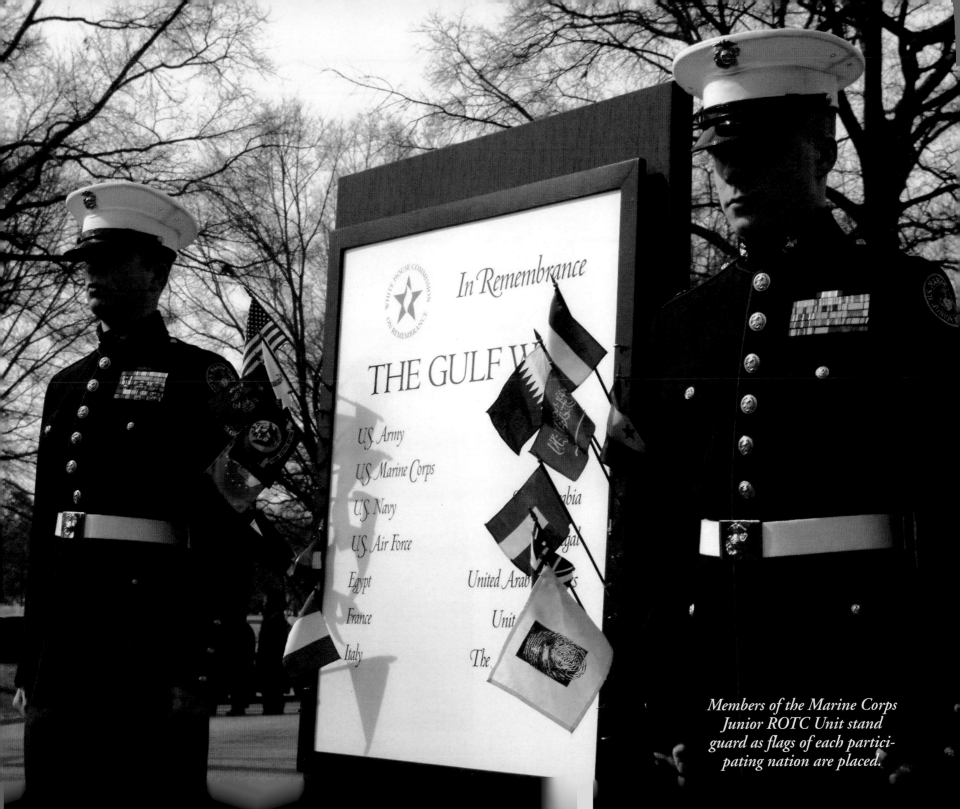

In Remembrance

THE GULF W[AR]

WHITE HOUSE COMMISSION ON REMEMBRANCE

U.S. Army

U.S. Marine Corps

U.S. Navy

U.S. Air Force

Egypt

France

Italy

Saudi Arabia

...gal

United Arab ...s

Unit...

The ...

Members of the Marine Corps Junior ROTC Unit stand guard as flags of each partici-pating nation are placed.

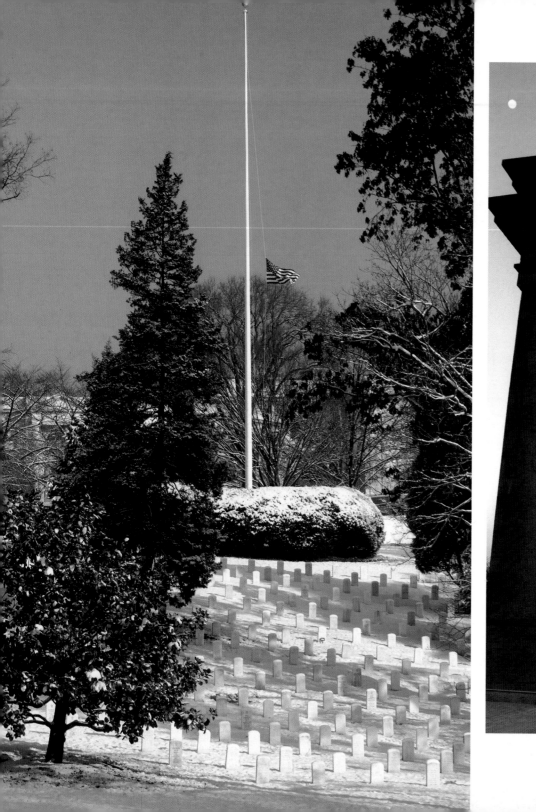
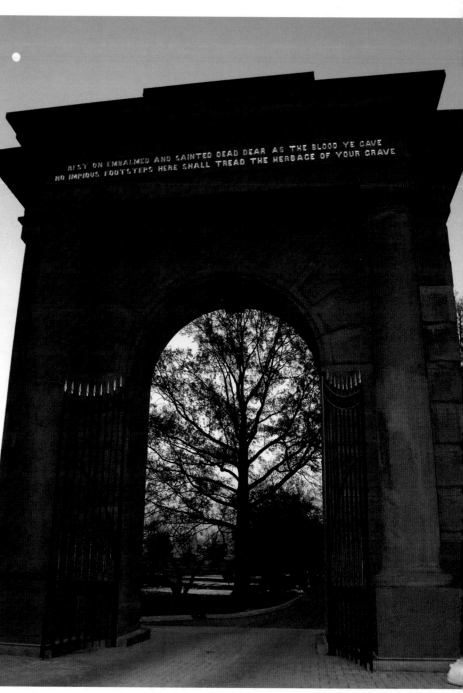

REST ON EMBALMED AND SAINTED DEAD DEAR AS THE BLOOD YE GAVE
NO IMPIOUS FOOTSTEPS HERE SHALL TREAD THE HERBAGE OF YOUR GRAVE

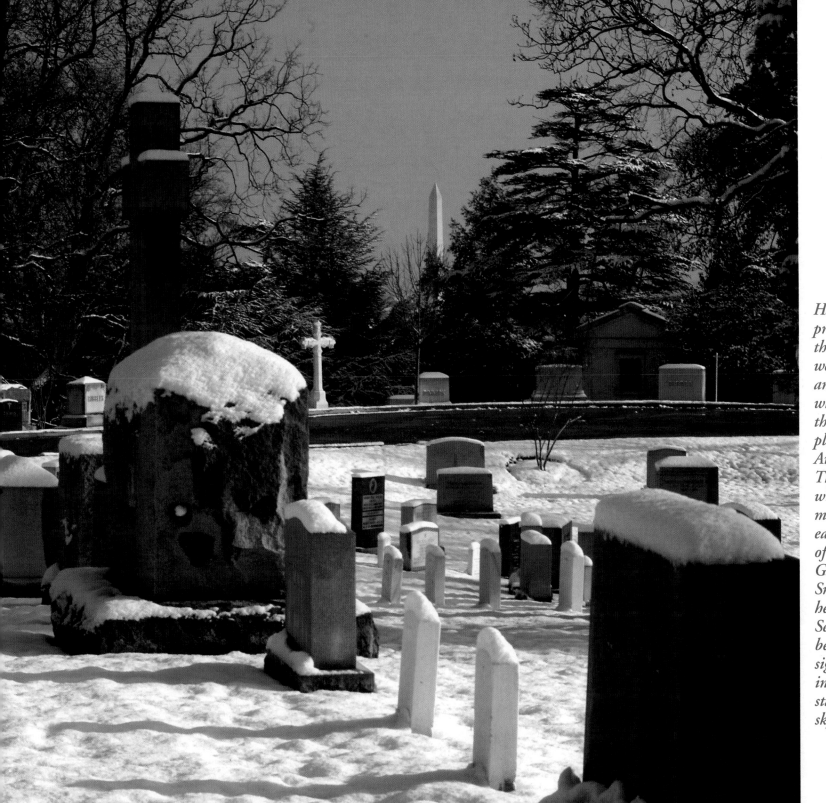

Half mast is the proper position of the flag during the week to give honor and respect to those who are laid in their final resting place each day at Arlington (far left). The beauty of the winter sky and full moon is seen in this early evening view of the McClellan Gate (center). Snow-capped headstones in Section 4 make a beautiful Winter sight as the Washington Monument stands out in the sky (left).

The Presidential Salute Battery of the Old Guard (below) renders honors to visiting foreign dignitaries and a final salute at many funerals in Arlington. Here the unit fires a welcoming salute from Dewey Drive in Section 4.
Visitors can feel the concussion as fire roars from the barrel when the Presidential Salute Battery renders honors (right) at Red Springs at the end of McClellan Drive, the only other location that is used by these guns in Arlington.

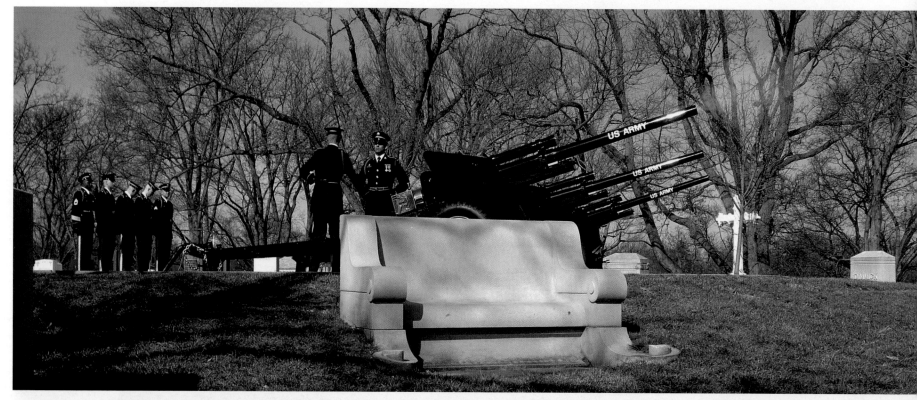

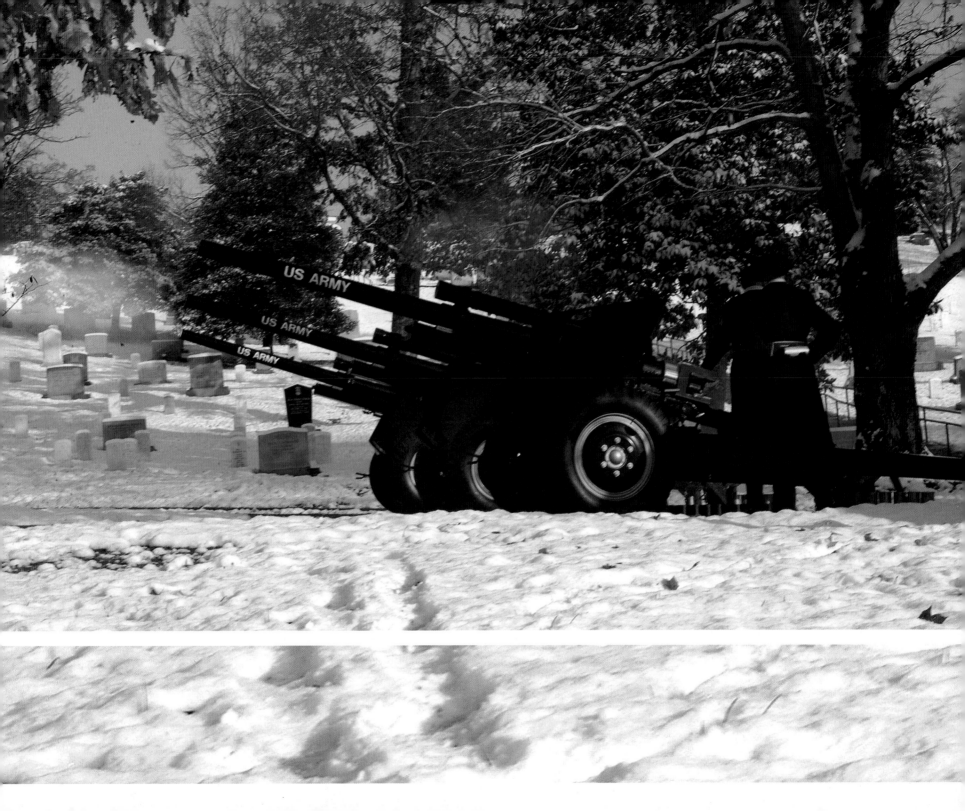

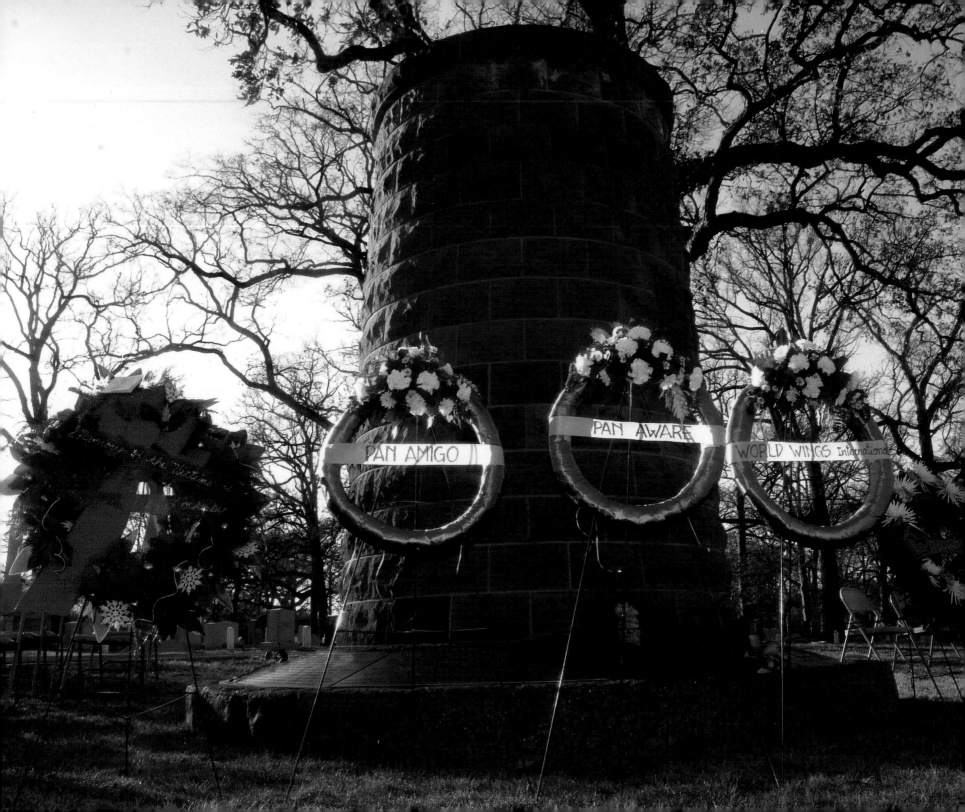

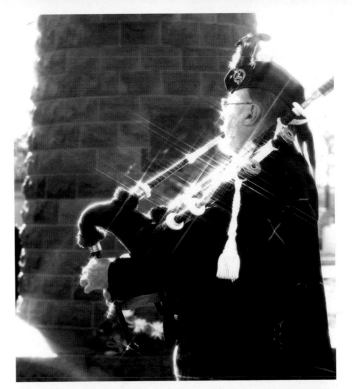

The annual ceremony for Pan Am Flight 103 takes place at the Lockerbie Cairn in Section 1. This memorial is made of 270 Scottish red sandstone blocks, each one representing a life lost in the terrorist attack on December 21, 1988. It was a gift from the people of Scotland to the people of the United States. This annual ceremony includes families and friends of the lost, government officials, a joint Color Guard, the Army Band, and the playing of the traditional Scottish bagpipes.

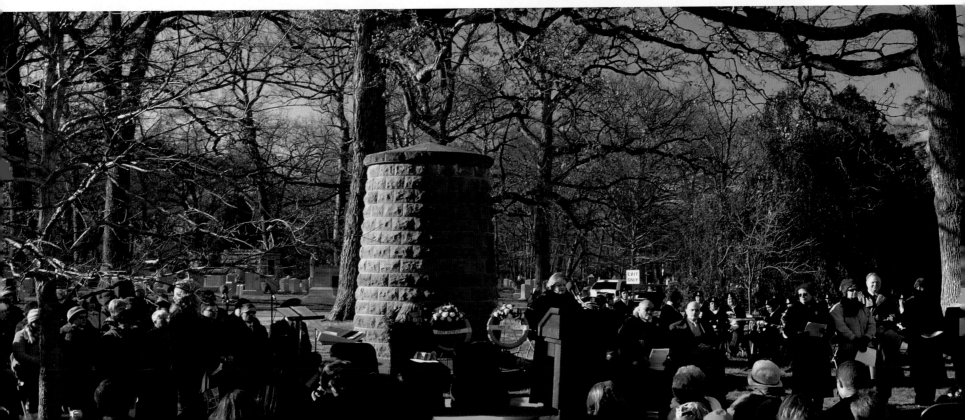

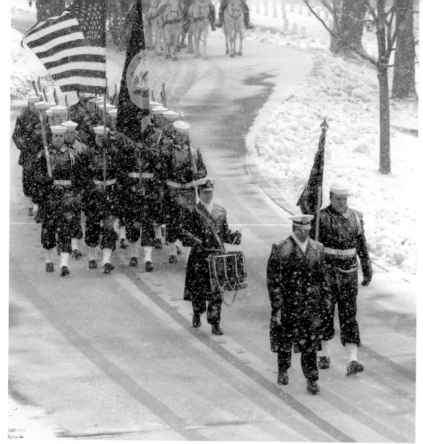

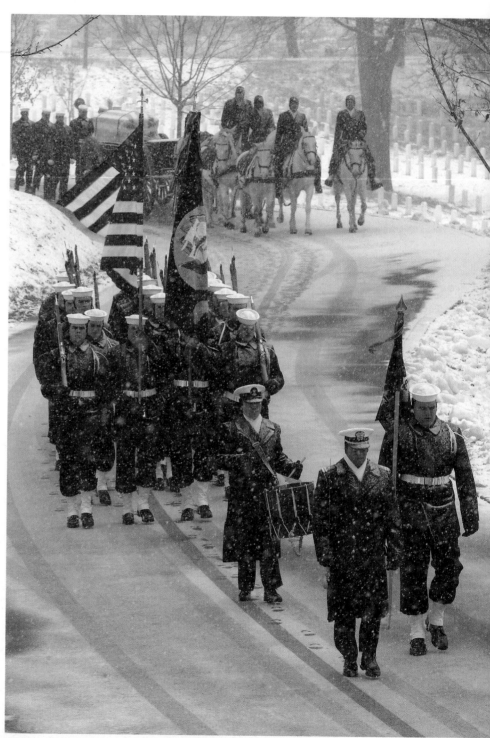

The Navy Ceremonial Guard and members of the Army's Caisson Platoon of the Old Guard work together in the Winter storm, not for the crowds or tourists but to give the proper honor and respect to a Navy shipmate being brought to a final resting place. Snow and ice pelt their faces and the footing is difficult, yet each step forward remains sure and solid.

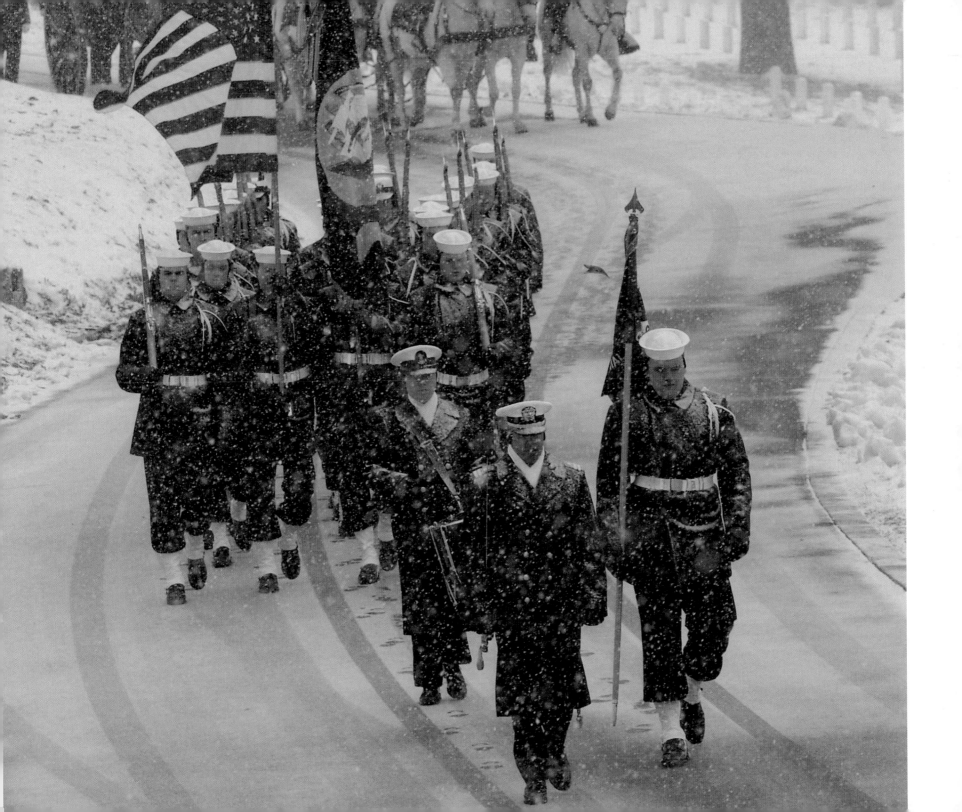

Freedman's Village

During the Civil War slaves escaped north to freedom; but how could the Union protect and integrate them into society? The answer was the Freedman's Village. On what is today's southern end of Arlington National Cemetery, a temporary camp was established to house and educate the newly freed slaves—also known as contraband. The camp grew to the size of a village and served its purpose for more than thirty years.

Run by the Freedman's Bureau, the village provided housing, education, job training, religious services, medical care, and food to its residents. Anywhere from two to four families lived in each of the fifty one-and-a-half-story houses. Both children and adults attended classes in the school, which peaked at 900 students. Former slaves learned to become blacksmiths, wheelwrights, carpenters, shoemakers, and tailors. Often their products were sold to the village or used in the school or the hospital. Farm workers also grew crops to sell for profit.

Life in the village was not easy, albeit easier than the plantations most of the former slaves escaped from. Although designed to hold 600 residents, the village was eventually overwhelmed with 1,100 residents, so strong was the determination to begin new lives as free men and women. With crowded numbers came outbreaks of scarlet fever, measles, and whooping cough, yet the death rate in the village was less than the entire city of Washington, D.C.

To deal with overcrowding, the residents lived under military discipline and were processed out of the village after a brief period of employment. The village also offered protection, as U.S. Colored Troops prevented former slave owners from retrieving their fomer slaves.

The village regularly contributed to the surrounding area as well. During the Civil War, villagers helped reconstruct the Capitol Building. In 1866, with the military occupation of the South, the residents formed the

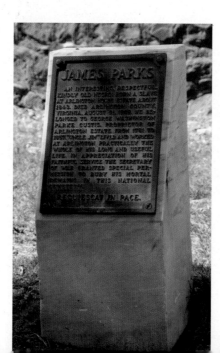

107th Regiment of the U.S. Colored Troops. A former slave, William Syphax, became a delegate to the Virginia National Assembly, while Jesse Pollard, another resident, became Arlington, Virginia's first black judge. Sojourner Truth, the icon of the Underground Railroad, taught former slaves and helped villagers find jobs in the area.

Freedman's Village closed in 1882 and the land was given to the military. The last residents were given ninety days to leave on December 7, 1887. Today the village is part of the grounds of Arlington National Cemetery, populated with more than 3,800 grave markers inscribed with "civilian," "citizen," and other generic terms. ↶

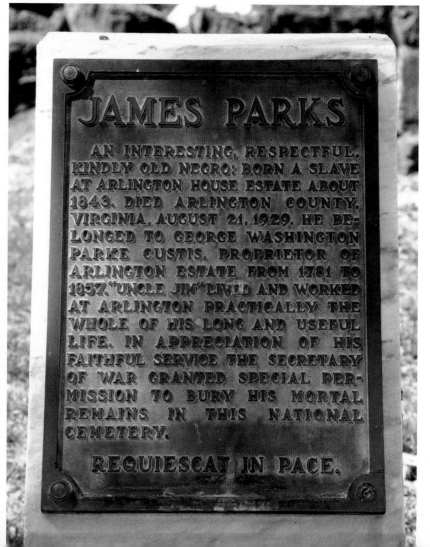

JAMES PARKS

AN INTERESTING, RESPECTFUL, KINDLY OLD NEGRO; BORN A SLAVE AT ARLINGTON HOUSE ESTATE ABOUT 1843, DIED ARLINGTON COUNTY, VIRGINIA, AUGUST 21, 1929. HE BELONGED TO GEORGE WASHINGTON PARKE CUSTIS, PROPRIETOR OF ARLINGTON ESTATE FROM 1781 TO 1857. "UNCLE JIM" LIVED AND WORKED AT ARLINGTON PRACTICALLY THE WHOLE OF HIS LONG AND USEFUL LIFE. IN APPRECIATION OF HIS FAITHFUL SERVICE THE SECRETARY OF WAR GRANTED SPECIAL PERMISSION TO BURY HIS MORTAL REMAINS IN THIS NATIONAL CEMETERY.

REQUIESCAT IN PACE.

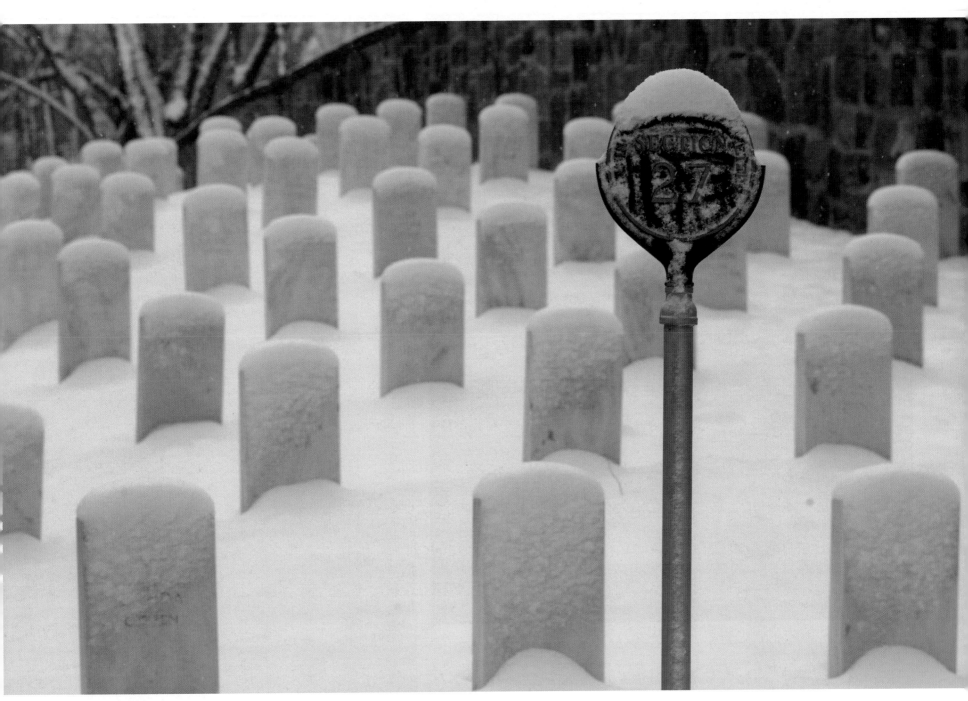

Section 27 can be said to be the beginning of Arlington National Cemetery.

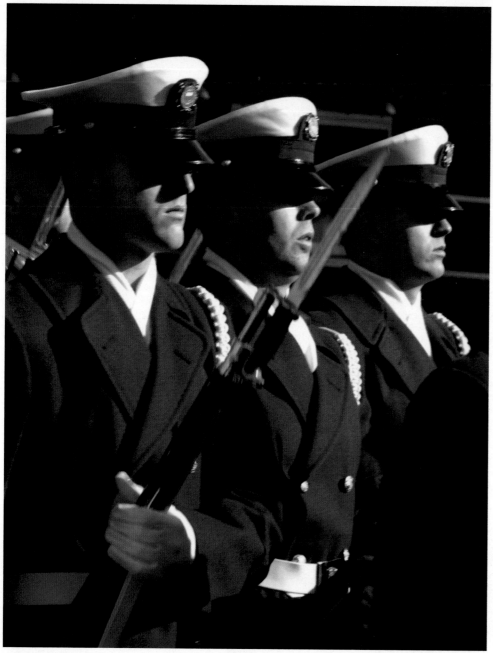

The men and women of the U.S. Coast Guard Ceremonial Honor Guard—although the smallest of the five Honor Guard units—perform more than 1,200 ceremonies annually, many of which are held in Arlington in a virtually flawless manner.

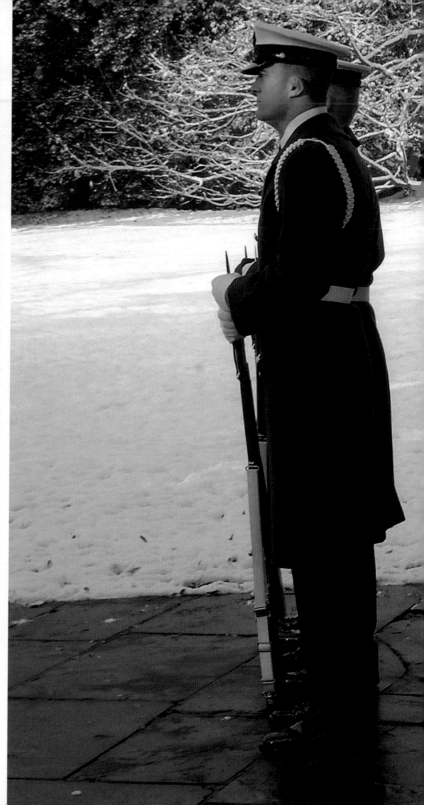

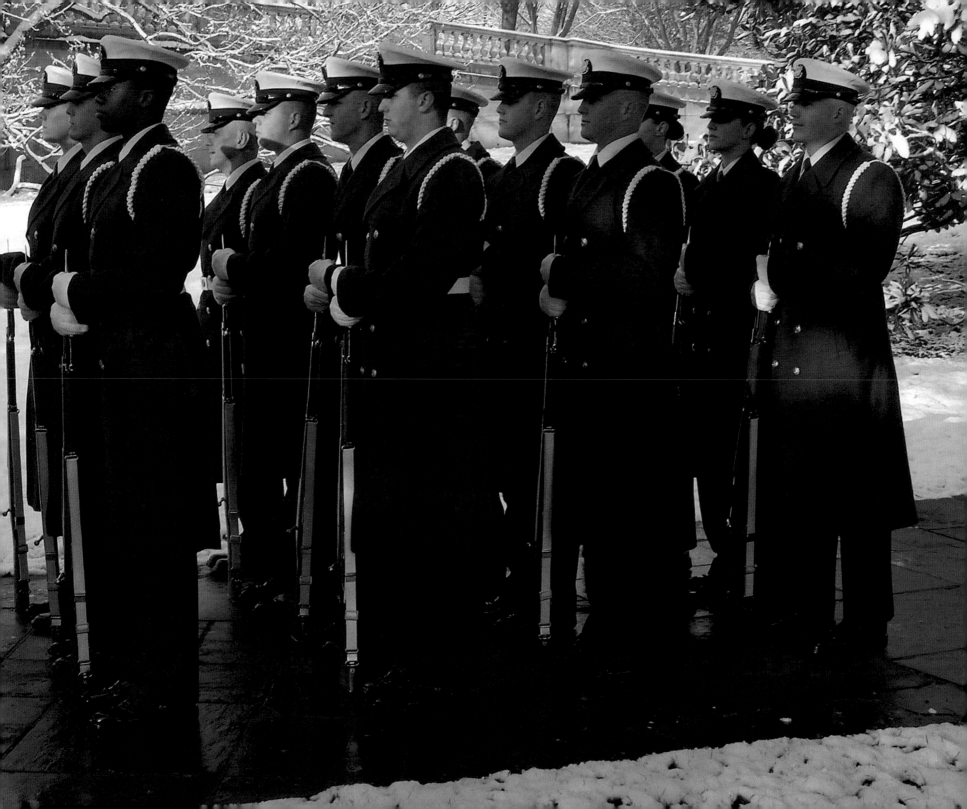

Unknowns

The Tomb of the Unknowns is the centerpiece of Arlington National Cemetery. Two crypts, one for the unknown dead of World War I and one for World War II and the Korean War, are guarded twenty-four hours a day by soldiers of the Third U.S. Infantry Regiment—The Old Guard. A third crypt, for the unknown of the Vietnam War, is empty.

Following World War I, the first unknown was exhumed from one of the four American cemeteries in France and picked at random by a veteran. The body was transported to the United States where General John J. Pershing greeted it at Arlington National Cemetery, and the body was laid to rest on November 11, 1921.

After World War II, plans were made to inter an unknown from that war at the Cemetery, but the plan had to be postponed when the Korean War broke out. It was not until 1956 that bodies representing the unknown from World War II were exhumed from graves in Europe, Africa, Hawaii, and the Philippines and two were selected—one to represent the European Theater and one the Pacific. For a Korean War unknown, four bodies were exhumed from the National Cemetery of the Pacific in Hawaii, and one was

chosen. The final determination of the two remains of World War II unknowns was made on the USS *Canberra*, located off of the Virginia Capes. One was picked and the other was given a burial at sea, and the last two unknowns of the wars were brought to Washington, D.C., for burial on May 28, 1958.

An unknown from the Vietnam War was interred on May 25, 1984, but was exhumed and identified in 1998. Using technology not available in previous wars, the unknown was identified as U.S. Air Force First Lieutenant Michael J. Blassie and was reinterred at the Jefferson Barracks National Cemetery near St. Louis, Missouri.

The unknown from every war in American history are buried at Arlington National Cemetery, with the exception of the American Revolution (there are living memorials to that war).

Fourteen unknown soldiers and sailors from the War of 1812 were discovered in 1905 near today's U.S. Navy Yard and reinterred into one tomb. Marking the site is a large granite monument with the inscription, "Symbolic of all who made the supreme sacrifice in that war."

The remains of 2,111 Union Civil War soldiers from Bull Run to the final days of the war have been collected and are kept in a masonry vault topped by a monument with cannons and cannon-

balls. Although Arlington National Cemetery was begun as a Union cemetery, there are Confederates buried within its bounds. Twelve unknown Confederates are buried with soldiers and civilians from the Civil War in concentric circles around a statue of a woman extending a wreath to her fallen sons.

The Cemetery also contains three special memorial sections where tombstones represent people whose identities are known but their bodies cannot be located, from World War II, Korea, and Vietnam. The headstones are placed closer together than normal burial spots and sections are on slopes steep enough to prevent burying caskets. ❧

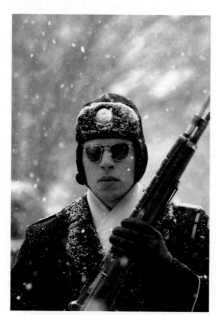

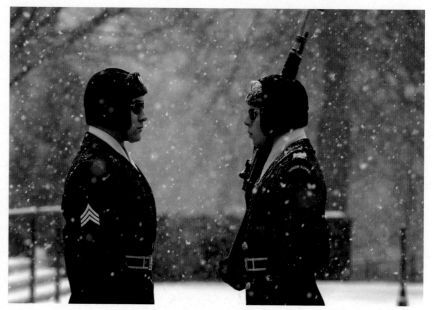

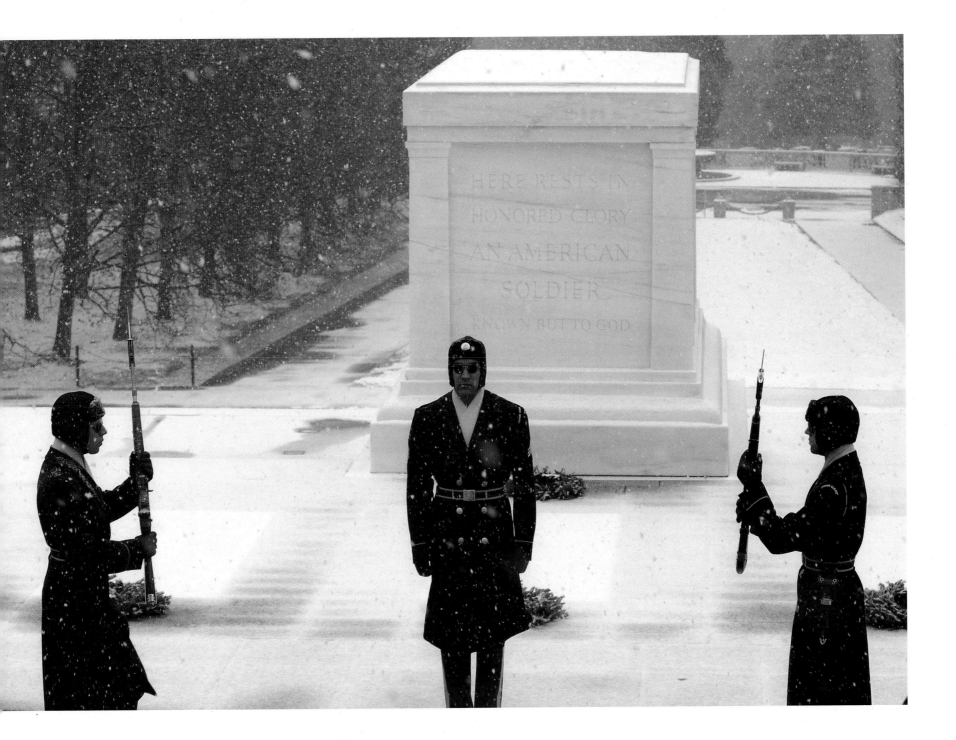

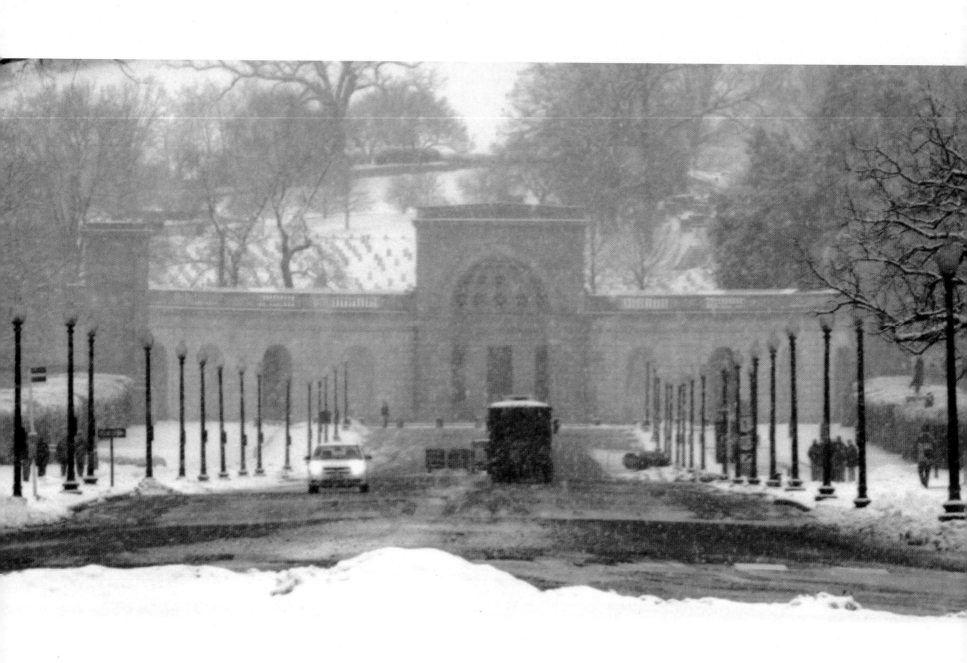

ABOUT

The photographer

ROBERT C. KNUDSEN is a professional photographer with tens of thousands of Arlington images in his portfolio taken during over four thousand hours at the cemetery. A lifetime member of the Navy League and an honorary member of the Marine Corps League, he has been an official photographer with the Association for the U.S. Army for over nineteen years. He has taken photographs for every branch of the military, both houses of Congress, every president from Lyndon Johnson until today, the Washington Nationals, and Disney World, among other clients. He was featured as one of the top panoramic photographers in the country by KODAK in 2000. He lives in Fairfax Station, Virginia, with his wife, Andrea, and two children, Dustin and Nicoll.

The text author

KEVIN M. HYMEL is the research director of *WWII History* and *Military Heritage* magazines. He has written numerous articles for each and has spent the last fifteen years writing on military matters. He is the author of *Patton's Photographs: War as He Saw It* and coauthor of *Patton: Legendary World War II Commander* with the late Martin Blumenson. Hymel has a master's degree in American History from Villanova University and lives in Arlington, Virginia.